Web Site
Creation Kit

Web Site Creation Kit

Kelly Valqui

Charles River Media, Inc.
Hingham, Massachusetts

Publisher: David F. Pallai
Production: Publishers' Design & Production Services
Cover Design: The Printed Image

CHARLES RIVER MEDIA, INC.
20 Downer Avenue, Suite 3
Hingham, Massachusetts 02043
781-740-0400
781-740-8816 (FAX)
info@charlesriver.com
www.charlesriver.com

This book is printed on acid-free paper.

Kelly Valqui. Web Site Creation Kit.
ISBN: 1-58450-083-2

Library of Congress Cataloging-in-Publication Data

Valqui, Kelly.
 Web site creation kit / Kelly Valqui.
 p. cm.
 Summary: Presents a course in designing Web pages along with clip art, ready-to-use design templates, email response forms, banner ads, and buttons.
 ISBN 1-58450-083-2 (paperback with CD-ROM : alk. paper)
 1. Web sites—Design—Juvenile literature. 2. Web site development—Juvenile literature. [1. Web sites—Design. 2. Web site development.] I. Title.
 TK5105.888 .V35 2001
 005.2'76—dc21

 2001004529

Printed in the United States of America
01 02 7 6 5 4 3 2 First Edition

To my sons, Renzo and Javier, thank you for being my inspiration.
Chris, thank you for seeing me through this project.

Contents

About the Author xvii

1 UNDERSTANDING WEB PAGES 1

What Are Web Pages? 3

What Is HTML? 6
 HTML Basics 7

Building Your Own Web Site Project 9
 Storyboarding 9

Flowcharts 12

Saving a Web Page 13
 Saving a Web Page with a Text Editor 13
 Saving a Web Page Using a Web Editor 15
 Naming the Home Page 16
 Viewing a Web Page in a Web Browser 17
 Testing Your Web Page in Internet Explorer 17
 Testing your Web Page in Netscape Navigator 19

Activity 21

Summary 23

2 TOOLS OF THE TRADE 25

What Do You Need to Create Web Pages? 27
 Web Editors 27
 Paint Programs 29

Downloading Netscape Composer 29

Starting Netscape Composer 34

Launching Composer from Navigator 37

Overview of Composer's Interface 38
 Composition Toolbar 40
 Formatting Toolbar 40
 Edit Mode Toolbar 40
 Workspace 41

Closing Netscape Composer 42

Activity 42

Summary 42

3 CREATING A WEB PAGE WITH COMPOSER 45

Getting Started by Setting Page Properties 47
 Location 49
 Title 49
 Author 49
 Description 49

Using the View Menu 50

Adding Text 52

Applying Format Using the Format Menu 54

Creating Headings 56

Creating Lists 58
 Formatting Lists 59

Aligning Text 61

Saving and Browsing Your Web Pages 63
 Saving a Web Page 63
 Display a Page in Navigator 64

Activity 65

Summary 67

4 FORMATTING ELEMENTS 69

Formatting Your Web Pages 71

Adding Background Color 71

Changing Font Properties 77

 Font Color 78

 Font Face 80

 Font Size 81

Using Bold, Underline, and Italics 82

Adding Horizontal Lines 83

Inserting Special Characters 87

Activity 88

Summary 89

5 HYPERLINKING 91

Understanding Hyperlinks 93

Creating a Link 94

 Creating an E-Mail Link 96

Targeting a Link to a New Window 98

Linking within the Same Page 99

Using Images as Links 102

Removing Links 102

Activity 103

Summary 105

6 IMAGES 107

Image Types for the Web 109

Image Formats 110

GIF Images 110

 Transparent GIFs 112

 Interlaced GIFs 113

 Animated GIFs 113

JPEG Images 114

PNG Images 114

File Sizes and Downloading 115

Measuring Your Images 118

Measuring on a PC 118

Measuring on a Mac 119

Inserting Images with Composer 119

File Location 119

Insert an Image 119

Edit the Image's Properties 124

Changing the Appearance of an Image Size 126

Constrain 127

Align Text to an Image 128

Spacing 128

Adding a Border 130

Creating Image Links 132

Activity 133

Summary 138

7 WORKING WITH TABLES **139**

Using Tables to Organize Content 141

Inserting a Table 143

Understanding Table Widths 145

Setting Your Table's Width in Pixels 145

Setting Your Table's Width in Percentages 147

Changing the Appearance of a Table 147

Changing or Editing an Entire Table 148

Size 149

Borders and Spacing 151

Table Alignment 152

Caption 153

Background Color 154

Changing or Editing Cell Properties 156

Selection 156

Size 157

Content Alignment 157

Cell Style 158

Text Wrap 158

Background Color 158

Adding and Deleting Rows, Columns, and Cells 159

Deleting a Cell or Group of Cells 160

Combining (Merging) Cells 161

To Split a Cell into Two Cells 162

Activity 162

Summary 167

8 WORKING WITH FORMS 169

Defining HTML Forms 171

Composer and Forms 172

The <FORM> Tag 173

The <FORM> Attributes 173

ACTION Attribute 173

METHOD Attribute 174

Form Fields 174

Working with the Input Form Fields 175

One-Line Text Fields 175

Check Boxes 177

Radio Buttons 178

Reset and Submit Buttons 179

Non-Input Form Fields 181

Selection Menus 181

Text Areas 183

Activity 185

Summary 187

9 COOL JAVASCRIPT 189

What Is JavaScript? 191

JavaScript Is Not HTML 193

JavaScript Is Not Java Programming 194

JavaScript and Web Browsers 196

What Can You Do with JavaScript? 196

Disadvantage of Using JavaScript 196

How Do I Get a Script Already Created? 198
 Finding Scripts 198

Inserting a JavaScript on Your Web Page 198

Writing Easy Scripts 202
 Status Bar Text 203
 Entering Date and Time 205

Learning More about JavaScript 206

Activity 208

Summary 210

10 WEBMASTER TOOLS **211**

What Are Webmaster Tools? 213

Where Can I Find Webmaster Tools? 213

Chat Rooms 214

Instant Messenger 223

Message Boards 225

Sound Files 229
 The MIDI File 230
 Other Sound File Formats 230

Downloading Sound Files from the Web 230

Inserting Sound Files on a Web Page 232
 Embedding MIDIs 233

Activity 234

Summary 236

11 GETTING PEOPLE TO FIND YOU

237

What Are Search Engines?	239
Defining Search Engines and Directories	240
Understanding How Search Engines Work	242
How to Use HTML Meta Tags	242
Getting Your Site to Rank High in a Search Engine	243
Pick Your Strategic Keywords	243
Position Your Keywords	244
Have Relevant Content	244
Registering Your Web Site with Search Engines	245
Summary	248

12 USING THE COMPANION CD-ROM

249

HTML TemplateMASTER CD-ROM, 3rd Edition	251
HTML 4.0 Tutorials	252
Detailed CD-ROM Directory	252
JumpStart	253
Just Enough HTML	254
Exotic HTML	255
Techniques and Resources	
Web Editor Reviews	257
Web Design Resources	258
Graphical Techniques	258
Paint Shop Pro 6	259
Banner Advertising	259
Multimedia on the Web	260
Advanced Web Programming	260
Web Site Planning	261
Style	261
Sample Web Pages	261
Web Page Themes	262
HTML Templates	262

Clip Art Collection 268

Web Site Promotion 280

JavaScript CD Cookbook, 3rd Edition 280

Introducing JavaScript 281

Communicating with Readers 282

JavaScript Environment 282

JavaScript Games 282

The Status Bar 283

JavaScript Clocks 283

JavaScript Strings 283

JavaScript Math 284

JavaScript Colors 285

JavaScript Forms 285

Data Structures 286

JavaScript Cookies 286

JavaScript Windows 286

JavaScript Multimedia 287

Newer Browsers Only 287

JavaScript 1.2 Goodies 288

The Future of JavaScript/JScript 288

To Start the HTML TemplateMASTER CD-ROM, 3rd Edition 288

To Start the JavaScript CD Cookbook, 3rd Edition 288

APPENDIX A CAREER OPPORTUNITIES 289

Types of Web Developers 290

The Web Application Developer 291

The Graphic/Multimedia Web Developer 291

Electronic Commerce Web Developer 292

HTML/Site Design Web Developer 292

The Role of a Web Developer 292

What Can You Expect to Charge/Salary? 293

Summary 294

GLOSSARY 295

WHAT'S ON THE CD-ROM 299
HTML TemplateMASTER CD-ROM 3rd Edition 299
JavaScript CD Cookbook, 3rd Edition (and reference) 299
Student Files 299

INDEX 301

About the Author

Kelly Valqui is the creative director at 8 Ball Media, a Web design and application development firm in Miami, Florida. Kelly is also a co-author of *HTML TemplateMASTER CD-ROM 3/E* (Charles River Media), *Web Design and Development* (Charles River Media), and *FrontPage 2000 – Designing for the Web* (Prentice Hall). Kelly teaches at Miami-Dade Community College and Florida Computer and Business school. You can reach Kelly via e-mail at Kelly@8ballmedia.net.

Understanding Web Pages

IN THIS CHAPTER

- What Are Web Pages?
- HTML Basics
- Building a Web Site Project
- Storyboarding
- Flowcharts
- Properly Saving a Web Page and File Conventions
- Working with Web Browsers

WHAT ARE WEB PAGES?

What exactly is a Web page? Simple, it's a document formatted for the Web. Web pages are electronic documents that display text, images, games, sounds, and other gadgets such as chat rooms. You access and view Web pages using your computer and an Internet connection. Figure 1.1 shows an example of a Web page from a popular Web site found on the Web.

Since your computer is the device that accesses the Web page, you will need a special program called a *Web browser* to display the document. The Web browser displays the Web page based on the instructions from

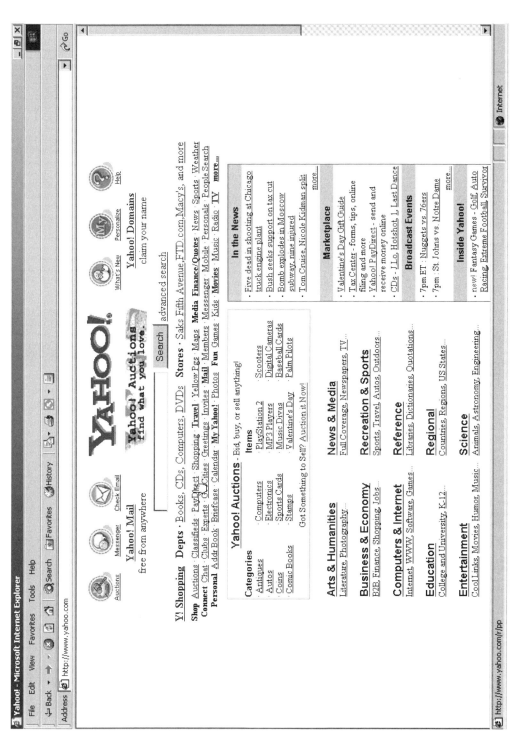

FIGURE 1.1 A Web page from Yahoo!. (© 2001 Yahoo!, Inc. All rights reserved.)

the code that formats the Web page; this code is called HyperText Markup Language, or HTML. Figure 1.2 shows what a Web page might look like on the Web. Figure 1.3 shows how the HTML code for that Web page instructs the Web browser to display the page.

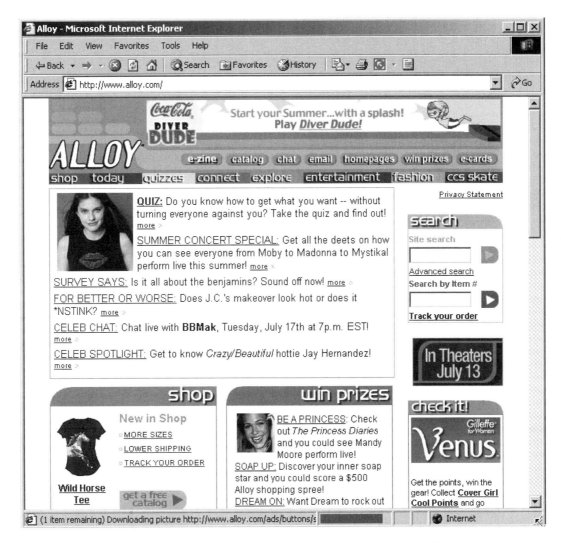

FIGURE 1.2 An example of a Web page. (© 2001. Alloy Inc. All rights reserved.)

```
www.alloy[1] - Notepad                                          _ □ ×
File  Edit  Format  Help
<!-- THIS DOCUMENT WAS GENERATED FROM A TEMPLATE: z_Home.atp -->
<!-- ANY CHANGES MADE TO A GENERATED DOCUMENT COULD BE OVERWRITTEN -->
<html>
<head>
        <title>Alloy</title>
<style>
<!--
.shopsearch { font-size: 11px; margin-bottom: 0px; font-family: Arial, Helvetica, san
-->
</style>
        <meta name="target" content="home, homepage, Alloy, main, mainpage" />
        <meta name="keywords" content="gossip, chat, horoscope, horoscopes, trivia, t
        <meta http-equiv="Content-Type" content="text/html; charset=iso-8859-1" />
        <link rel="stylesheet" href="/styles/alloy.css" type="text/css" />
        <link rel="stylesheet" href="/styles/services.css" type="text/css" />
        <script type="text/javascript" src="/jslib/include.js"></script>
        <script language="JavaScript" type="text/javascript">
        <!--
        var pageName="home";    var cat="";
        //-->
        </script>
        <script language="JavaScript" type="text/javascript" src="/jslib/ad_src.js"><
        <script language="JavaScript" type="text/javascript" src="/jslib/home.js"></s
        <link rel="stylesheet" type="text/css" href="/styles/home.css" />
</head>
<body onLoad="window.name='ALLOY';" bgcolor="#FFFFFF" text="#000000" leftmargin="0" t

<table width="600" border="0" cellspacing="0" cellpadding="0" align="center">
        <tr>
                <td width="129">
                <div><img src="/images/top/graphics/topovals.gif" width="129" height=
                <div><a href="/"><img src="/images/top/graphics/logo.gif" width="129"
                <td align="right" valign="bottom" bgcolor="#FF9900">
                <table width="471" border="0" cellspacing="0" cellpadding="0">
                        <tr>
                                <td bgcolor="#FF9900">
```

FIGURE 1.3 An example of the HTML source code to show how the HTML instructs elements to display on the Web page in Figure 1.2. (© 2001. Alloy Inc. All rights reserved.)

WHAT IS HTML?
• • • • • • • • • • • •

HTML is the computer language that is used to create documents on the Web. HTML documents are text files that consist of HTML *tags*. Tags are instructions that tell your Web browser how to display each element, such as a paragraph of text or an image, on your Web page. Tags are composed of commands (instructions) that are enclosed by angle brackets; all tags start with a < left angle bracket and end with a > right angle bracket.

For example: <HTML> *Other HTML elements and text.* </HTML>

The <HTML></HTML> tags tell the Web browser where the Web page starts and where it ends. This particular pair of tags is referred to as a *container tag*. Container tags contain elements on the Web page, such as text and images. A container tag has an "on" tag, such as the <HTML> in the previous example, and an "off" </HTML> tag. The off tag has a slash "/" before the command. You will learn more about container tags and other types of tags as you work through the lessons in this book.

HTML BASICS

The following tags are called *document tags*. Document tags are the basic tags that make up a Web page.

```
<HTML>
<HEAD>
<TITLE>This is the title to the Web page.</TITLE>
</HEAD>
<BODY>
Hello World!
</BODY>
</HTML>
```

In Figure 1.4, we can create a title on our Web page by placing descriptive text in between the <TITLE></TITLE> tags (these tags appear at the top of the page in Figure 1.4). The text between the <TITLE> container tags will appear in the title bar of a Web browser.

Figure 1.5 shows how the page displays the text "Hello World" in the Web browser; this is because the text was placed between the <BODY> container tags. The <BODY> container tags are used to display elements such as text and images in a Web browser window. Seems rather simple? You will learn more advanced tags and techniques later in this book.

The <HEAD></HEAD> container tags contain other HTML tags that are important for the browser or search engine, such as the <TITLE> container tag. The <BODY></BODY> tags contain the elements of the Web page that will display in the browser. The <HEAD></HEAD> tags (most often referred to as the "head section" of an HTML document) are reserved more for the "mechanics" of the Web page; the <BODY></BODY> tags (often referred to as the "body section" of an HTML document) are reserved for the viewer.

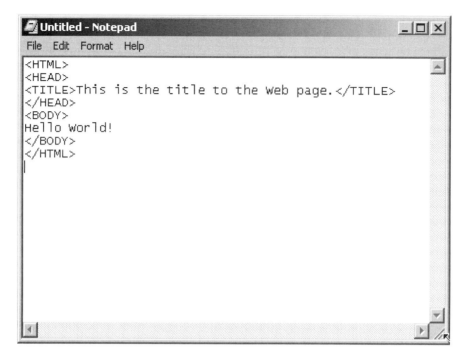

FIGURE 1.4 Use the <TITLE> container tags to create a title for your Web page.

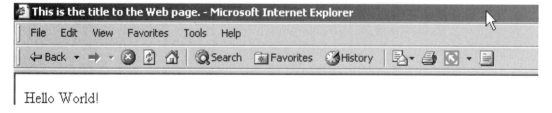

FIGURE 1.5 How the basic body tags work within a Web browser.

NOTE

You can view the coding to a Web page in a Web browser on the Web or from a disk by selecting VIEW, and then SOURCE from the menu bar in your Web browser. This allows you to view how a Web page author created his or her Web page.

Step Review: Creating a Basic HTML Document

1. Start your favorite text editor, such as Notepad.
2. Type the following basic HTML tags:

```
<HTML>
<HEAD>
<TITLE>This a basic HTML template.</TITLE>
</HEAD>
<BODY>
</BODY>
</HTML>
```

3. Save the document as an HTML file as per the instructions outlined later in this chapter (see *Saving a Web Page*).

BUILDING YOUR OWN WEB SITE PROJECT

One of the most important things you will need to learn in designing your own Web site is how to organize and plan your project—project meaning the type of site you want to design. Are you putting together a Web site for your family? Are you designing a Web site about a favorite game? Will you be adding music files to your Web site? Figure 1.6 shows an example of a gaming site.

STORYBOARDING

Storyboarding allows you to suggest layout ideas on paper or by other means before you sit down at your computer and begin designing a Web site. A storyboard can be as simple as some scribbles on several napkins of what you think each page should look like. It can also be a full color drawing or presentation on professional paper to present to others who may be helping with the building of the site.

If you are doing the storyboarding for yourself, you can grab a couple of pieces of plain paper and begin sketching out your ideas and adding side notes. These side notes should include font styles (Arial, Verdana, etc.), font colors, and other color schemes such as background color (you will learn more about fonts and styles later in this book). This will give

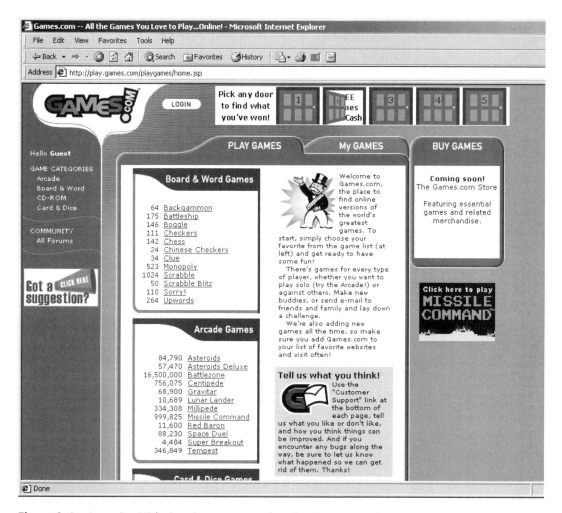

Figure 1.6 A gaming Web site. Games.com makes classic games such as Monopoly, Clue, Risk, and Battleship available via this online gaming community. (© 2001. Games.Com Inc. All rights reserved.)

you a better idea of where to place your Web page items such as pictures and text relative to the Web browser window.

HINT

Try not to confine yourself to the structure of the storyboard; its only use is to help you organize the Web site's content. A finished Web site rarely looks the same as the storyboard.

At this stage, you might find that you don't have enough content for your site, and may want to look for more things to add to your pages. The opposite could be true, too; you might find that you have too much content, and need to get rid of some of the information. Figure 1.7 shows an example of a storyboard.

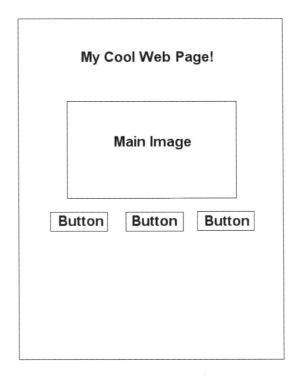

FIGURE 1.7 What a storyboard for a Web page might look like.

In Figure 1.8, we see the final Web page after the images and buttons have been added to the storyboard design.

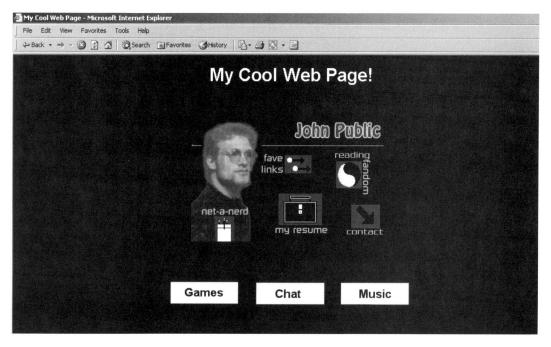

Figure1.8 The finished Web page using the storyboard in Figure 1.7

FLOWCHARTS

You will need to develop a linking system so that your viewers can navigate your site easily. Providing links to all of your Web pages in a logical format reduces the chance of visitors becoming confused and will help them find things logically.

To avoid confusion, you can use a flowchart to help you create the navigation flow of your Web site. You can use your storyboards and arrange them in manner that seems most logical. You might want to consider asking a friend to look at the arrangement of the storyboards, and see if the flow is logical to him or her. Alternatively, you can draw an outline of your Web pages, drawing boxes that represent your Web pages with lines connecting to each box (Web page) that symbolizes a link. Figure 1.9 shows an example of a flowchart created using the outline method from which you can build your linking system.

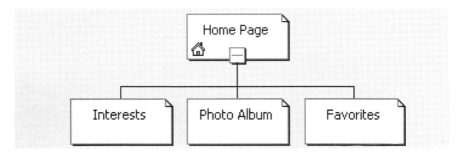

FIGURE 1.9 A flowchart for a personal Web site.

SAVING A WEB PAGE

Along with learning design techniques such as storyboards and flow charts, it's important to understand how HTML documents are saved before deployment on the Web. The application you are using to create your Web page will determine how you will need to save your page.

SAVING A WEB PAGE WITH A TEXT EDITOR

In a text editor, you will need to add the .htm or .html extension to your Web page's file name when saving, because a text editor defaults to the extension .txt— which represents a text file. Because you want your HTML documents to become a hypertext document, you will need to add the HTML extension so that the Web browser will render the document as a Web page.

In Figure 1.10, the .htm extension has been added to the file name *example* in the File Name field of the Save As dialog box from Notepad. Notice in the Save As dialog box that the Save As Type field defaults to the .txt extension. By adding the .htm or .html extension to the file name, the document is rendered to the Web browser as HTML; otherwise, if left with the .txt extension, the Web browser would render the document as text.

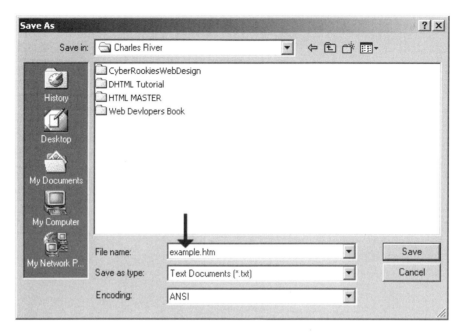

FIGURE 1.10 How the Save As dialog box might appear in your text editor.

NOTE

All Web browsers recognize both .htm and .html extensions. The earlier versions of Windows 3x operating systems used only three-letter extensions, such as the .htm, and could not read four-letter extensions such as .html. It is safe to say that today's platforms are universal when it comes to the HTML file extensions.

Step Review: Saving a Web Page with a Text Editor

1. After completing the coding for your HTML document in a text editor, click File>Save from the menu bar. The Save As dialog box will appear.
2. Navigate to the location on your hard disk where you want to save the file.

3. Type the name of your Web page in the File name field in the Save As dialog box.
4. Add the extension .htm or .html to the file name.
5. Click Save.

SAVING A WEB PAGE USING A WEB EDITOR

Saving a Web page with an application such as a *Web editor* will automatically default the file extension to .html or .htm, because it is an application that specifically creates HTML documents. A Web editor such as Netscape Composer allows you to create Web pages using menus and button commands. We will learn more about Web editors and Composer in later chapters. Figure 1.11 shows how Netscape Composer defaults to the .html extension in the Save Page As dialog box when saving a Web page.

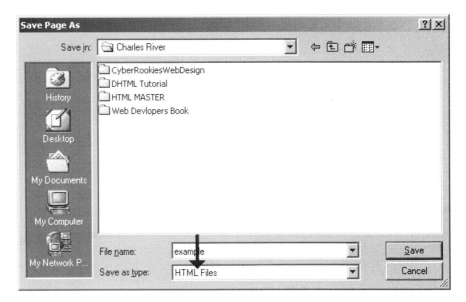

FIGURE 1.11 The Save As dialog box from Netscape Composer will appear when saving a document. Notice that the default file type is HTML Files in the Save As Type field. There is no need to apply the .html extension when using this type of application to create Web pages.

NOTE

Composer defaults to the .html extension because it is not a Microsoft product. However, if you are using a Microsoft product to create your Web pages, such as FrontPage, the Web page's file extension will default to .htm.

NAMING THE HOME PAGE

Another thing you must consider is how to save the home page. Because the home page is the initial entry point to your Web site, the Web *server* on which your pages reside must be able to determine which is your home page. A Web server is a computer on the Internet that hosts Web pages. The Web server determines this by the default file name of an HTML document. You must save your home page as this default file name.

Contact your hosting provider and ask what your default file name is to your home page. Most likely, it will be default.htm (.html) or index.htm (.html). For the lessons in this book, we will use *default.html* as our default file name as shown in Figure 1.12.

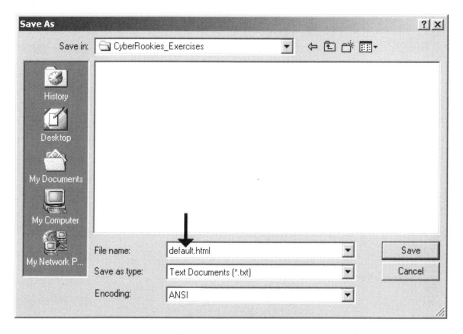

FIGURE 1.12 The default file name for our home page.

VIEWING A WEB PAGE IN A WEB BROWSER

You will also need to consider the types of Web browsers your viewers will be using to access your site. The two main Web browsers used on the Web today are Netscape Communicator (www.netscape.com) and Internet Explorer (www.microsoft.com).

The Web browser plays a huge role in how your Web pages are displayed. This means that viewers visiting your site might see a completely different result, depending on which browser version or platform he or she is using. Of course, you would like to make your Web page accessible to everyone, so it is important that you test your Web pages in multiple Web browsers, especially in both Navigator and Explorer.

TESTING YOUR WEB PAGE IN INTERNET EXPLORER

1. Start Internet Explorer.
2. Click File>Open from the menu bar. The Open dialog box will appear (Figure 1.13).

FIGURE 1.13 The Open dialog box from Internet Explorer.

3. Click Browse in the Open dialog box. The Microsoft Internet Explorer dialog box will appear (Figure 1.14).

FIGURE 1.14 Click Browse to access your HTML files on a disk.

4. Pull down the Look In: menu and navigate to the HTML file you want to open.
5. After locating the HTML document, either double-click it to display the file location in the Open dialog box, or click the file once and then click Open in the Microsoft Internet Explorer dialog box. The file path to the Web page will appear in the Open dialog box (Figure 1.15).

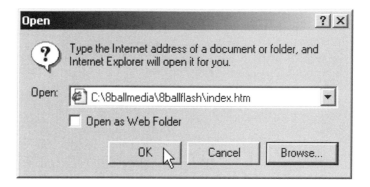

FIGURE 1.15 The file path to the HTML file located on the hard disk.

6. Click OK to view the Web page in Internet Explorer.

TESTING YOUR WEB PAGE IN NETSCAPE NAVIGATOR

1. Start Netscape Navigator.
2. Click File>Open File from the menu bar. The Open File dialog box will appear (Figure 1.16).

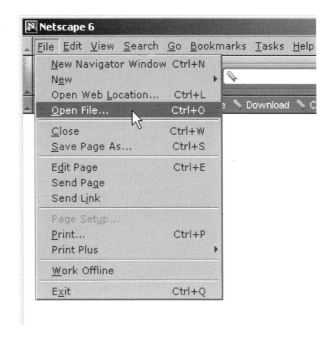

FIGURE 1.16 Netscape Navigator's Open dialog box.

3. Pull down the Look In: menu and navigate to the HTML file you want to open (Figure 1.17).

 Once the desired HTML document is located, either double-click it to display the file location in the Open dialog box, or click the file once and then click Open in the Open File dialog box.
4. The Web page will appear in Navigator's window.

Throughout this book are examples provided either in Netscape Navigator or in Internet Explorer; sometimes examples will be provided in both. Nevertheless, it is important that you test your pages in both Web browsers at all times. Figure 1.18 shows an example of Internet Explorer's interface, and Figure 1.19 shows an example of Netscape Navigator's in-

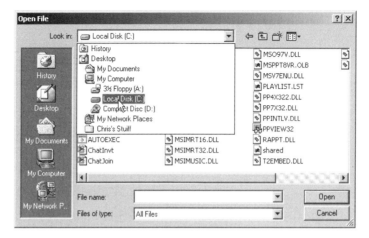

FIGURE 1.17 The Look In: menu.

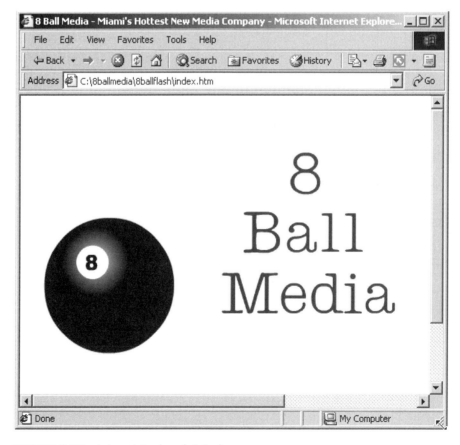

FIGURE 1.18 Internet Explorer's interface

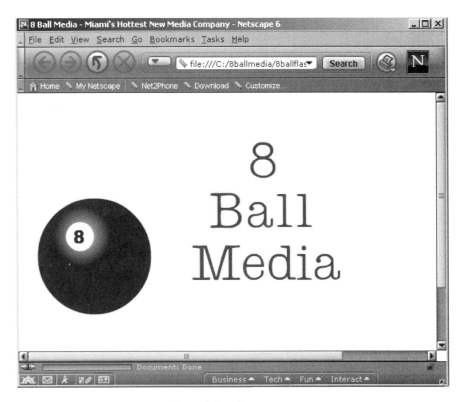

FIGURE 1.19 Netscape Navigator's interface.

terface. As you can see, both browsers have noticeable differences in their features, not to mention differences in their technologies.

ACTIVITY

In this exercise, you will create an HTML page using the basic document tags, save the page in a folder, and view it in a Web browser.

1. Create a folder on your hard disk; name it CyberRookies_Exercises.
2. Launch your text editor by clicking the Start button on the taskbar, then select Programs>Accessories, and then click on Notepad from the Accessories menu.
3. Type the following in your text editor:

```
<HTML>
<HEAD>
<TITLE>This is my first Web page.</TITLE>
<BODY>
Hello World!
</BODY>
</HTML>
```

4. Click File on the menu bar.
5. Click Save from the File menu. The Save As dialog box will appear.
6. From the Save As dialog box, navigate to your folder CyberRookies_Exercises and open the folder.
7. In the File name field of the Save As dialog box, type default.html and click Save (Figure 1.20).

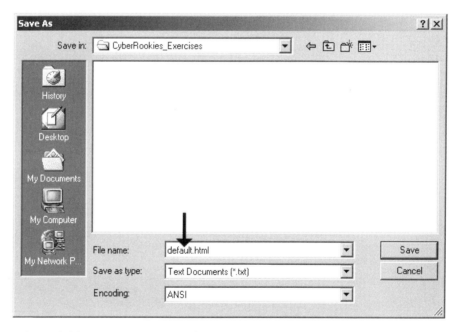

FIGURE 1.20 How your Save As dialog box should appear.

8. Start your Web browser and open the default.html file in the CyberRookies_Exercises folder.
9. Double-click the default.html file to display it in the Web browser.

SUMMARY
· · · · · · · · ·

- Web pages are electronic documents that display text, images, games, sounds and other gadgets such as chat rooms formatted to display on the Web using a Web browser.
- HTML is the computer language developed for the Web that instructs the way elements such as text and images appear in a Web browser window.
- Storyboarding is used to suggest layout ideas on paper or other media before you sit down to begin designing a Web site with your computer.
- Flowcharts enable you to construct a linking system for your Web site before you begin creating links. Creating a flowchart before you create your Web site will help avoid possible confusion with your navigation.
- When saving your Web pages in a text editor, you will need to include the .htm or .html file extension to your file name. However, if you are using a Web editor, the extension is applied by default.
- In order for a server to "serve" your home page, which is the initial page to your Web site, you will need to name your home page a default file name. Contact your hosting provider to find out what your default file name should be for your home page.
- Test your Web pages as you work on them in both Internet Explorer and Netscape Navigator to ensure that your pages display as intended.

Tools of the Trade

"... you don't get to choose how you're going to die, or when. You can only decide how you're going to live. Now!"

Joan Baez

Produced and © by
Natural Color
Productions

Printed in Singapore

BKMK VAN 6
Photo by: Eero Sorila

VANCOUVER

IN THIS CHAPTER

• Understanding Web Editors
• Defining a Paint Program
• Downloading Netscape Composer
• Working with Netscape Composer
• Composer's Interface

WHAT DO YOU NEED TO CREATE WEB PAGES?

All you really need to create Web pages is a text editor such as Window's Notepad to code HTML, and a Web browser such as Netscape Navigator or Internet Explorer to test and display your Web pages. However, in combination with these tools, it is suggested to use a Web editor and a paint program as well.

WEB EDITORS

A Web editor, such as Netscape Composer, enables you to create Web pages in a *drag-and-drop* environment, which allows you to create your Web pages using menus and command buttons, without any knowledge of programming.

The Web editor creates the HTML code for you. If you are familiar with using a word processor such as Microsoft Word, then you are familiar with some of the commands and menu items found in a Web editor. In this book, you will learn how to create Web pages using Netscape Composer's menus and commands and by editing the HTML code from Composer's HTML edit source feature (Figure 2.1).

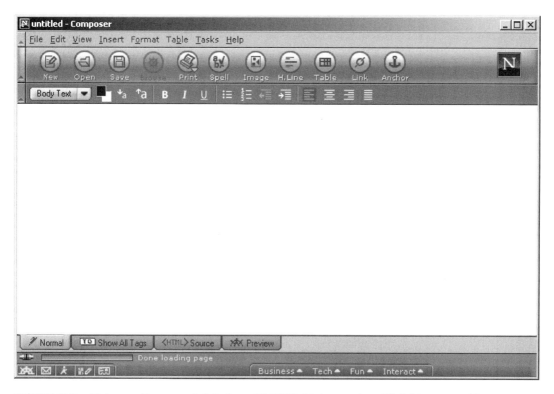

FIGURE 2.1 Netscape Composer's interface. (© 2001. Netscape, Inc. All rights reserved.)

HINT

You can get Netscape Composer for free by downloading Netscape 6 from www.netscape.com. Netscape 6 is a suite of several Web applications, including a Web browser (Navigator), a Web editor (Composer), an e-mail application (Messenger), and Instant Messaging.

PAINT PROGRAMS

ON THE CD

You can use paint programs to create or edit images, or find free images on the Web (be sure to read any disclaimers and to ask permission when necessary). You can find free trial versions of paint programs on the Web. PaintShop Pro 7 is the latest release of a professional paint program created by Jasc; an evaluation copy is provided on the companion CD.

In addition to the tools already discussed, you will need Web space to place your Web site so others can see your pages on the Web. You do not need Web space to test your Web pages; you can create, view, and test your Web pages right from your hard drive or even from a floppy disk.

HINT

You can find free Web space on the Web; one popular place is www.geocities.com, now owned by Yahoo!.

DOWNLOADING NETSCAPE COMPOSER

Since we are using Composer as our primary tool for creating our Web pages in this book, you may need to download Netscape 6.01 from Netscape's Web site. To download a free copy, log on to www.netscape.com.

WATCH OUT

At the time of writing, Netscape 6.01 was released. Since then, Netscape may have released a later version, and Netscape's Web site may have changed.

After logging on to Netscape's Web site, access their download area by clicking Download as shown in Figure 2.2.

Next, click the Netscape Browsers link to access the area of the Web site where you will download Netscape 6.01, as shown in Figure 2.3.

When the page loads, you will be in the "Netscape Products" section. Click Download for Netscape 6.01, as shown in Figure 2.4.

FIGURE 2.2 The Download button on Netscape's home page at www.netscape.com. (© 2001. Netscape, Inc. All rights reserved.)

FIGURE 2.3 Click the Netscape Browsers link to go to the Web page where you can download Netscape 6.01.

FIGURE 2.4 Click Download to begin downloading Netscape 6.01.

Once you click Download, the File Download dialog box will appear, asking you what you would like to do with this file. Select the Save This Program to Disk option, and then click OK as shown in Figure 2.5.

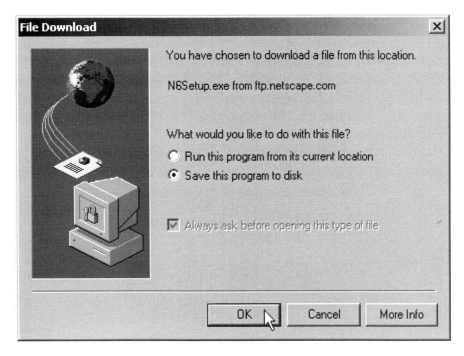

FIGURE 2.5 The File Download dialog box.

After clicking OK, the Save As dialog box will appear as shown in Figure 2.6. Notice the file name in the File Name field. In our example, the file name is N6 SETUP; this file is referred to as the setup file.

Typically, the Save As dialog box will open the Program Files folder by default to use as your destination folder, also shown in Figure 2.6. We recommended that you download Netscape 6.01 here. However, you can navigate to your desired destination folder to download. Once you have chosen your destination folder, click Save on the Save As dialog box to begin the download.

Your connection speed to the Internet and your own system hardware will determine how long the file will take to download onto your system.

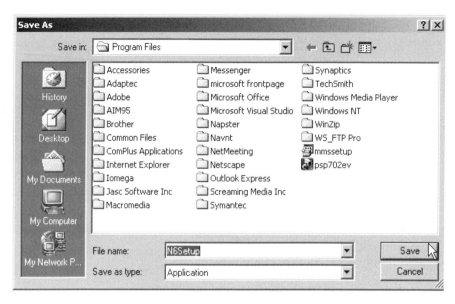

FIGURE 2.6 The Save As dialog box.

After downloading Netscape 6.01, navigate to the destination folder where the Setup file is located, and double-click on the file. Netscape will launch its Setup wizard to walk you through the setup process.

STARTING NETSCAPE COMPOSER

Netscape 6.01 is a packaged suite of applications: Composer (Web editor), Navigator (Web browser), Messenger (e-mail program), and several other mini applications such as Instant Messenger.

To launch Composer, you will have to start the entire Netscape 6.01 package by clicking Start from on task bar. Select Programs from the Start menu. Select Netscape 6.01 from the Programs menu, and click on Netscape 6.01 from the Netscape 6.01 menu. Figure 2.7 shows an example of how to start Netscape 6.01 using Windows 2000.

Step Review: Starting Netscape

1. Click Start from the taskbar to display the Start menu.
2. Select Programs from the Start menu.

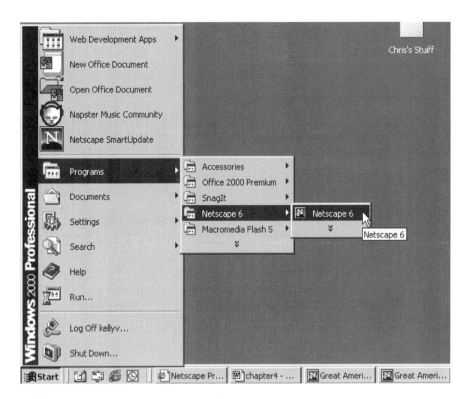

FIGURE 2.7 Launching Netscape 6.01.

3. Select Netscape from the Programs menu.

4. Select Netscape from the Netscape menu. Netscape Navigator will launch as the default program.

When Netscape 6.01 launches, Navigator starts as the default application and displays Netscape's home page (if you are connected to the Internet). If you are not connected to the Internet, Navigator will display a blank screen in the browser window with an alert box that states "home.netscape.com could not be found. Please check the name and try again." Click OK to close the alert box so you can begin working with Navigator. Figures 2.8 and 2.9 show how Navigator will display, depending on whether you are online when you launch the Web browser.

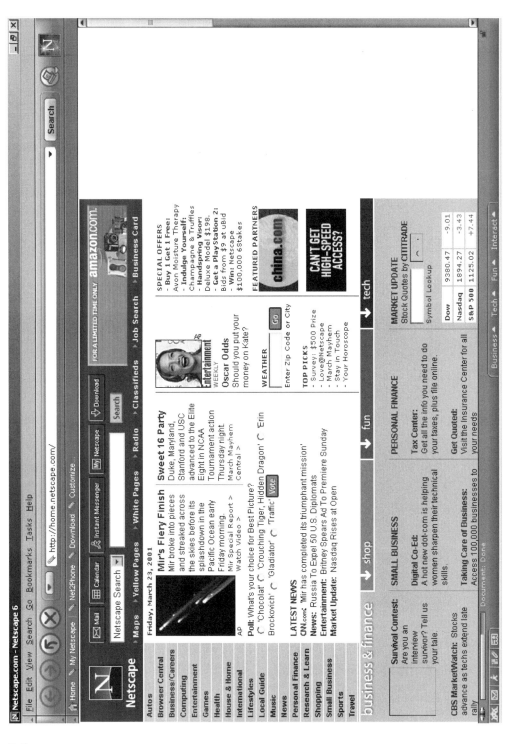

FIGURE 2.8 If you are online and launch Netscape 6.01, Netscape's home page will display. (© 2001. Netscape, Inc. All rights reserved.)

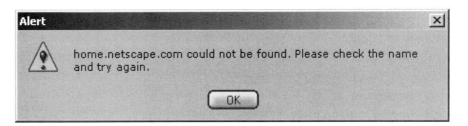

FIGURE 2.9 If you are not connected to the Internet when you launch Netscape 6.01, Navigator will display a blank screen with an alert box notifying you that home.netscape.com could not be found. Click OK, and a blank screen will display in Navigator.

LAUNCHING COMPOSER FROM NAVIGATOR

Whether online or not, you can launch Composer right from the window of Navigator. At the bottom left of Navigator's window is a menu of icons called the *taskbar* (not to be confused with Window's taskbar) , that allows you to launch several of the applications that come with Netscape 6.01's package.

These applications include Navigator, Mail, Instant Messenger, Composer, and the Address Book. Clicking the Composer icon from the taskbar will open a new window and launch Composer. Figure 2.10 shows the taskbar buttons. Starting from the left, the first button launches Navigator, the second launches Messenger, the third launches Instant Messenger, the fourth launches Composer, and the fifth launches the Address Book.

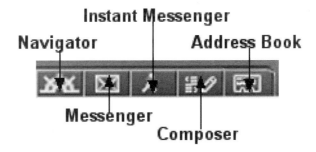

FIGURE 2.10 The taskbar launches the different applications that come with Netscape 6.01's package. From left to right: Navigator, Messenger, Instant Messenger, Composer, and Address Book.

To launch Composer, click the Composer button from the taskbar. When you click the Composer button, Composer will launch in a new window separate from Navigator. You can leave Navigator open to test your Web pages as you create them.

Step Review: Launching Composer

1. From Netscape's window, click the Composer button from Netscape's taskbar. Composer will launch in a separate window.

OVERVIEW OF COMPOSER'S INTERFACE

Netscape Composer is an HTML editor that allows you to create and edit Web pages. Composer is a WYSIWYG (What You See Is What You Get) editor, so you can see how your page will look to your viewers as you create it. It's not necessary for you to know HTML, since most of the basic HTML functions are available as commands from the toolbars and menus. However, throughout this text you will be introduced to the HTML elements that are created as you work on your Web page. Figure 2.11 shows Composer's interface with the toolbars denoted.

This brief overview is to show you the location of the toolbars and how to activate them if need be. We will cover how to use the toolbar and menu items throughout the course of this book.

Before we discuss the different toolbars available to you in Composer, you must first see if they are active. To activate all of the toolbars in Composer, click View>Toolbars to display the Toolbar menu as shown in Figure 2.12. Each toolbar should have a check next to it. If they do not, click on the menu item and Composer will activate the toolbar. Continue to do this until all of the toolbars are activated.

Step Review: Activating Composer's Toolbars

1. Click View from the menu bar. The View menu will appear.
2. Click Toolbars from the View menu. The Toolbars menu will appear.
3. From the Toolbars menu, click on each toolbar item that does not have a check mark next to it to activate that toolbar, or click on each toolbar item that has a check mark next to it to deactivate that item.

FIGURE 2.11 The toolbars and menus in the Composer window.

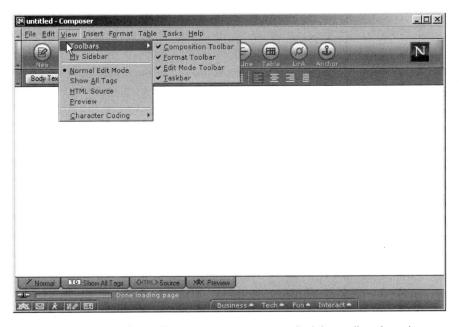

FIGURE 2.12 How the toolbar menu appears once all of the toolbars have been activated.

COMPOSITION TOOLBAR

The first toolbar we will look at is the Composition toolbar. The Composition toolbar offers command buttons that are the most commonly used. The commands on the Composition toolbar are defined in Figure 2.13.

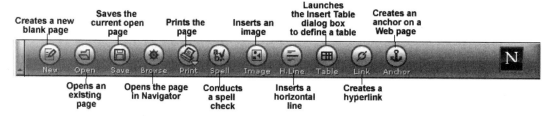

FIGURE 2.13 The commands on the Composition toolbar.

FORMATTING TOOLBAR

The Formatting toolbar offers commands that allow you to format the text on your Web page in some way, such as bold, underlined, color, type, and alignment as shown in Figure 2.14.

FIGURE 2.14 The Formatting toolbar.

EDIT MODE TOOLBAR

Composer allows you to quickly switch between four editing modes or views. Each editing mode allows you to continue working in your page, but displays varying levels of HTML as shown in Figure 2.15.

FIGURE 2.15 The Edit Mode toolbar once it has been activated.

Normal: Choose this mode to show table borders and named anchor icons. All other HTML tag icons are hidden. This is where you will design your Web page.

Show All Tags: Choose this mode to show table borders and all HTML tag icons.

HTML Source: Choose this mode to see the page as unformatted HTML code.

Edit Preview: Choose this mode to see the page as it will appear in a browser window.

WORKSPACE

The workspace is the actual document itself, which is the large white area of the window as shown in Figure 2.16. This is where you will create your Web page.

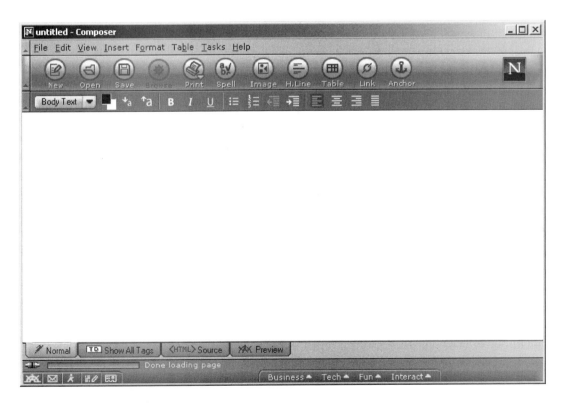

FIGURE 2.16 The workspace.

CLOSING NETSCAPE COMPOSER

To close Composer, simply click the X button located in the top right-hand corner of the window, or click File>Quit.

Step Review: Closing Netscape

1. To quit Composer, click the X button located in the top right-hand corner of the window, or click File from the menu bar and click Quit from the File menu. Composer will close.

ACTIVITY

In this exercise, you will simply start Composer, display the View>Toolbars menu from the menu bar, and close Composer.

1. Start Composer by clicking the Start button on the taskbar. From the Start menu, select Programs>Netscape 6.01.
2. From the Netscape 6.01 menu, click on Netscape 6.01. Navigator will launch.
3. From Navigator's taskbar, click the Composer icon. Composer will launch.
4. From Composer, click View>Toolbars from the menu bar. Activate all the toolbars in the Toolbars menu if not activated by clicking each toolbar option. A check mark will appear by each one when activated.
5. Ensure that the Edit Mode toolbar is activated. Click each mode tab of the Edit Mode toolbar.
6. Close Composer by clicking File>Quit.

SUMMARY

- There are several tools you can use to help you create Web pages. It is suggested that you use a Web editor such as Composer, and a paint program to create your Web pages.

- You can download a free version of Composer from www.netscape .com.
- Composer comes packaged with Navigator and Messenger in the Netscape 6.01 suite.
- Composer's interface is comprised of menus and toolbars much the same way a word processor's interface is designed.

Creating a Web Page
with Composer

IN THIS CHAPTER

- Setting Page Properties
- Using the View Menu
- Adding Text
- Formatting Text Using the Format Menu
- Creating Headings
- Creating Lists
- Formatting Lists
- Aligning Text
- Saving and Browsing a Web Page

GETTING STARTED BY SETTING PAGE PROPERTIES

After launching Composer, a new window will open displaying a blank page. Setting the Page Properties for your Web page is an important part of Web page design. Page Properties allows you to set the page title, and provide authorship and a brief description about your Web site. This information is added to your Web site through the Page Properties dialog box, which then adds the information to the Web page by placing it in between the <HEAD></HEAD> commands. This information is useful if

you plan to publish your Web page on the Web, since search engines use this type of information to index your page.

To edit these properties as shown in Figures 3.1 and 3.2, open the Format menu, and choose Page Title and Properties.

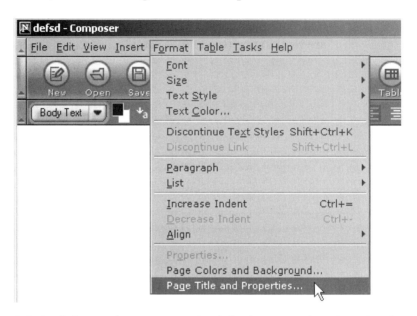

FIGURE 3.1 Use the Page Properties dialog box to set the title, authorship, and description of the Web site.

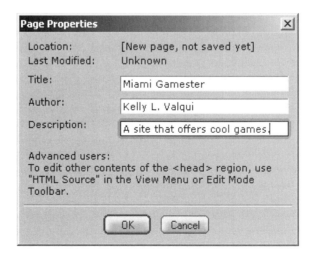

FIGURE 3.2 The Page Properties dialog box.

LOCATION

The file name and location of the document that you are currently working on is saved. If the document has not been saved, then "New page, not saved yet" will appear in the Location field. This is insignificant to the actual Web page itself; it's just a note informing you what document you are working on (see Figure 3.2).

TITLE

Type the text you want to appear as the title in the title bar of a Web browser. This is how most search engines locate Web pages, so choose a title that is very descriptive that conveys what your page is about (see Figure 3.2).

NOTE

A Web page title is placed in the Web page's HTML code between the <TITLE></TITLE> tags. This title appears in the title bar of a Web browser.

AUTHOR

Type the name of the person who created the Web page, or the school name or company it represents. This information is helpful to readers who find your document by using a search engine. In addition, this provides your authorship to viewers who view your HTML code (see Figure 3.2).

DESCRIPTION

Enter a brief description about your Web page's content. The search engine uses this to display to the viewer as a description of your site when the user conducts a search. This information should be as descriptive and enticing as possible to get the user to select your site from the search engine's results (see Figure 3.2). When finished entering the properties for your page, click OK.

NOTE

Authorship and the description of the Web page are placed between <META> tags. Meta tags are placed after the <TITLE></TITLE> tags and before the closing </HEAD> tag in the HTML source. Meta tags are used to provide search engines with more information about your page, and can help with the ranking of your Web site within a search engine. For example, <META NAME="author" CONTENT="Kelly L. Valqui">, <META NAME="description" CONTENT="This is Kelly Valqui's personal home page."> are <META> tags generated from the Page Properties dialog box.

Step Review: Setting Page Properties

1. Click Format from the menu bar, and then click Page Titles and Properties from the Format menu. The Page Properties box will appear.
2. In the Title: field of the Page Properties box, type the text you want to appear as the title of the Web page in the Web browser's title bar.
3. In the Author: field, type the name of the author.
4. In the Description: field, type a description of your Web site that you want to display in the results page of a search engine.
5. Click OK in the Page Properties dialog box.

USING THE VIEW MENU

Although you will most often use the Edit Mode toolbar to view and edit your Web pages in this book, this section shows you how you can view your Web page by using the View menu from the menu bar. Following are some examples of how your Web page may view after you complete entries in the Page Properties dialog box.

Composer will add the title of the Web page to the title bar and create the HTML code in the source file to the Web page. To view the HTML code, click on View>HTML Source; the window will switch to HTML mode where you can view and edit the HTML code. See Figures 3.3 and 3.4 for examples.

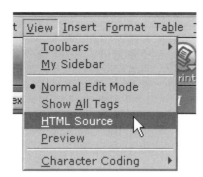

FIGURE 3.3 You can access the HTML source
to the Web page by clicking View>HTML Source.

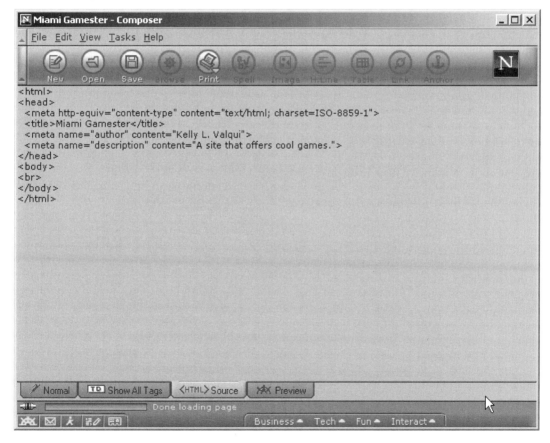

FIGURE 3.4 The HTML source code is displayed with the title, authorship, and description.

NOTE

Notice that the meta tags have been added to the HTML source code so search engines will find my page.

To change back to Edit Mode (where you create your pages using menus and commands), click View>Edit Normal Mode. Composer will revert to Edit Mode as shown in Figure 3.5.

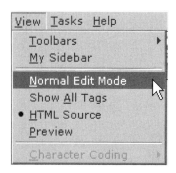

FIGURE 3.5 To change back to Normal Edit Mode, click View>Edit Normal Mode.

Step Review: To Use the View Menu

1. Click View>HTML Source to view the HTML code.
2. Click View>Edit Normal Mode to switch back to Normal Mode.

ADDING TEXT

To add text to your Web page in Composer, just begin typing. There are two ways to group text, with *line breaks* and *paragraphs*. Line breaks and paragraphs are different in HTML. A *line break* forces a return to the *next* line when you press Enter on your keyboard. By default, Composer is set to create line breaks whenever you press Enter.

A *paragraph* separates blocks of text from each other by adding a line space between each block of text.

NOTE

Line breaks are created in HTML by using the
 tag. Paragraphs are created in HTML using the <P></P> tags.

In this book, *formatting* refers to selecting and changing the default text in some way, such as applying bold, italics, or an underline. Other forms of formatting include changing font properties such as size and type, or changing sections of text by indentation and alignment.

Figure 3.6 shows an example of a Web page that has both line breaks and paragraphs as a part of its formatting. Figure 3.7 is the HMTL that

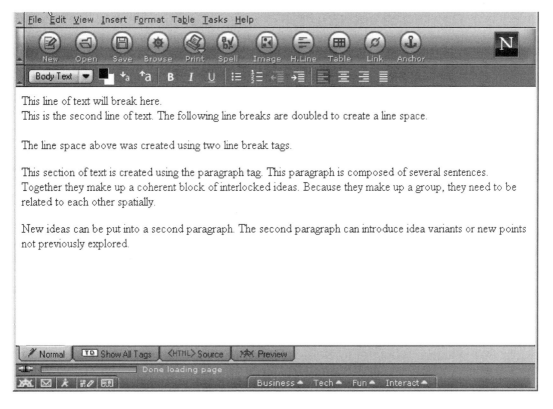

FIGURE 3.6 A Web page formatted using both line breaks and paragraphs.

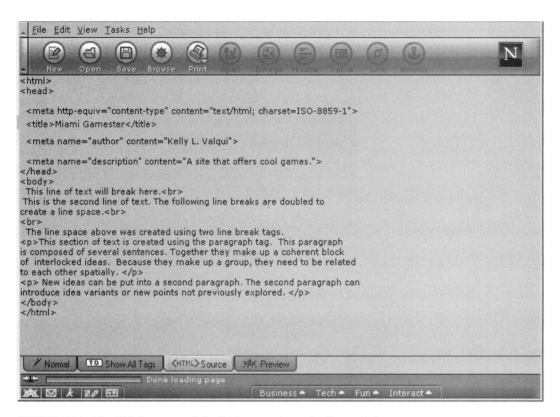

FIGURE 3.7 The HTML source of the Web page shown in Figure 3.6.

creates the formatting. Notice the double
 tags used to create a line space between two sections of text, whereas using the <P></P> tags does this automatically.

Step Review: Add Text to a Web Page

1. To add text to a Web page, click in the Composer workspace.
2. Begin typing as you would in a word processor.

APPLYING FORMAT USING THE FORMAT MENU

You can format using Composer by selecting Format from the menu bar, or for fast selection of formatting options, you can use the Format pull-down menu in the Formatting toolbar. Figure 3.8 shows the Format

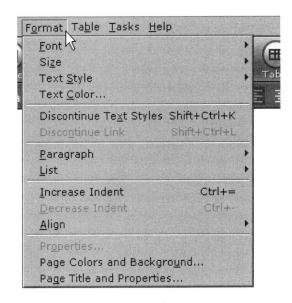

FIGURE 3.8 Format menu from the menu bar.

menu for the menu bar. Figure 3.9 shows the Format pull-down menu from the Formatting toolbar.

FIGURE 3.9 Format pull-down menu from the Formatting toolbar.

To format text, select the text you want to format and choose one of the following formats from the Format pull-down menu:

- **Body Text**: Applies the default font type and style for regular text.
- **Paragraph**: Inserts a paragraph tag (<P></P>). The paragraph format inserts a line space before and after the paragraph.
- **Address**: This format can be used for a Web page signature that indicates the author's contact information, which can include the date and copyright notice. Composer defaults the address format in italics.
- **Preformatted**: This is useful for text that you want to display in a fixed font, such as code examples and poetry. Using the Preformatted style to format text will keep white spaces and returns intact, preserving the layout of the original text.
- **Blockquote**: Choose this format to indent quoted text on both the left and right margins. The indentation usually defaults to five spaces (usual spacing for default Tab key).

ON THE CD ROM

 You will find FORMATTING.HTM in the CyberRookie_Example_Files folder on the companion CD-ROM. FORMATTING.HTM is an example of "formatting."

Step Review: Apply Formatting to Text

1. Select text from the Web page in the workspace area.
2. Select a formatting option such as Body Text, Paragraph, and so on from the Format pull-down menu in the Formatting toolbar.

CREATING HEADINGS

Headings are commonly used in HTML to create titles and arrange information on a Web page.

Each heading produces a boldface title followed by a paragraph break. In Figure 3.10, we see heading sizes vary from size 1 (very large) to size 6 (very small).

To create a heading, select the text you want to format, open the Format pull-down menu, and choose the level of heading you want as shown in Figure 3.11.

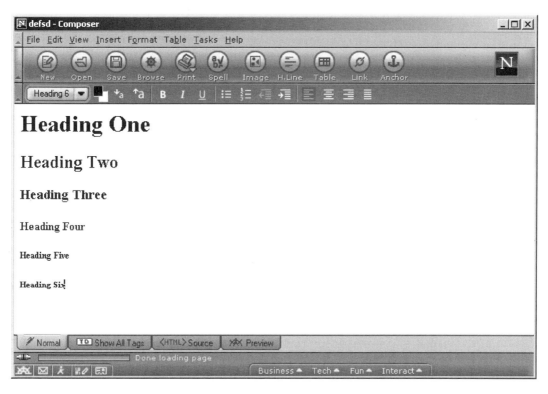

FIGURE 3.10 The six different levels of headings.

FIGURE 3.11 Access the different levels of formatting by clicking on the Format pull-down menu.

NOTE

The Format pull-down menu will default to a format type when Composer starts. In Figure 3.11, the Format pull-down menu defaulted to "Body Text." Be aware that your default format may differ from our example.

Try to use headings in a hierarchal manner. For example, choose "Heading 1" for your main heading, "Heading 2" for the next level, and so on.

Step Review: Create a Heading

1. Select text from the Web page in the workspace area.
2. Select the Format pull-down menu from the Formatting toolbar.
3. From the Format pull-down menu, select a heading option such as Heading 1.

CREATING LISTS

Lists are very useful because they provide information in a structured format. Lists are often used to create an outline, or to focus on major points of information such as a summary. There are three types of lists: ordered, unordered, and definition. Figure 3.12 shows a Web page with all three lists.

To apply a list format, highlight the text you want to format, choose Format menu from the menu bar, choose List, and then select the list style.

- **Numbered**: Items are numbered.
- **Bulleted**: Each item has a bullet (dot) next to it (as in this list).
- **Term and Definition**: These two styles work together, creating a two-column format like the one you find in a glossary. Use the Term tag for the word being defined, and the Definition style for the definition. The Term text appears flush left, and the Definition text appears indented. Once the list is complete, you can use **boldface** type to enhance the Term text.

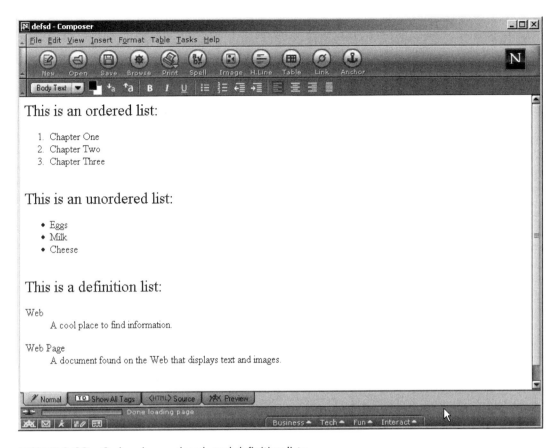

FIGURE 3.12 Ordered, unordered, and definition lists.

NOTE

You can quickly apply a list style to text by selecting the text and clicking the Numbered List and Bulleted List buttons on the toolbar.

FORMATTING LISTS

There might be times when you want to change the list style from the default style. To do this, click within the text of the list item you want to change. If you want to change the entire list, highlight the whole list.

Click Format from the menu bar, choose List, and then List Properties as shown in Figure 3.13.

Choose a bullet or number style from the List Properties dialog box as shown in Figure 3.14. For numbered lists, also specify a starting number. If it is a bulleted list, you can change the bullet style.

Step Review: Creating and Formatting Lists

1. Select the text you want to display in a list, or insert your cursor in a place on the Web page you want to begin a list.
2. Select Format>List>List Properties from the menu bar.
3. Choose a bullet or number style from the List Properties menu.

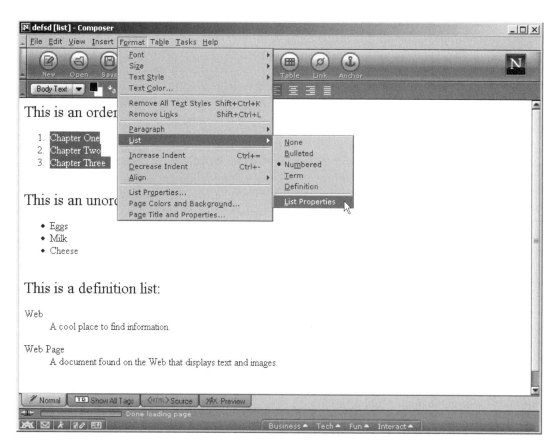

FIGURE 3.13 Accessing the List Properties dialog box from the Format menu on the menu bar.

FIGURE 3.14 List Properties box.

ALIGNING TEXT

You can align sections of text in your Web page using the align commands. Figure 3.15 shows an example of text (lists) aligned left, centered, and right in a Web page.

To align, select the section of text you want to align. Click the Format menu and choose Align, then choose an alignment option as shown in Figure 3.16.

Step Review: Align Text on a Web Page

1. Select the text on the Web page you want to align.
2. Click the Align Left, Align Right, Align Center or Align Justify button from the Formatting toolbar. You can also access the Format>Align menu from the menu bar and then select an option from the Align menu.

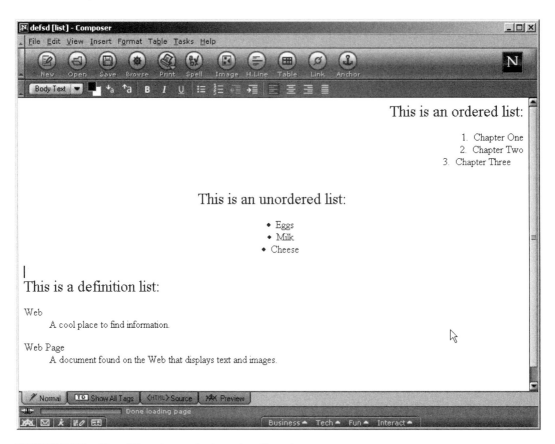

FIGURE 3.15 The different ways text can be aligned.

FIGURE 3.16 You can align text by using the Align menu from the Format menu.

SAVING AND BROWSING YOUR WEB PAGES

Once you are finished editing your Web page, you need to save it to your disk. You can then test how your Web page will display by launching it in Navigator.

SAVING A WEB PAGE

To save a new page as an HTML file on your local drive, click the File menu and choose Save. The Save As dialog box will appear, where you can specify a file name or location, as shown in Figure 3.17.

FIGURE 3.17 To save a Web page, click File>Save.

If you haven't already given your page a title, Composer prompts you to do so.

You don't need to add the .html extension to the file name; Composer adds it for you.

Choose Save As if you want to give the page a different file name or location; we provide an example for you in Figure 3.18.

FIGURE 3.18 The Save As dialog box allows you to name your Web page file and navigate to the location where you want to save it.

DISPLAY A PAGE IN NAVIGATOR

To display your saved Web page in Navigator, click the Browse button from the Composition toolbar, as shown in Figure 3.19. A Navigator window will launch and display the Web page as if it were on the Web.

FIGURE 3.19 The Browse button on the Composition toolbar.

Step Review: To Save and Browse a Web Page

1. Once you are finished editing your Web page, click the Save button from the Composition toolbar.

2. To view your work, click the Browse button from the Composition toolbar. Netscape Navigator will launch and display the Web page.

ACTIVITY
••••••••

In this exercise, you will create the main page to the Miami Gamester site. You will create a heading, paragraphs of text, lists, and add page properties.

1. Create a folder called Miami_Gamester in the folder CyberRookies_Exercises you created in Chapter 1.
2. Start Composer. A new page will appear.
3. From the Format menu on the menu bar, select Page Title and Properties option. The Page Properties dialog box will appear.
4. In the Title field, type "Miami Gamester Games Home Page".
5. In the Author field, type your name.
6. In the Description field, type "Miami Gamester is an online gaming site for JavaScript games."
7. Click OK.
8. Begin typing on the first line in the workspace, "Miami Gamester". Press Enter.
9. Type "Welcome to the Miami Gamester site. Here you will find cool JavaScript games. Feel free to play one of the games online or copy the script of one of our games to use on your own Web site. Please give proper credit to the author of the script. If you like, submit a JavaScript game of your own by clicking on the link Submit a Game below. We will be sure to give you proper credit as the author of the game. Enjoy!" Press Enter.
10. Type "Cool Games", and press Enter. Type "Submit a Game", and press Enter. Type "Favorite Sites", and press Enter.
11. Type "Miami Gamester", and press Enter. Type webmaster@miamigamester.com, and press Enter.
12. Select the first line of text "Miami Gamester". Select Heading 1 from the Format pull-down menu. Click the Align Center button on the Formatting toolbar.
13. Select all three sentences "Cool Games," "Submit a Game," and "Favorite Sites". The section of text will highlight blue. Click the Bullet

List button from the Formatting toolbar. Click the Align Center button.

14. Select both the "Miami Gamester" and the "webmaster@miamigamester.com" sentences. Click the Align Center button from the Formatting toolbar.

15. Click the Save button from the Composition toolbar. The Save As dialog box will appear. Navigate to the folder you created, Miami_Gamester.

16. Name the file "default," and click Save from the Save As dialog box.

17. Click Browse from the Composition toolbar. Figure 3.20 shows an example of how default.html should display in Navigator.

18. Close Composer.

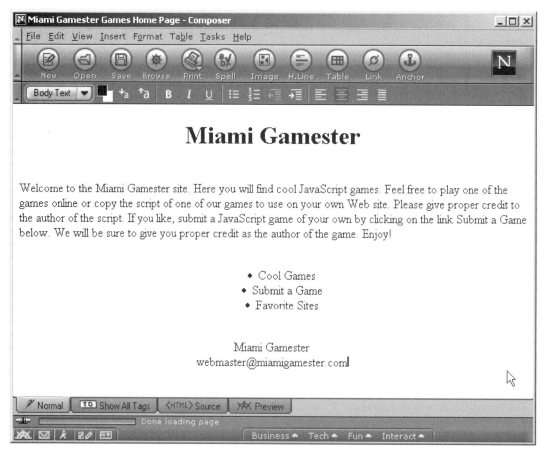

FIGURE 3.20 How the Web page default.html from Activity 4 should appear in Navigator.

SUMMARY

- You can provide important information on your Web pages for search engines to use for indexing by accessing the Page Properties dialog box.
- You can add text to your Web page and apply formatting such as bold, italics, alignment, and headings much the same way a word processor allows.
- There are six levels of headings you can apply to your Web page.
- You can create bulleted (unordered) or numbered (ordered) lists to help organize important points of information.
- You can quickly display your Web page in Navigator by clicking the Browse button from the Composition toolbar.

Formatting Elements

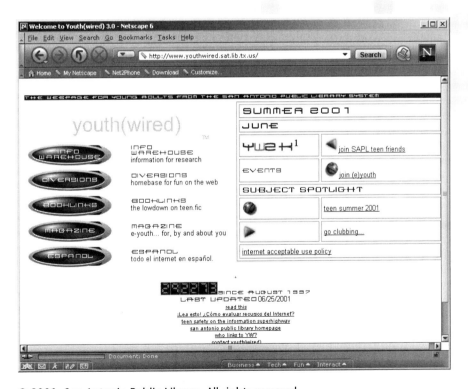

IN THIS CHAPTER

- Change the Background Color of a Web Page
- Change Font Properties
- Apply Boldface, Underline, and Italic Formats
- Insert Horizontal Lines
- Insert Special Characters

FORMATTING YOUR WEB PAGES

In the previous chapter you added and formatted sections of text using page layout techniques in Composer. You can also format your Web pages by adding background color, changing font properties, inserting horizontal rules, and inserting special characters.

Figure 4.1 is an example of a Web page that is formatted using some of the characteristics you will learn in this lesson

ADDING BACKGROUND COLOR

You can change the background color or specify a background image for the page you're currently working on. Consideration should be given

FIGURE 4.1 A Web page that uses a background and colors to enhance the design. (© 2001. www.miamiheat.com "The Miami Heat." All rights reserved.)

when selecting and changing the background color or image of a Web page. Changing the background properties will affect the way other Web page elements such as text, images, and links appear on a Web page. Figure 4.2 shows a Web page with a background image. Figure 4.3 shows the same Web page without the background image.

To set the colors and background for the current page, click the Format menu and choose Page Colors and Background as shown in Figure 4.4. The Page Colors and Background dialog box will appear as shown in Figure 4.5.

FIGURE 4.2 A Web page with a background image.

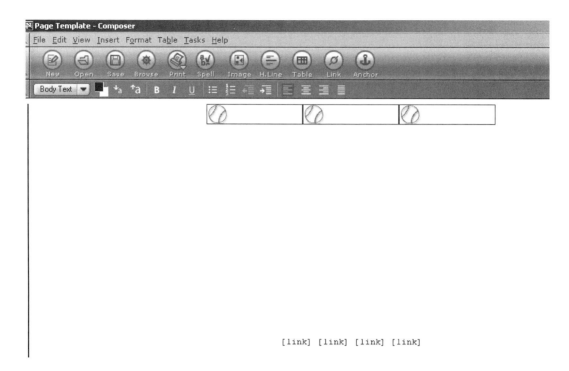

FIGURE 4.3 The Web page in Figure 4.2 without the background image.

FIGURE 4.4 Select Page Colors and Background from the Format menu to change the color of the background.

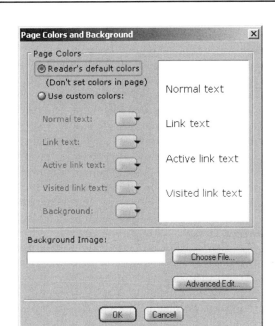

FIGURE 4.5 The Page Colors and Background Properties dialog box.

You can edit the following properties from the Page Colors and Background dialog box:

Reader's default colors: Select this if you want your page to use the color settings from the viewer's browser for text and link elements.

Use custom colors: Select this if you want to specify the colors of text and link elements. When this option is selected, each text element is dimmed, allowing you to select a color from the drop-down list. A sample of how the text or link will look for each element appears in the pane on the right. Figure 4.6 shows an example of how the Page Colors and Background dialog box will appear if this option is selected.

Background image: Select this if you want the background of your page to be an image. Type the name of the image file, or click Choose File to locate the image file on your hard drive. Whatever image you choose will *tile* the background of the Web page. A background image is typically a small image, usually around 100 pixels by 100 pixels. When an image is used for a background in a

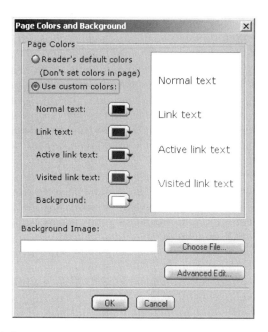

FIGURE 4.6 Page Properties and Background Color dialog box with the Use custom colors: option selected.

Web page, the image is *tiled*, meaning it is repeated over and over again to cover the background of the Web page.

HINT

You can specify both a background color and image in case the viewer's Web browser is set not to view images. However, background images are tiled and override background color selections.

Step Review: To Change the Background Color or Image

1. Click Format>Page Colors and Background from the menu bar. The Page Colors and Background dialog box will appear.
2. Select an option to change the background of the Web page, such as Use customer colors: .
3. If you select the Use custom colors: option, select a color for the text and the background from the pull-down menus.

4. If you select the Background Image: option, click Choose File. The Open HTML File dialog box will appear.
5. Navigate to the image you want to use as the background image, and click Open from the Open HTML File box. The image will tile in the background.

CHANGING FONT PROPERTIES

You can change the way default text will display in a Web page by changing its font properties. When hand-coding HTML, the font is changed using the tags. The tag controls text style. These tags are containers and must surround the text affected.

Three *attributes*, Size, Face, and Color, specify how the text is presented. Some HTML tags offer tag attributes. Tag attributes are options that affect or enhance the way the tag displays content on screen. Attributes are embedded into the open tag. For example, you can place the following code in your HTML source code to change the font color to red:

```
<font color="red">This text is red.</font>
```

In the tag example, "font" denotes the type of tag; in this case, we are telling the browser we are going to change the font color to red. "Red" is the value of the attribute, so the format for a tag and attribute pair would be <tag attribute="value"></tag>. You can use multiple attributes for a tag by adding additional attributes and their values in the "on" tag. For example:

```
<font color="red" size="5" face="arial"></a>.
```

NOTE

There is a lot of controversy over the use of the pair tags. It has been deprecated (placed on the "to-be-removed list") in the HTML 4.01 standard, in favor of style sheets. However, because most browsers still support the pair tags, and will most likely continue to do so for a while to come, you can be comfortable using it to change the font properties of your Web page text.

When using a Web editor such as Composer, you do not need to worry about the tag. Composer will add the HTML for you when you change the font properties in your Web page.

FONT COLOR

To change the text color, highlight the text you want to change and then click the color picker from the Formatting toolbar. There are two color pickers. The top color picker will change the text color of the text you select, as shown in Figure 4.7. The bottom color picker will change the background color of the current Web page as shown in Figure 4.8.

FIGURE 4.7 The top color picker will change the color of the text.

FIGURE 4.8 The bottom color picker will change the color of the background color.

ON THE CD

A listing of all the Web-safe HTML color codes is included on the companion CD-ROM. Open the CD-ROM, and double-click on the file COLOR.HTM. Your default Web browser will launch, displaying a Web page with a hexadecimal color chart as shown in Figure 4.9.

To change the color of your text, select the text you want to format and click on the top color picker on the Formatting toolbar. The Text Color box will appear as shown in Figure 4.10. You can select the color by clicking on the color with the dropper, or, if you are familiar with HTML color codes, you can type a specific code in the HTML color string field.

FIGURE 4.9 The hexadecimal chart (COLOR.HTM) found on the CD-ROM.

FIGURE 4.10 The Text Color box.

Step Review: To Change the Text Color

1. Select the text that you want to change in color.
2. Click the Choose Color for Text option on the Formatting toolbar. The Text Color box will appear.
3. Click on a color from the Text Color box.
4. Click OK.

FONT FACE

You can change the type of font you want to use for your Web page. By default, Composer will display your font in Times, which is the default font for most computers.

To change the default font, select Format>Font from the menu bar. The Font menu will appear, showing a few font types. Not all of the fonts installed on your system will appear. Instead of specifying a font that may

not be available to all who view your Web page, it's safe to select one of the fonts provided in the menu as shown in Figure 4.11, since those fonts work on every computer. Custom fonts that you want to use to format your Web pages may not be supported on your viewers' machines.

FIGURE 4.11 Click Format>Font to access the different font types available for formatting.

Step Review: To Change the Font Type

1. Select the text you want to change.
2. Click Format>Font from the menu bar.
3. Select a font type from the Font menu. The text will appear in the font type selected.

FONT SIZE

You can change the font size from the default size, which is usually font size 3 in HTML terms. However, Netscape does not use the font tag to change the size of the text; it uses relative size tags based on the default size, such as <BIG></BIG> or <SMALL></SMALL>. These tags will

render text smaller or larger, based on the actual size of the default text. To change the font size, select Format>Size as shown in Figure 4.12.

FIGURE 4.12 You can change the text size by selecting Format>Size.

Step Review: To Change the Font Size

1. Select the text you want to change in size.
2. Select Format>Size from the menu bar.
3. Choose a font size from the Size menu. The text will be rendered in the size you selected.

USING BOLD, UNDERLINE, AND ITALICS

Changing the text style is easy. You can apply boldface, underline, or italics to your text by selecting the text and then selecting one of the styles from the Formatting toolbar as shown in Figure 4.13.

FIGURE 4.13 Choose the text style by selecting commands from the Formatting toolbar.

HINT

To quickly remove all formats from selected text, open the Format menu and choose Discontinue Text Styles.

Step Review: To Bold, Underline, or Italicize Text

1. Select the text.
2. Click B (Bold), U (Underline), or I (Italics) from the Formatting toolbar. Text will render whatever format option you select.

ADDING HORIZONTAL LINES

Horizontal lines (also called rules) are useful to separate sections of a Web page. Horizontal lines are straight lines that go from one side of the Web page to the other. Figure 4.14 shows a Web page without a

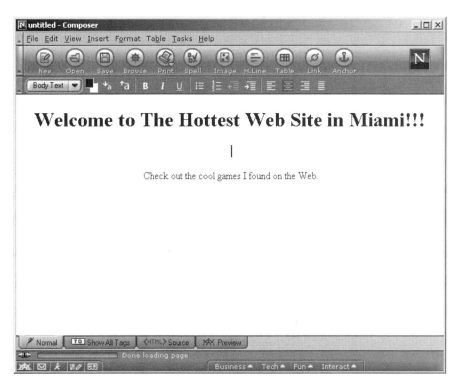

FIGURE 4.14 A Web page without a horizontal rule.

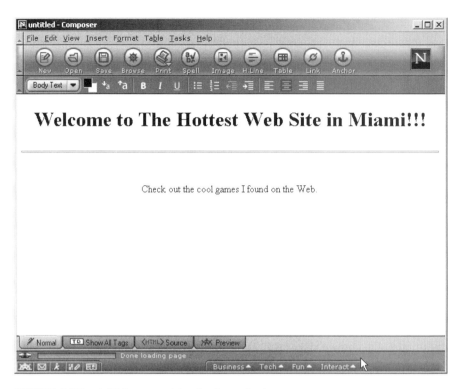

FIGURE 4.15 A Web page with a horizontal rule.

horizontal line. Figure 4.15 shows the same Web page with a horizontal rule inserted.

To add a horizontal line to your page, position the cursor where you want the line to appear. Click the H. Line button (as shown in Figure 4.16) on the Composition toolbar, or open the Insert menu from the menu bar and choose Horizontal Line.

FIGURE 4.16 The Horizontal Rule button on the Composition toolbar.

You can change the horizontal line properties by double-clicking on the horizontal line from the workspace. The Horizontal Line Properties box will appear as shown in Figure 4.17.

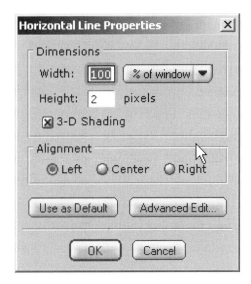

FIGURE 4.17 Horizontal Line Properties dialog box.

You can customize a line's height, length, width, alignment, and shading.

Width: Choose a measurement unit (pixels or percentage), and enter a number for the width.

Height: Enter a number for the line's height (in pixels).

3-D Shading: Click this to add depth to the line with a drop shadow.

Alignment: Specify where you want to place the line.

Figure 4.18 is an example of the Horizontal Line Properties box with the Width field, Height field, 3-D Shading, and Alignment field changed. You see the resulting horizontal rule in Figure 4.19.

NOTE

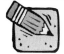

Click Save Settings in the Horizontal Line Properties box to use these settings as the default for all horizontal lines.

FIGURE 4.18 The Horizontal Line Properties box with the default settings changed.

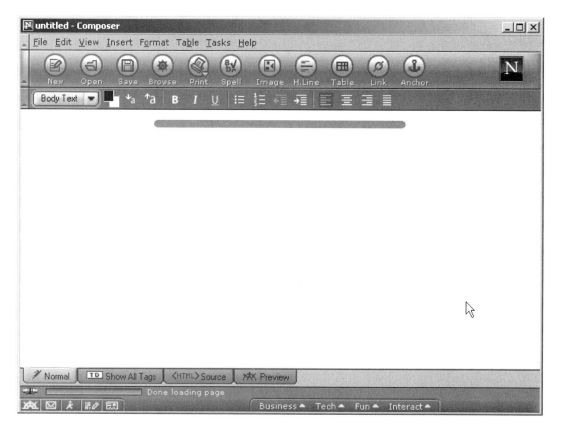

FIGURE 4.19 The resulting horizontal bar from Figure 4.18.

Step Review: To Insert a Horizontal Rule

1. Position your cursor on the Web page where you want your horizontal line to appear.
2. Click the H. Line button from the Composition toolbar. The horizontal rule will appear.

INSERTING SPECIAL CHARACTERS

There may be times when you will want to insert special characters other than the characters found on your keyboard. To insert characters such as symbols or accented letters (©®™Σ), position your cursor where you want the special character to appear.

1. Open the Insert menu and choose Characters and Symbols. The Insert Character dialog box appears as shown in Figure 4.20.

FIGURE 4.20 The Insert Character dialog box.

2. Choose a category of characters. If you choose Accent Uppercase or Accent Lowercase, click the Letter pull-down menu and choose the letter you wish to apply an accent to. Not all letters have accented forms.

3. From the Character pop-up menu, choose the character you want to insert.
4. Click Insert, and then Close.

Step Review: To Insert a Character

1. Click Insert>Characters and Symbols from the menu bar. The Insert Character dialog box will appear.
2. Select a character from the pull-down menus in the Category section.
3. Click Insert. The character selected will appear on the Web page.
4. Close the Insert Character box.

ACTIVITY
• • • • • • • •

In this exercise, we will open the default.html file you created previously. In addition, you will change the background color, change the font properties, insert horizontal lines, and insert a special character.

1. Start Composer.
2. Open the default HTML file by clicking Open button on the Composition toolbar. The Open HTML File dialog box appears.
3. In the Open HTML File dialog box, navigate to your folder Miami_Gamester located in the CyberRookies_Exercises folder on your hard disk. Double-click default.html. Default.html appears in Composer.
4. Access the Page Properties and Background Color dialog box by selecting Format>Page Properties and Background Color from the menu bar.
5. Click Use custom colors:. Change the following text properties to:

 • **Normal text**: White
 • **Link text**: Light Purple
 • **Active link**: Light Green
 • **Visited link text**: Grey
 • **Background**: Dark Blue

6. Click OK. The Web page should appear with a dark blue background with white text (since we haven't created links yet).

7. Select the main heading "Miami Gamester." Change the font type to Helvetica, Arial by selecting Format>Font>Helvetica, Arial.

8. Position your cursor just below the "Miami Gamester" heading. Click on the H. Line button from the Composition toolbar to insert a horizontal line.

9. Position your cursor just after the last bulleted item "Favorite Links" (you may have to press Enter twice to exit the bulleted list). Insert another horizontal line by clicking the H. Line button.

10. Position your cursor just after the "Miami Gamester" at the bottom of the Web page. Click Insert>Characters and Symbols to display the Insert Character dialog box.

11. Select Common Symbols from the Category menu. Select the copyright © symbol from the Character pull-down menu.

12. Click Insert to insert the copyright symbol, and then click Close to close the Insert Character dialog box.

13. After the copyright symbol, type "2001".

14. Select the sentence from the paragraph of text "Please give proper credit to the author of the script."

15. From the Formatting toolbar, click the Bold (B) button and the Underline button (U). The text will appear in boldface and underlined.

16. Save your changes and display your page in Navigator or Internet Explorer. Your Web page should appear as shown in Figure 4.21.

17. You can leave default.html open in Composer and continue on to the next exercise, or you can close Composer.

SUMMARY
• • • • • • • • •

- You can format your Web pages by adding background color and changing font properties.
- Careful consideration should be given when changing the background color and font properties. You should keep in mind that changing the background color will affect the way links and fonts appear on a Web page.
- You can emphasize text by applying bold, underline, or italics.
- Horizontal rules are useful to separate sections of your Web page.
- You can insert special symbols such as a copyright notice to display on your Web page.

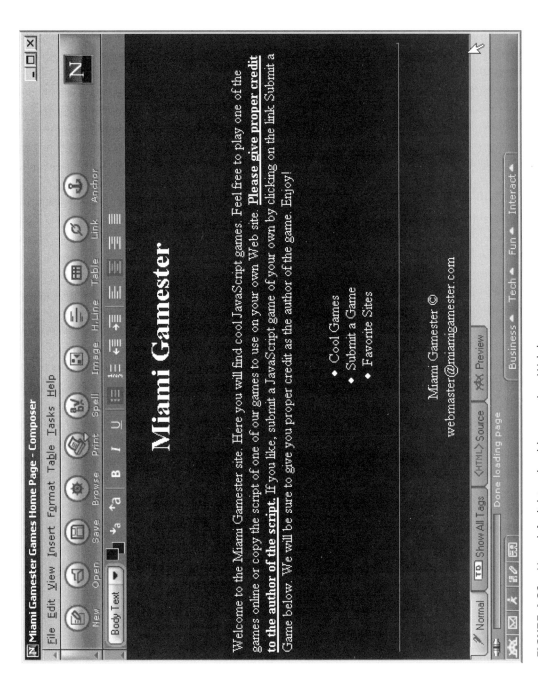

FIGURE 4.21 How default.htm should appear in a Web browser.

Hyperlinking

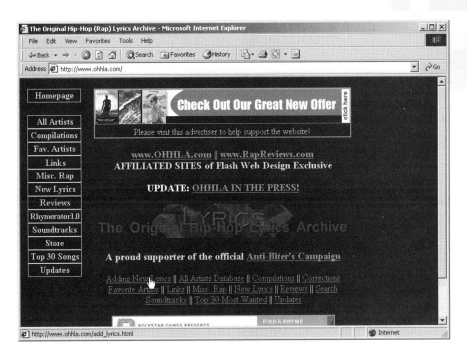

IN THIS CHAPTER

- Creating a Hyperlink to Another Web Page
- Linking to a Remote URL
- Creating an E-Mail Link
- Targeting a Link to a New Window
- Linking within the Same Page
- Removing a Link

UNDERSTANDING HYPERLINKS

Hypertext, the ability to jump from one document to another, provides the most powerful element of Web page design. You can use hyperlinks (more commonly referred to as just "links") to connect your Web pages to related documents on your Web site, within the same Web page, to another Web site, or to your e-mail.

NOTE

A Uniform Resource Locator (URL) is defined as an address on the Internet: for example, http://www.charlesriver.com.

CREATING A LINK

You can quickly create a link by "dragging and dropping" it from another window. For example, you can highlight a link from a Web page, bookmark, or e-mail window, and then drag and drop it onto your page. This will automatically copy over and generate the link for you. In Figure 5.1, the Web page to the right is the Charles River Media Web site (in its

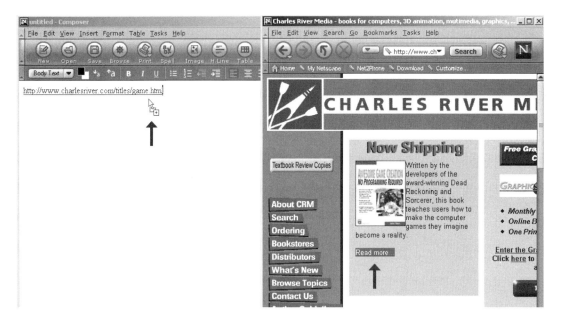

FIGURE 5.1. Creating a link by dragging and dropping.

own window) with a link that has been selected "Read more...". To the left of the Charles River Media's browser window is Composer with a blank workspace, where the image of the mouse is actually dragging the link that was selected in the Charles River Media to the workspace. Figure 5.2 shows the result.

You can also use the Link Properties dialog box to create a link to another page. To do so, select the text or image that you want to create the link from. Click the Link button (as shown in Figure 5.3) on the Standard toolbar; the Link Properties dialog box will appear as shown in Figure 5.4.

FIGURE 5.2 The link generated from dragging over a hyperlink "Read more…" from another window.

FIGURE 5.3 The Links button on the Standard toolbar.

FIGURE 5.4 The Link Properties dialog box.

You can see a list of all named *anchors* and headings in the page by clicking the More Properties button in the Link Properties box. Anchors are used to create links within the same Web page, which you will learn more about later in this chapter. The Link Properties dialog box will expand.

Type the local path and file name or remote URL of the page you want to link to in the Link Location field. If you're not sure of the path and file name or a local file such as another Web page, click Choose File to look for it on your hard disk.

For remote URLs (an outside Web site or Web page found on another Web server), type the full URL including the *protocol,* such as http://www.charlesriver.com. A protocol is an agreed-upon format for transmitting data between two devices. The protocol to link to a Web page (or to transfer hypertext data from the Web server to your computer) on the Web is the http:// (HyperText Transfer Protocol) portion of the URL, and should be included whenever linking to a remote URL.

Step Review: To Create a Link to a Local File or to a URL

1. Select the text you want to become a link.
2. Click the Link button to access the Link Properties box.
3. Type the local path to a file name or remote URL. If need be, click the Choose File button to navigate your hard disk for a local file such as another Web page.
4. Click OK.

CREATING AN E-MAIL LINK

You can create an e-mail link by typing the command `mailto:` along with the e-mail address you want to link to in the Link Location field of the Link Properties dialog box. For example, the following link creates a link to the author of this book `mailto:kelly@8ballmedia.net` as shown in Figure 5.5. The `mailto:` command launches the user's e-mail program when the e-mail is linked. Remember not to include any spaces between the mailto: command and the e-mail address.

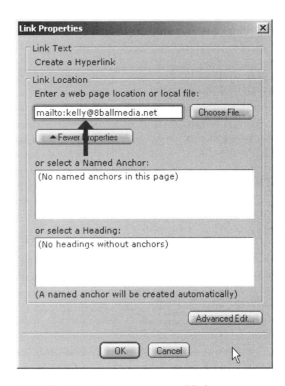

FIGURE 5.5 Creating an e-mail link.

Step Review: To Create an E-Mail Link

1. Select the text you want to create the E-Mail link from.
2. Access the Link Properties dialog box by clicking the Link button on the Standard toolbar, or by selecting Insert>Link from the menu bar. The Link Properties dialog box will appear.
3. In the Link Location field of the Link Properties box, type the mailto: command, along with the e-mail address. Do not include any spaces.
4. Click OK on the Link Properties box. The linked text will appear in the Composer window.

NOTE

To test the link you just created, open the File menu, choose Browse Page, and then click the link.

TARGETING A LINK TO A NEW WINDOW

Although linking to other Web sites on the Web is convenient for your viewers, it also invites them to leave your site. To offer your viewers links to other Web sites, but still keep your Web site open and available, you can target links to open in a new window. When you target your links to a new window, the window with your Web page will stay open, and a second window will open displaying the linked Web page.

To create the target, you will have to include the TARGET="_blank" attribute/value within the actual hyperlink. To do this, specify the link in the Link Location field, and then click the Advanced Edit button to add addition attributes to your links (you may have to click the More Properties button to expand the Link Properties box). This will launch the Advanced Property Editor.

The Advanced Property Editor allows you to add advanced attributes to your hyperlinks. In this case, we are adding an HTML attribute called TARGET. The attribute TARGET specifies a location where a URL will open, such as another window. To display a target URL in another window, we need to use the "_blank" value in combination with the TARGET attribute, which opens a new window and displays the page that was linked to.

In the Advanced Property Editor, click the HTML Attributes tab to make sure it's active. In the Add and HTML Attribute section, type "target" in the Name: field and "_blank" in the Value: field as shown in Figure 5.6. Click Add and then OK, and then close the Advanced Property Editor by clicking the box's X (Close) button in the top-right corner. Then click OK button in the Link Properties dialog box. Figure 5.6 shows an example of how to add the TARGET attribute in the Advanced Property Editor.

Step Review: To Create a Link Target to Another Window

1. Select the text you want to create a link with.
2. Click the Link button from the Composition tool bar.

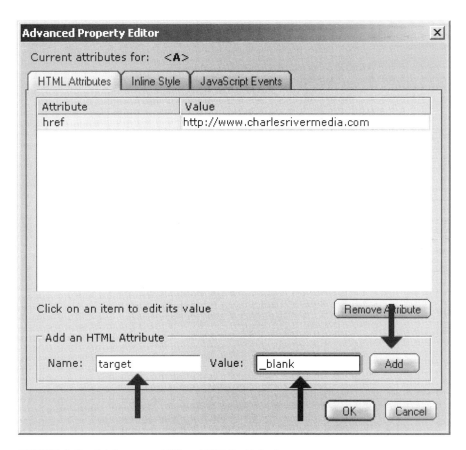

FIGURE 5.6 Adding an additional HTML attribute.

LINKING WITHIN THE SAME PAGE

To create a link within the same page—for example, a link that the reader can use to jump from one section to another—you must create an anchor, and then create a link that links to the anchor. Anchors are also called anchors or targets. You can think of an anchor as the "destination" section of a Web page. Since you are not linking to an actual file, or URL, you have to create some sort of destination section. This destination section, referred to as an anchor, is created by using a descriptive name; the name you create as your anchor is placed in the code and will become the target for your link.

NOTE

Linking within the same Web page is useful when you want to create long Web pages and do not want to force the viewer to scroll for information.

To create an anchor, place the cursor at the beginning of a text line, or select some text where you want to create an anchor. Click the Anchor button (as shown in Figure 5.7) on the Composition toolbar, or open the

FIGURE 5.7 The Anchor button on the Composition toolbar.

Insert menu and choose Named Anchor. This will launch the Named Anchor Properties box as shown in Figure 5.8.

FIGURE 5.8 Named Anchor Properties box.

Type a name for the anchor in the Name Anchor Properties dialog box (up to 30 characters). Don't include spaces. If you need to, use an underscore "_" to separate words. If you selected some text before you clicked the Anchor command, this box already contains a name. Click OK. An anchor icon appears in your document to mark the anchor's location. Now you are ready to link to the anchor.

To link to the anchor, select the name of the anchor in the Named Anchor field of the Link Properties box as shown in Figure 5.9.

FIGURE 5.9 Select the Named Anchor as your link.

Step Review: To Create a Link within the Same Page

1. Select the text that you want to create the anchor from.
2. Click the Anchor button on the Composition toolbar. The Anchor Properties box will appear.
3. Type a name for the anchor in the Named Anchor Properties dialog box.
4. Click OK. An anchor icon appears in your document to mark the anchor's location.
5. Select the text you want to use as the link to the anchor.
6. Click the Link button from the Composition toolbar. The Link Properties box will appear.

7. Select the name of the anchor in the Named Anchor field of the Link Properties box.

8. Click OK. The link will appear on the Web page linking to the anchor.

USING IMAGES AS LINKS

You can create images, such as JPEG or GIF files, as links in your pages. When the reader clicks a linked image, the browser window displays the page that the image is linkeded as if it was a text link. We will cover how to create image links in the next chapter.

REMOVING LINKS

You may need to remove a link when updating your Web pages. To remove a link, select the linked text (normally blue and underlined) or image. Click the Format menu and choose Remove Link as shown in Figure 5.10. The link will be removed, and the text will display normally.

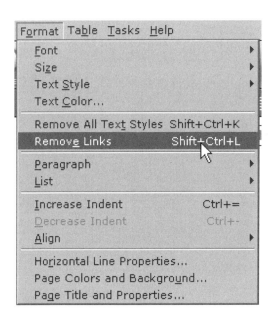

FIGURE 5.10 You can remove a link from text by selecting the text and choosing Format>Remove Link from the menu bar.

Step Review: To Remove a Link

1. Select the linked text or image.
2. Click Format>Remove Link from the menu bar. The link will be removed from the selected text or image.

ACTIVITY

In this exercise, you will create three links with the items in the bulleted list, and an e-mail link. You will create targeted links in the upcoming exercises.

1. Start Composer, and open default.html if you closed it in the previous exercise.
2. Select the first bulleted item "Cool Games." Click the Link button from the Composition toolbar. The Link Properties box will appear.
3. In the Link Location field, type "coolgames.html" (we will create this file in later exercises). Click OK.
4. Repeat steps 2 and 3 for "Submit a Game"—link to submitagame .html, and "Favorite Sites"—link to favoritesites.htm.
5. Select the e-mail address webmaster@miamigamester.com. Click the Link button.
6. Type "mailto:webmaster@miamigamester.com" in the Link Location Field, click OK.
7. Save your changes and view in your Web browser. Notice that the hyperlink color does not render until the document is loaded into a Web browser. Figure 5.11 shows an example of how default.html may appear.

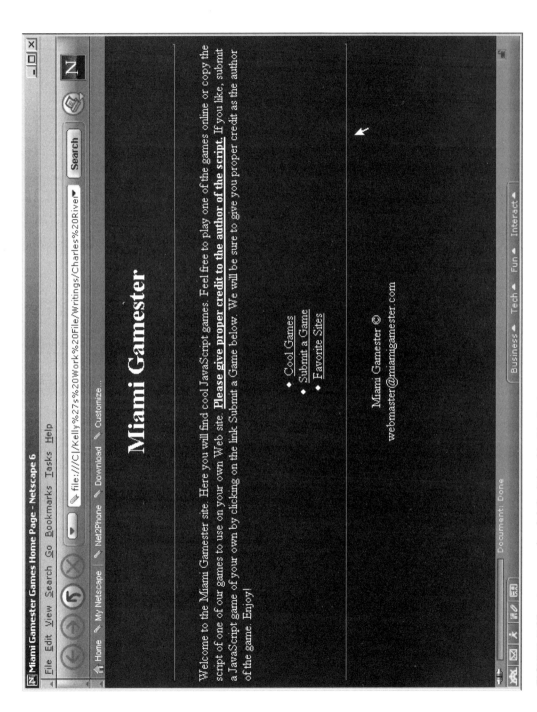

FIGURE 5.11 An example of default.html in Navigator.

SUMMARY

- You can create links to other Web pages within a site and to remote URLs. However, it's important to include the http:// protocol when linking to a remote URL.
- When you create e-mail links, you must use the mailto: command in order to launch the viewer's e-mail program when the link is clicked.
- If you link to other Web sites, it is suggested that you target those links to display in a new window so that the viewer does not exit your Web site.
- You can link within the same Web page by creating anchors and linking to those anchors.
- You can remove a link from your Web page by clicking the Format menu and choosing Remove Link from the menu.

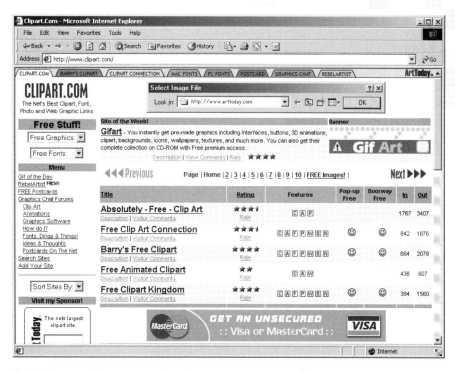

IN THIS CHAPTER

- Image Types for the Web
- Image Formats
- GIFs, JPEGs, and PNGs
- File Size and Downloads
- Measuring File Sizes
- Inserting Images With Composer
- Editing Image Properties

IMAGE TYPES FOR THE WEB

When dealing with the Internet and the Web, there are some restrictions as to the types of images you use for your Web pages. Unlike creating a document for print, you will have to deal with *bandwidth* and color limitations. Bandwidth is the speed at which data (HTML files, images, sound files, etc.) travels through the Internet. For example, you experience bandwidth whenever you download a sound file from the Web. Bandwidth is measured in *kilobytes per second* (kbps). If a user had a 28.8kbps connection to the Internet, that user can only download 28 kilobytes per second. Therefore, small file size is everything when it comes to Web page design. Download time for your Web page is one of the most important factors you should consider when creating your Web pages.

IMAGE FORMATS

Image formats used for the Web are completely different from image formats used for traditional print media such as magazines, brochures, and advertisements,—mainly because of bandwidth issues.

HINT

There are many types of file formats for computer graphics such as BMP, TIFF, and PICT, to name a few. Most of these formats are not used for the Web because they produce files that are too large to download.

The most widely supported image formats for the Web are *GIF* (Graphic Interface Format), JPG or *JPEG* (Joint Photographic Experts Group), and, eventually) *PNG* (Portable Network Graphic). These image formats are supported by Web browsers, allowing the viewer to download Web pages and view these images easily using their choice of browser.

GIFs, JPEGs, and the upcoming PNG (not well supported among Web browsers yet) are used for the Web because they all have one thing in common: *compression.* Compression is the key to creating small (file size) graphics. While compression is not an issue when dealing with any type of print publication, it's everything when publishing on the Web. Figure 6.1 shows an example of a photograph being saved as a JPEG format. Notice the estimated bandwidth time in the Preview section of the Firework's Export Preview dialog box. Fireworks is a paint program created by Macromedia—you can download a trial version at www.macromedia.com.

Figure 6.2 is the same image; however, this time the image is being exported from Fireworks as a GIF. Notice how the file size increased to 32.74k and is estimated to download in 10 seconds at 28.8kbps.

GIF IMAGES

By definition, GIFs contain 256 colors or less, unlike JPEGs, which are 16-million colors. There are two types of GIFs: *GIF87a* and *GIF89a*. GIF87a

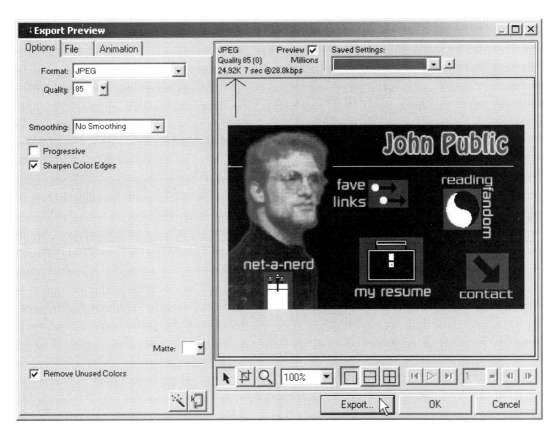

FIGURE 6.1 The image being exported from Fireworks in this example is estimated to download in seven seconds at 28.8kbps. The Preview section also denotes that the file size is 24.92k. (© 2001. Macromedia Inc. All rights reserved.)

supports *transparency* and *interlacing*, whereas GIF891 supports transparency, interlacing, and animation.

HINT

GIF is pronounced with a soft G as in "jiffy." However, many people pronounce it with a hard G as in "good." Either way is accepted.

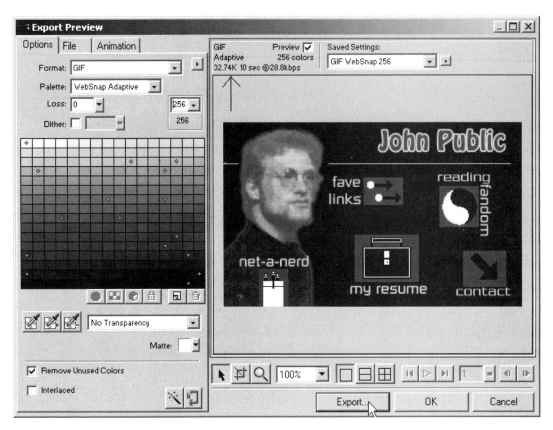

FIGURE 6.2 The same image as shown in Figure 6.1 converted in GIF format. (© 2001. Macromedia Inc. All rights reserved.)

TRANSPARENT GIFS

Transparent GIFs are used to create the illusion of the image "melting" into a background on a Web page. Most images have a rectangular shape around them, which is usually left of the canvas on which the images were created. Some designers remove this area by creating the image as a transparent GIF. Figure 6.3 shows an image (butterfly) with a white background. Figure 6.4 is the same image with a transparent background. The checker background appears through what used to be a white canvas.

FIGURE 6.3 A butterfly image with a white background.

FIGURE 6.4 The same image with a transparent background.

INTERLACED GIFS

Interlaced GIFs are images that when downloaded, start out blocky and then focus into clear images. Interlace GIFs are supposed to give your viewer an idea of the images that are downloading, allowing them to decide if they want to wait for them. However, this seems more annoying than helpful. You may want to think twice before opting to using an interlace GIF.

ANIMATED GIFS

Animated GIFs are images that produce a slide-show effect. They are simply a sequential collection of images placed into a single file. Figure 6.5 shows an example of an animated GIF's frames. Each frame has a separate image in a specific order. The frames loop at a set speed to create an animation, much in the same way as a movie reel runs through a camera.

HINT

For more information on how animated GIFs work and how to create your own, visit www.kaleidoscapes.com/kc_intro.html.

FIGURE 6.5 A set of framed images used to create an animation.

JPEG IMAGES

HINT

JPEGs are commonly found on the Web using the three-letter file extension .JPG, rather than the four-letter version .JPEG. The three-letter extension .JPG, offers support for DOS (Data Operating System) machines, whereas .JPEG is used for non-DOS platforms.

The JPEG file format offers a 16-million-color alternative to the GIF format and works beautifully with photographs. JPEGs offer a lossy compression, meaning that JPEGs are compressed higher than a GIF, making the download time faster. However, this does not mean that you should create and save all of your images as JPEGs. Images that contain 256 colors and are considered GIFs should not be converted to a JPEG. If they are, a visible loss will be noticed within an image, creating a choppy or blurry look, as shown in Figure 6.6.

PNG IMAGES

PNG is the newest image file format designed specifically for the Web. PNG can replace GIF and many common uses of TIFF (an image format used for print). PNGs offer transparency and compress better than GIF, but the difference is generally only around 5 to 25 percent. Poor Web browser support for PNG remains a problem for PNG developers and

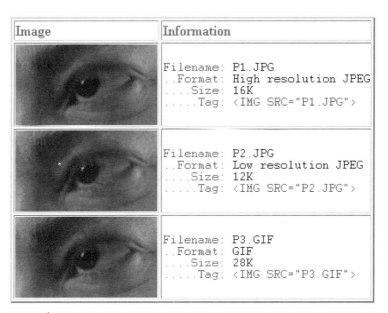

FIGURE 6.6 An image saved in both JPEG and GIF format.

Web designers who are interested in using the PNG format. Consider this before deciding to use PNG.

FILE SIZES AND DOWNLOADING

As you know, images for the Web need to be small. However, how small is small? Let's do a little math. A kilobyte is 1024 bytes, a megabyte is 1,048,576 bytes, and a gigabyte is 1,073,741,824 bytes. If in theory it takes every kilobyte one second to download on the Web, an image that is 40k will take 40 seconds to download into a viewer's Web browser. A 100-megabyte file could take a week and a half!

116

FIGURE 6.7 Thumbnail images of larger photos. (© 2001. 3 Doors Down. All rights reserved.)

However, many issues go into the download times. The viewer's computer speed, connection speed, and file size all play a role. For instance, many educational institutes and large companies have connection speeds beyond that of the average home user, and typically more powerful computers.

Nevertheless, keeping image files small, around the size of 10k–15k, will ensure that your pages download fast for most if not all of your viewers.

If you are offering products online, creating *thumbnails* for your viewers will allow them to decide if they want to see the full-size image. A thumbnail is a smaller version of an image that is linked to the larger-sized image. Figure 6.7 shows the Web site of the popular music group 3 Doors Down. The site offers a selection of images on a Web page, and a thumbnail version of each. When a user clicks on the thumbnail, the larger version of the image will load in another Web page as shown in Figure 6.8.

FIGURE 6.8 A larger photo linked to a thumbnail version. (© 2001. 3 Doors Down. All rights reserved.)

MEASURING YOUR IMAGES

How can you tell the file size of your images? Macs and PCs report file size differently. File sizes are always rounded numbers (10k, 22k); your computer rounds up the size of your image files to the next largest number, depending on how large your hard drive is. You can test this by copying an image file from your hard drive to a floppy, and then test each file size. The floppy will render a different file size because of the medium it is on. The following section includes an example of how a PC renders file size.

MEASURING ON A PC

The file size shown by the icon is very close to the actual size. However, for a more accurate reading, highlight the image file, go to the File menu, and select Properties. This will give you an accurate file size. Figure 6.9 shows an example of a folder called "Kelly's Work Folder" measured to 386MB.

FIGURE 6.9 A folder being measured on a PC.

MEASURING ON A MAC

To measure your image file on a Mac, highlight the image you want to check, go to the File menu, and choose the Get Info command.

INSERTING IMAGES WITH COMPOSER

You can insert GIF and JPEG images into your Web page using Composer. You can also insert bitmap images with Composer and convert them to JPEGs or GIFs. Bitmap images are comprised of a set of bits, with each bit or group of bits corresponding to a pixel in the image. If you are using clip art from a CD that you purchased, or from a clipart library, most of the images are bitmaps. Since bitmaps are not supported on the Web, you must convert them to GIF or JPG.

FILE LOCATION

As you know, images are separate files that are not contained within the HTML document itself. Rather, it is an image file that should be located on your hard disk within the same folder or subfolder where your Web pages are saved. When storyboarding (see the section *Storyboarding* in Chapter 1), you should pick out the images you are going to use prior to creating your Web site. The images you choose should be saved within the same folder where your Web pages will be stored on the root level, or within a subfolder on the root level (see the section *Flowcharting* in Chapter 1).

Before you insert an image on your Web page with Composer, you need to copy the image into your folder. You can download free images from the Web, or you can copy and paste an image file from another location on your hard drive into your Web site folder. For the most part, all of your images and Web files can be stored within the same folder. In this book, you will save all of your image files and HTML files in one single location, the root level of your Web site folder.

INSERT AN IMAGE

Once your images are in your Web folder, you are ready to insert them on your Web page. To insert an image, position your cursor in the location

FIGURE 6.10 The Insert>Image menu.

you want the image to display, and click the image button on the Composition toolbar. Alternatively, select Insert>Image from the menu bar as shown in Figure 6.10. The Image Properties box will appear as shown in Figure 6.11.

FIGURE 6.11 The Image Properties box.

From the Image Properties box, you can specify a file path to the image in the Image URL: field, or simply click the Choose File button to launch the Open HTML File dialog box and navigate to the image file. Once you locate the image you want to open, select the image file and then click Open as shown in Figure 6.12.

FIGURE 6.12 The Open HTML File dialog box allows you to locate the image you want to insert on your Web page.

The image will display in the Image Properties box, showing the file path to the image file and the actual size of the image. Also in the Image Properties box is the Alternative Text: field as shown in Figure 6.13. In Figure 6.13, we have already typed in the alternative text "Miami Gamester"; otherwise, the Alternative Text: field would be empty.

FIGURE 6.13 Image Properties box.

Alternative text is text that will display in place of an image if the user's Web browser doesn't support images, or if the user has the image feature turned off. If the user's browser does display the image, and you have specified alternative text for that image, a small yellow tool tip will display the alternative text when the mouse is placed over an image, as shown in Figure 6.14.

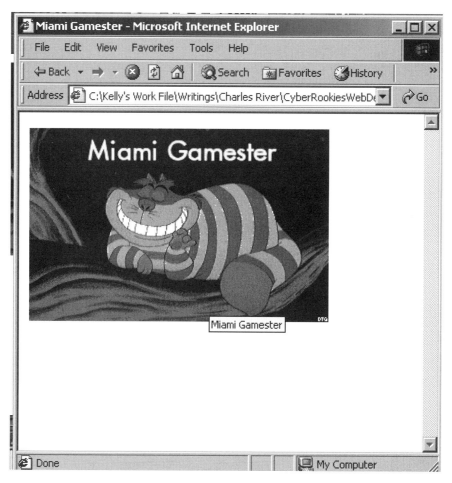

FIGURE 6.14 Whenever alternative text is provided for an image, a yellow tool tip will display the alternative text when the user's mouse is placed over the image.

Once you have supplied the alternative text in the Image Properties box, click OK on the Image Properties box and the image will display on the Web page as shown in Figure 6.15.

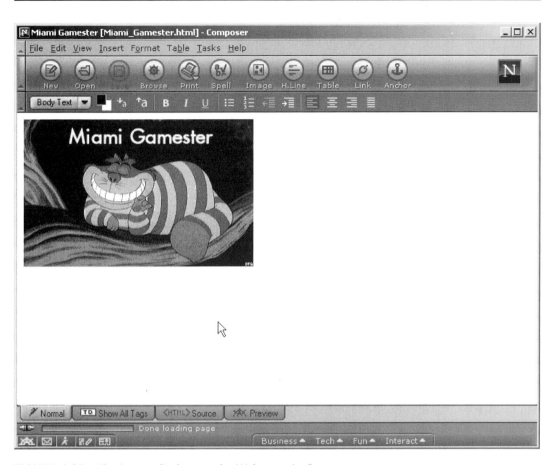

FIGURE 6.15 The image displays on the Web page in Composer.

HINT

Sometimes, users may surf the Web with their image feature disabled in the Web browser application. This enables them to surf and download Web pages faster since the browser does not download the images on the Web page. Using alternative text for your images will ensure that the viewer at least gets some type of description of the image displayed to them on the Web page.

Step Review: Insert an Image

1. Place your cursor where you want the image to appear in the Composer workspace.
2. Click the Image button on the toolbar, or open the Insert menu and choose Image from the Insert menu. The Image Properties box will appear.
3. Specify the image file name location by clicking Choose File on the Open HTML File box. Navigate to the image file, select the file, and click OK. The image will now display in the Image Properties box.
4. Type descriptive alternative text in the Alternative Text: field.
5. Click OK to display the image on the Web page.

HINT

To quickly insert an image, drag and drop it onto your page from another window.

EDIT THE IMAGE'S PROPERTIES

Once you've inserted an image into your page, you can edit its properties and customize the layout, such as the height, width, spacing, and text alignment in respect to the image.

To edit the properties for a selected image, double-click the image, or select it (click on it once) and click the Image button on the toolbar. The Image Properties dialog box will appear. Click More Properties from the Image Properties box to expand the list of settings as shown in Figure 6.16.

Once More Properties is clicked, the Image Properties box expands, allowing you to access a variety of properties to the selected image as shown in Figure 6.17.

Step Review: To Access the Image Properties Box

1. Double-click the image inserted on the Web page, or select the image and then click the Image button on the Composition toolbar. The Image Properties box will appear.
2. Once you have changed the desired properties, click OK.

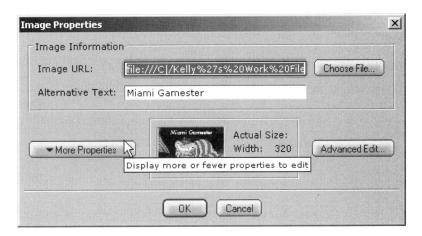

FIGURE 6.16 Click More Properties from the Image Properties box to access more of the image's properties such as the dimensions and alignment.

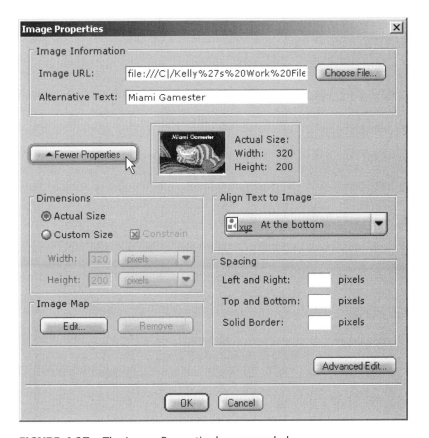

FIGURE 6.17 The Image Properties box expanded.

CHANGING THE APPEARANCE OF AN IMAGE SIZE

You can change the appearance of an image's size using the Dimensions: section of the Image Properties. Click Custom Size from the Dimensions: section of the Image Properties box. Specify the new height and width, in pixels. This setting doesn't affect the original image file's size in bytes, just the appearance on your Web page. This is done by HTML, which tells the Web browser how many pixels to allot for the Image. Figure 6.18 shows an example of an image's dimensions being changed from the actual image dimensions to a custom dimension. Click Original Size to undo any changes you've made to the dimensions.

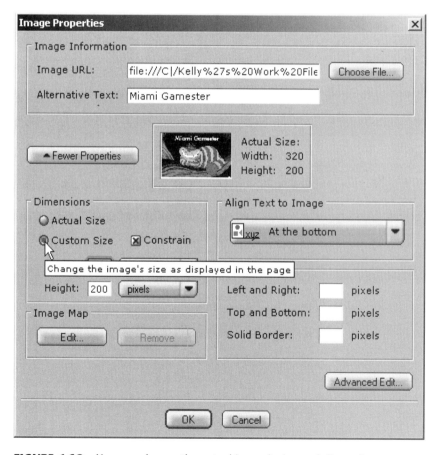

FIGURE 6.18 You can change the actual image's size and dimension on a Web page by specifying custom sizes (in pixels) in the Dimensions: section of the Image Properties box.

HINT

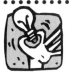

Consider resizing your images with a paint program instead of Composer. The image file size does not change when you resize the image to a smaller size in Composer. When you re-size the image to a smaller image using a paint program, the actual file size will also change.

CONSTRAIN

If you change the image size, it's a good idea to check the Constrain box (as shown in Figure 6.19) in order to maintain the image's aspect ratio so that

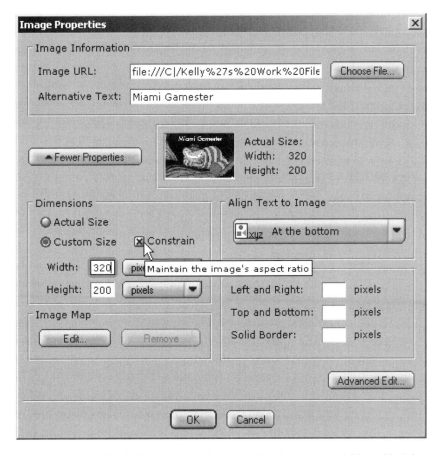

FIGURE 6.19 Check the Constrain box to resize the images width and height proportionately.

it doesn't appear distorted. Maintaining the image's aspect ratio means that when you change the height of an image, the width will adjust accordingly so that the image resizes the height and width proportionately.

Step Review: Change the Appearance of an Image Size

1. Select the image and access the Image Properties box.
2. Enter a number in pixels in the Width: and Height: fields.
3. Click the Constrain box to contain the images aspect ratio.
4. Click OK.

ALIGN TEXT TO AN IMAGE

If you've placed your image next to any text, you can click the Align Text to Image button, as shown in Figure 6.20, to indicate where you want your text positioned next to the image. When you click the Align Text to Image button, a menu will appear with alignment options. Each option gives an example of how the text will display next to the image.

HINT

To see the effects of alignment changes, it's a good idea to view your page in a browser window.

Step Review: To Align Text to an Image

1. Select the image and access the Image Properties box.
2. Select the Align Text to Image button and choose an alignment option from the menu. The text will align to the image.
3. Click OK.

SPACING

You can specify the amount of space surrounding the image, between the image and the other Web page elements such as text. You specify this space in pixels in the Left to Right:, Top and Bottom: fields in the Spacing

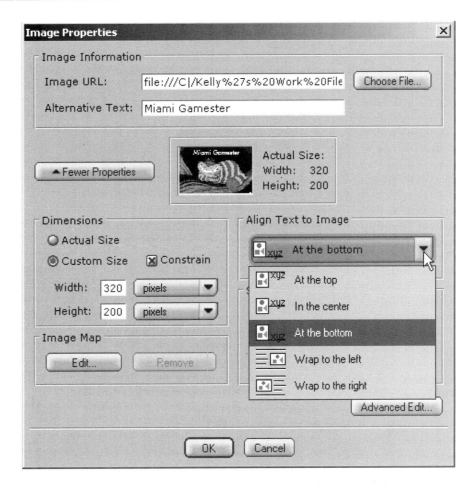

FIGURE 6.20 Click the Align Text to Image button to align text relative to your image.

section of the Image Properties box as shown in Figure 6.21. However, this feature is not well supported among Web browsers. Consider other spacing methods such as added border space to the actual image.

Step Review: To Add Spacing around an Image

1. Select the image and access the Image Properties box.
2. Enter a number in pixels in the Left to Right: and Top to Bottom: fields in the Spacing section.
3. Click OK.

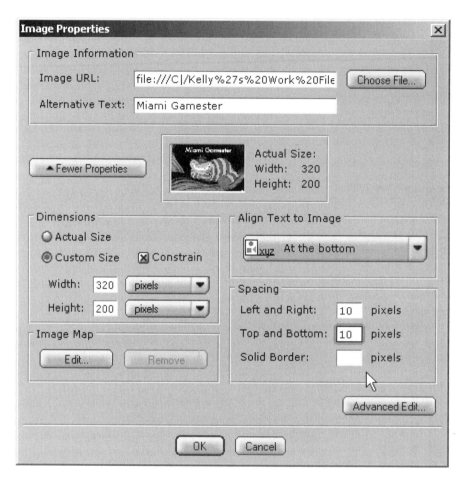

FIGURE 6.21 You can change the spacing around an image from the Spacing section of the Image Properties box.

ADDING A BORDER

You can also put a solid black border around the image. You define the width of the border in pixels as shown in Figure 6.22. Specify zero for no border. Entering zero for the border size will ensure that all Web browsers display the image without a border. When you use an image as a hyperlink, a blue border will appear around the image if the border is not set to zero.

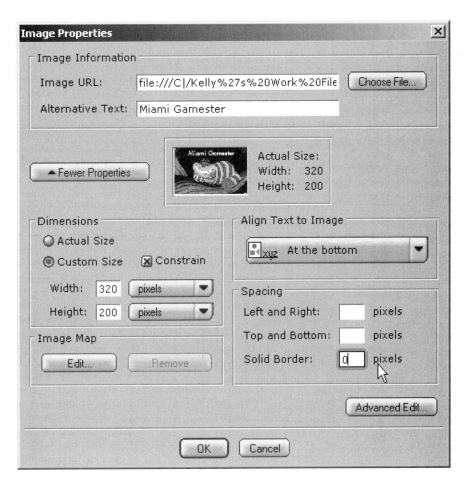

FIGURE 6.22 Set the border to zero in the Spacing section of the Image
Properties box.

When you are finished changing all the desired image properties, click
OK from the Image Properties box. The box will close, and whatever
changes you made will render on the image.

Step Review: Adding a Border to an Image

1. Select the image and access the Image Properties box.
2. Specify a number in pixels in the Border: field on the Spacing sec-
 tion. Set the border to zero for no border.
3. Click OK.

CREATING IMAGE LINKS

As mentioned previously, you can use images as hyperlinks. Once the image has been inserted in the Web page, you can use it to create a hyperlink by selecting the image and then clicking the Link button from the Composition toolbar. The Link Properties dialog box will appear as shown in Figure 6.23. Just as with text, you then specify the location of the link by clicking the Choose File button from the Link Properties box, or by typing a URL in the "Enter a web page location or local file:" field. Click OK on the Link Properties box.

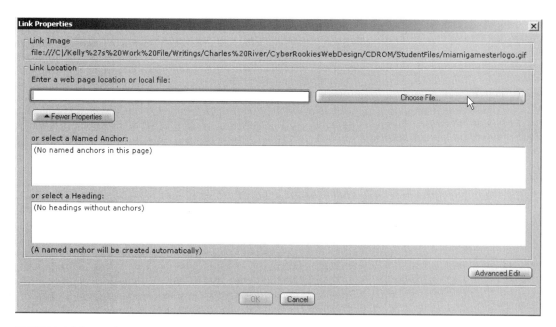

FIGURE 6.23 Link Properties box.

Step Review: To Create an Image Link

1. Select the image.
2. Click the Link button on the Composition toolbar. The Link Properties box will appear.
3. Type in the file path to a local file, or to a Web address. To browse your computer for a local file rather than entering the file path, click Choose button and navigate to the file on your computer.
4. Click OK.

ACTIVITY

In this exercise, you will insert images into an existing home page.

ON THE CD

1. Copy the files miamigamesterlogo.gif, submitbutton.gif, favorites-button.gif, and coolgamesbutton.gif from the Student Files on the CD-ROM to your miami_gamester.
2. Start Composer and open default.html if you closed it in the previous exercise.
3. Select the heading at the top of the Web page "Miami Gamester," and press Delete on your keyboard as shown in Figure 6.24.

FIGURE 6.24 Select the heading "Miami Gamester", and then press Delete.

4. Click the Image button from the Composition toolbar. The Image Properties dialog box will appear.

5. From the Image Properties box, click the Choose File button; the Open HTML File will appear.

6. Navigate to and open the miami_gamester folder, select the file cybergameslogo.GIF, and then click button as shown in Figure 6.25. The image appears in the Image Properties box.

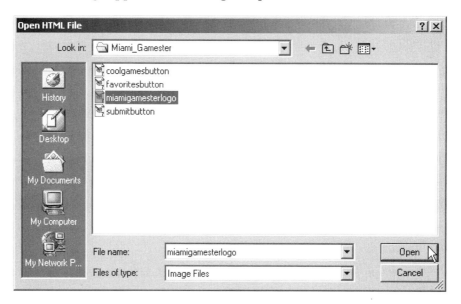

FIGURE 6.25 Select the image file miamigamersterlogo.gif from the miami_gamester.

7. Type the text "Welcome to Miami Gamester's Web Site" in the Alternative Text: field.

8. Enter "0" in the Solid Border: field as shown in Figure 6.26.

9. Click OK. The image will appear on the Web page. If it does not center on the Web page, select the image by clicking on it once, and then click Align Center on the Formatting toolbar as shown in Figure 6.27.

10. Press Enter to move down to the next line.

11. Click the Insert Image button, insert the image coolgamesbutton.gif, provide the alternative text "Cool Games", and set the border to "0."

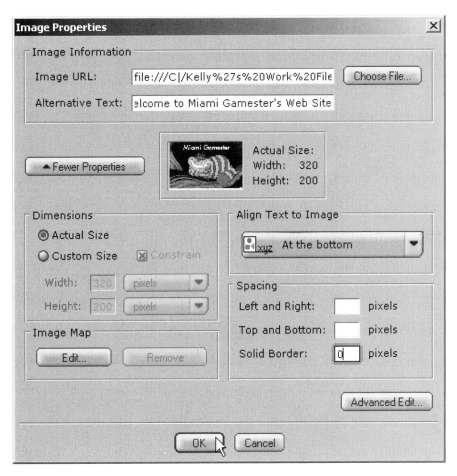

FIGURE 6.26 Enter alternative text for the image and specify the border in the Image Properties box.

12. Click the Insert Image button, insert the image submitbutton.gif, provide the alternative text "Submit a Game," and set the border to "0."

13. Click the Insert Image button, insert the image favoritesbutton.gif, provide the alternative text "Favorite Links", and set the border to "0."

14. Click Save from the Composition toolbar.

15. Click Browser from the Composition toolbar to display the Web page in Navigator. The Web page should display similar to the

FIGURE 6.27 Center the image by clicking Align Center on the Web page.

FIGURE 6.28 The completed Web page.

Web page shown in Figure 6.28. You may also want to display the image in Internet Explorer to ensure the page displays properly.

SUMMARY

- There are many types of image formats; however, GIFs, JPEGs, and PNGs are the only image formats that are supported by Web browsers.
- Small image file sizes is key for fast downloading of Web pages.
- You can insert images by clicking the Image Insert button from the Composition toolbar.
- You can edit an image's properties by double-clicking the image to display the Image Properties box.
- Some properties you can change or edit are width, height, alternative text, border, and alignment.
- Alternative text is important in that you can display text to those viewers whose Web browser does not support images, or if the viewer has the image feature disabled.
- You can use an image as a hyperlink by selecting the image, clicking the Link button, and then specifying a URL or a Web page location.

Working with Tables

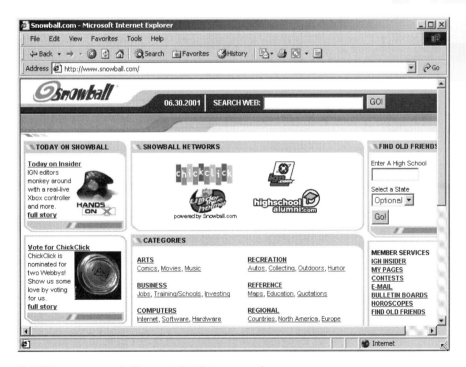

IN THIS CHAPTER
• • • • • • • • • • • • • •

- Using Tables to Organize Content
- Inserting a Table
- Understanding Table Widths
- Editing and Changing Table Properties
- Adding and Deleting Rows, Columns, and Cells
- Combining Cells
- Moving, Copying, and Deleting Tables

USING TABLES TO ORGANIZE CONTENT

Tables are useful for organizing text and images into formatted rows and columns on your Web pages. For example, if you have a music site with all of your favorite artists, you can create a table that aligns the artist name, album name, and song next to each other in rows and columns, providing an organized format for your listings.

Many designers use tables for layout techniques, since HTML is somewhat unforgiving in terms of placement for images and text on a Web page. Tables currently are used as a primary design tool throughout the Web. Figure 7.1 shows an example of a Web page (Charles River Media's

FIGURE 7.1 Charles River Media uses tables to display content in a columnar format. (© 2001. Charles River Media. All rights reserved.)

home page) that uses a table for layout design. Notice how the content and images align in columnar format.

Figure 7.2 (also from Charles River Media) shows how a table is used to display content in an organized format.

FIGURE 7.2 How a table can be used to organize information. (© 2001. Charles River Media. All rights reserved.)

INSERTING A TABLE

If you have used a spreadsheet program such as Excel or a word processor such as Word to insert tables in a document, you are already familiar with the basic skills needed to use tables in Composer.

With Composer, you insert a table by placing the pointer where you want the table to appear. Click the Table button on the Composition toolbar, or choose Table from the Insert menu. The New Table Properties dialog box will appear as shown in Figure 7.3. Here you can specify the number of rows, columns, border size, and width of the table. You set the number of rows and columns by entering a number in the Row: and Column: fields of the Insert Table dialog. You can then enter a number for the Height: and Width: fields (in pixels or percentages), which will specify how much space in width and height to allow for the table. Enter a number for the border thickness in the Border: field; enter zero for no border. Once you specify these settings, click OK and the table will insert on your Web page.

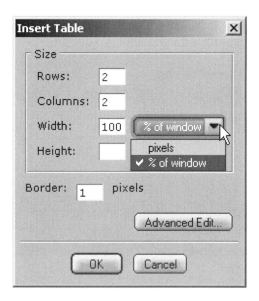

FIGURE 7.3 The Table Properties dialog box.

HINT

Composer uses a red dotted line to indicate tables with a zero border; the dotted line disappears when the page is previewed or browsed.

HINT

You do not have to specify a height for the table, since the table will default to a height based on the contents of the table.

Step Review: Inserting a Table

1. Place your cursor where you want the table to display.
2. Click the Table button located on the Composition toolbar. The Insert Table dialog box will appear.
3. Specify the number of rows, columns, width, height (optional), and border.
4. Click OK. The table will display on the Web page.

UNDERSTANDING TABLE WIDTHS

The width of the table is an important factor in Web design. Your viewer's screen resolution plays a role in the way your tables will display. Generally, there are three sizes of screen resolution: 640×480, 800×600, and 1040×768 (in pixels).

SETTING YOUR TABLE'S WIDTH IN PIXELS

Setting your table in pixels will set a fixed size that is not resizable relative to the actual browser's window size. For example, if you set your table's width to 800 pixels, the table takes up 800 pixels of the browser window regardless of the browser's screen resolution size. This would require a viewer with a screen resolution set to 640×480 to scroll horizontally to see the entire table.

The advantage to setting a predefined width for a table is that you have more control over the way your content will appear to the user. However, remember that your user's screen resolution can vary on average from 640 pixels to 1040 pixels in width. You should always consider the lowest common denominator when setting your table's width, which would be 640 pixels. Figure 7.4 shows the popular Web site www.teen.com displayed with a resolution set at 1040 in width. Teen.com uses a table as

146

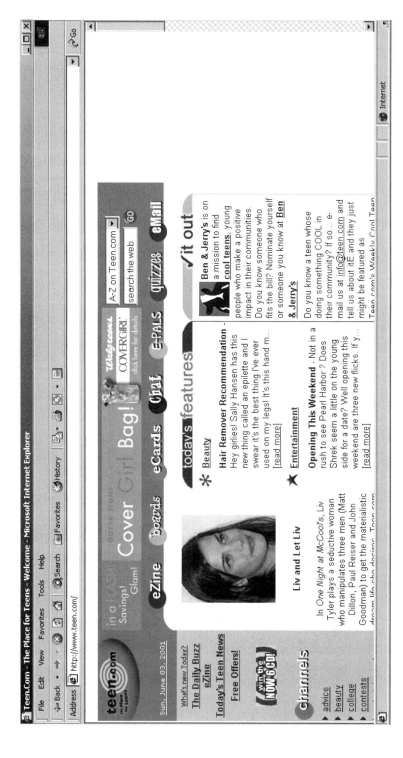

FIGURE 7.4 A Web page that uses fixed table widths for its design. (© 2001. Teen.Com. All rights reserved.)

a design tool for the page layout. The table is set at 765 pixels in width, which is why there is a white space left at the right-hand side on the page when viewing the page using a 1040 screen resolution—only 765 pixels of the 1040 pixel screen are being used.

SETTING YOUR TABLE'S WIDTH IN PERCENTAGES

Setting your table width to a percentage such as 100% will resize your table based on the actual size of the browser window. The advantage to this setting is that the table size is that of whatever percentage of the screen width; the table will adjust according to the percentage the table was set to in respect to the window. Figure 7.5 shows a table that is created in Composer using percentage of 100.

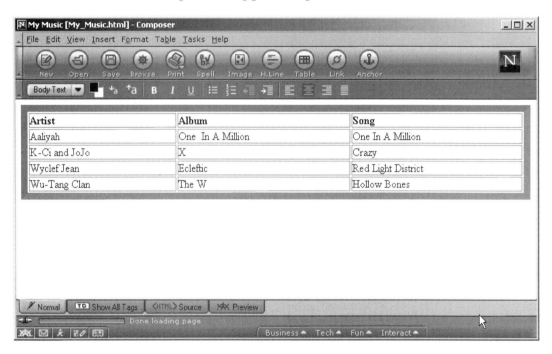

FIGURE 7.5 A table using a percentage of 100.

CHANGING THE APPEARANCE OF A TABLE

You can modify properties that apply to an entire table, as well as the rows, columns, or individual cells within a table. Changing the properties

of a table as a whole will affect all of the rows, columns, and cells. Any changes made to individual cells will only affect the cell in which the properties have been changed. For example, Figure 7.6 shows a table with a border that has been set to 10 pixels. This change is done by accessing the Table Properties and affects the table as a whole.

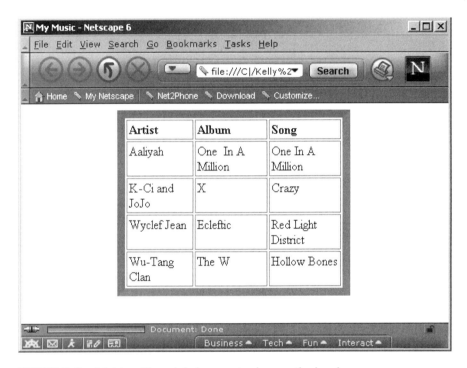

FIGURE 7.6 A table with a global property change, the border.

Figure 7.7 shows the same table; however, the top row of cells has been changed. Each individual cell of the top row has a background color specified.

CHANGING OR EDITING AN ENTIRE TABLE

To change or add properties for a table such as a caption, the background color, or cell spacing, you must access the Table Properties box. To access the Table Properties box, select the table by clicking anywhere inside it.

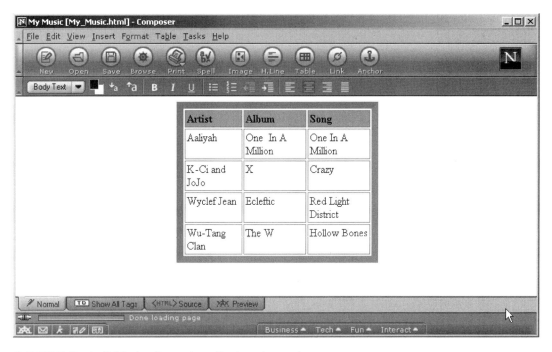

FIGURE 7.7 Individual cells can be edited or changed.

Click the Table button on the toolbar, or open the Table menu from the menu bar and choose Table Properties as shown in Figure 7.8.

The Table Properties box will appear with the Table and Cell tabs as shown in Figure 7.9. Click the Table tab to edit these properties.

Step Review: To Access the Table Properties Box

1. Click within the table on the Web page.
2. Click the Table button from the Composition toolbar, or, click Table>Table Properties from the menu bar. The Table Properties box will appear.
3. You can change the properties discussed in the following sections.

SIZE

Use this to specify the number of rows and columns. Indicate the height and width of the table, and then choose "% of window" or "pixels."

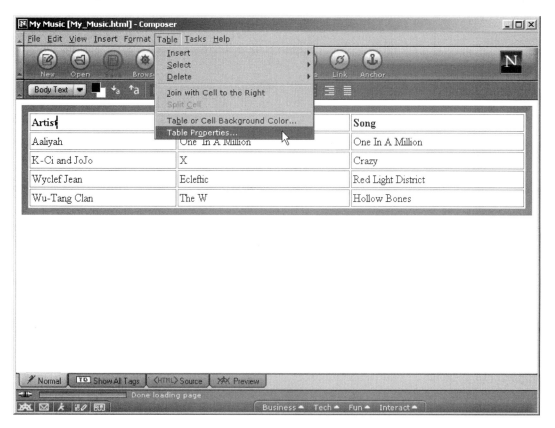

FIGURE 7.8 You access the Table Properties box by clicking Table from the menu bar and Table Properties from the Table menu.

Remember, if you specify height or width as a percentage, the table's height or width changes whenever the Composer window's or browser window's height or width changes. These properties most likely are already set when you first inserted the table in the Insert Properties box; nonetheless, you can change them from here.

Step Review: To Change the Size of a Table

1. Access the Table Properties box.
2. Change the table size by typing a pixel (e.g., 800) size or a percentage size (e.g., 80%) in the Width: field and/or Height: field.

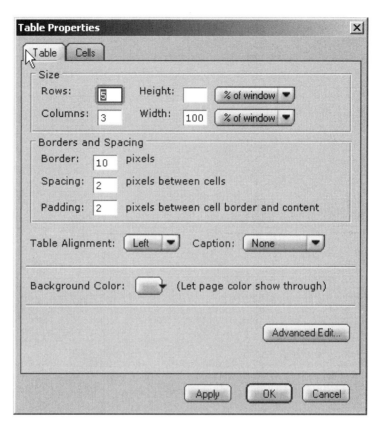

FIGURE 7.9 Select the Table tab from the Table Properties box.

3. Click Apply to apply the changes and continue editing the Table Properties, or click OK to make the changes and close the Table Properties box.

BORDERS AND SPACING

Use this section to specify (in pixels) the border width by typing a number in the Border: field. You can change the space between cells in the Spacing: field, and the cell padding (the space between the contents of the cell and the cell's border) in the Padding field.

Step Review: To Change the Table Border and Spacing

1. Access the Table Properties box.
2. Change the border width in pixels by typing a number in the Border: field. The border surrounding the table will change.
3. Change the spacing (the space between the cells) by typing a number (in pixels) in the Spacing field.
4. Change the padding (space between the contents of the cell and the cell's border) by typing a number (in pixels) in the Padding field.

TABLE ALIGNMENT

Use this to align the table within the page. Choose an alignment option from the pop-up menu. These options are Left, Center, and Right as shown in Figure 7.10.

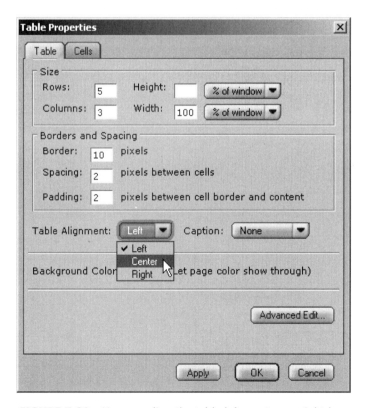

FIGURE 7.10 You can align the table left, center, or right by selecting the Table Alignment pull-down menu.

Step Review: To Align the Table

1. Access the Table Properties box.
2. Click the Table Alignment pull-down menu and select an alignment option. The table will align on the Web page.

CAPTION

Select an option from the Caption pop-up menu if you want to insert space for a caption, and then choose a placement from the pop-up menu as shown in Figure 7.11. A caption is a title for the table that tells the user what the table represents as shown in Figure 7.12. Once you insert a caption, click on top of the table and type the title. You can format the title if you wish by changing the caption size or bolding the text in the caption.

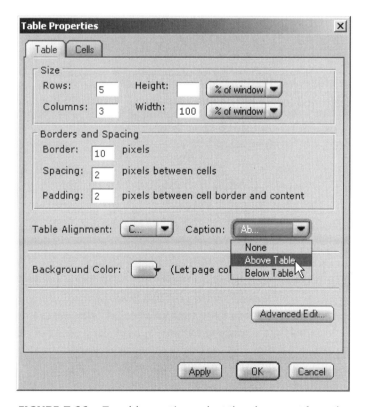

FIGURE 7.11 To add a caption, select the placement from the pop-up menu.

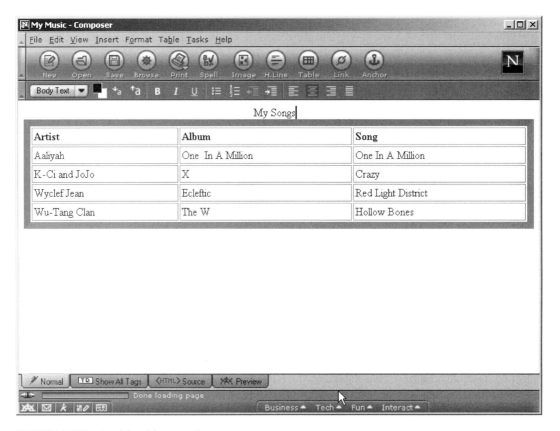

FIGURE 7.12 A table with a caption.

Step Review: To Add a Caption to a Table

1. Access the Table Properties box.
2. Select the type of caption from the Caption pop-up menu for the placement of your caption on the table.
3. The caption will insert on the table on the Web page. Click in the caption area and begin typing.
4. If you want, you can format the caption text by selecting it and choosing formatting options from the Formatting toolbar.

BACKGROUND COLOR

Click the Background Color button to choose a color for the table background, or leave it as transparent. When you select this option, the Table

Background Color box will appear with a choice of colors that you select by clicking on as shown in Figure 7.13.

FIGURE 7.13 The Table Background Color box.

If you want to use an image file as the table's background, check the box at Image, and then enter the file name and location. Background colors and images are not supported well in all Web browsers, so consider this before using this option.

Click Apply to preview your changes without closing the dialog box, or click OK to confirm them.

Step Review: To Change a Table's Background Color

1. Access the Table Properties box.
2. Click the Background Color button to choose a color from the Table Background Color box.
3. The table will change to the background color selected, or remain transparent if a background color was not chosen.

CHANGING OR EDITING CELL PROPERTIES

As mentioned earlier, you can change the properties of an individual cell. To add to or change the properties for one or more cells, select the row, column, or cell by clicking within the cell or selecting a section of cells. Open the Table menu and choose Table Properties. Click the Cells tab from the Table Properties box to edit the properties discussed next.

Step Review: To Access the Cell Properties Box

1. Click within the cell you want to change.
2. Click Table>Table Properties from the menu bar. The Table Properties box will appear.
3. Click the Cell tab from the Table Properties box. The Cell Properties box will display.

SELECTION

Choose Cell, Row, or Column from the pop-up menu in the Selection section as shown in Figure 7.14. Click Previous or Next to move through

FIGURE 7.14 Select the part of the table you want to change in the Selection section of the Cell Properties box.

rows, columns, or cells. This will select the section of the table you want to change (cell, row, or column).

SIZE

Enter a number in the Height: and/or Width: fields, and then choose "% of table" or "pixels" to change the size of a cell, row, or column. Enter a number in the Span: field to specify the number of rows or columns the selected cell overlaps. For example, you can specify a cell in one row to expand the size of two columns as shown in Figure 7.15. The table shown in Figure 7.16 renders a Column Span of 2.

FIGURE 7.15 Specify a cell in one row to expand the size of two columns.

CONTENT ALIGNMENT

Choose a horizontal or vertical alignment type (top, left, or center) for the text or data inside each cell from the Content Alignment section. You can also select the text and align it (horizontally) with the Formatting toolbar, just as you would text contained outside of the table.

FIGURE 7.16 A table with a Column Span of 2.

CELL STYLE

Choose Header from the pop-up menu to center and bold the text in the cell; otherwise, choose Normal.

TEXT WRAP

Choose "Don't wrap" from the pop-up menu to keep text from wrapping to the next line unless you insert a paragraph break. Otherwise, choose Wrap.

BACKGROUND COLOR

Choose a color for the cell background or leave it as transparent. Figure 7.17 shows an example of how the Cell Properties box might appear if you were to change all the properties for a cell.

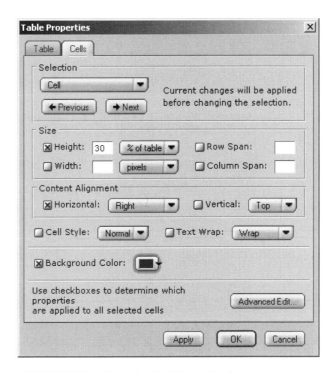

FIGURE 7.17 How the Cell Properties box might appear.

Click Apply to preview your changes without closing the dialog box, or click OK to confirm them.

Step Review: To Change Cell Properties

1. Select the cell by clicking it in, or select a group of cells.
2. From the menu bar, select Table>Table Properties. The Table Properties box will appear.
3. Click the Cell tab from the Table Properties box, and begin editing the cell properties.

ADDING AND DELETING ROWS, COLUMNS, AND CELLS

Composer allows you to quickly add or delete one or more in your table. In addition, you can set options that allow you to maintain the original

rectangular structure or layout of the table while you perform editing tasks.

To add a cell or group of cells (rows and columns) to your table, click inside the table where you want to add a cell (or cells). From the menu bar, click Table>Insert.

Choose one of the cell groupings as shown in Figure 7.18.

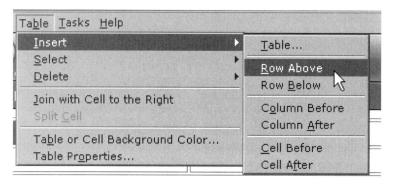

FIGURE 7.18 You can add cells to your table by using the Table>Insert menu.

Step Review: To Add a Cell or Group of Cells to Your Table.

1. Click inside the table where you want to add a cell (or cells).
2. Open the Table menu, and then choose Insert.
3. Choose one of the cell groupings. The additional cells will be added to your table.

DELETING A CELL OR GROUP OF CELLS

There may be times when you have an excess of rows, columns, or cells. You can delete them by clicking in the row, column, or cell, and then clicking the Table>Delete menu from the menu bar. Choose the item you want to delete from the Delete menu as shown in Figure 7.19. If you select Table from the Delete menu, the entire table will delete. Selecting Row(S) from the Delete menu will delete the row or rows you have selected. Selecting Column(S) will delete the column or columns you have selected. Choosing Cell(S) will delete the selected cells from the table. If you want

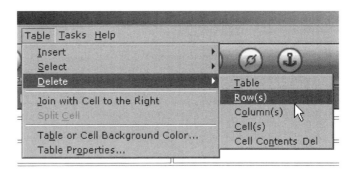

FIGURE 7.19 You can delete rows, columns, and cells using the Table>Delete menu.

to delete the entire contents from a cell, choose Cell Contents Del from the Delete menu.

Step Review: To Delete a Row, Column, or Cell

1. Select a row, column, cell, or group of cells.
2. Click Table>Delete from the menu bar.
3. Select an option from the Delete menu. Whatever option you choose will delete from the table.

COMBINING (MERGING) CELLS

To combine two cells, click inside the cell, open the Table menu, and choose Join With Cell To The Right as shown in Figure 7.20.

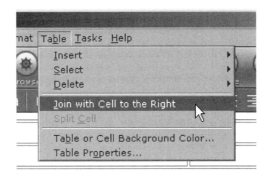

FIGURE 7.20 To combine cells, click Table>Join With Cell To The Right.

TO SPLIT A CELL INTO TWO CELLS

Click inside the cell, open the Table menu, and then choose Split Cell as shown in Figure 7.21. The cell will split into two cells.

FIGURE 7.21 Use the Table>Split Cell menu to split a cell into two.

ACTIVITY
• • • • • • • •

In this exercise, you will create a table for information and links to the JavaScript games for the Miami Gamester site.

1. Start Composer. A new blank Web page will appear.
2. Click Save from the File menu. You will be prompted to provide a title for the new Web page.
3. Type "My Cool Games" in the Page Title box as shown in Figure 7.22, and click OK.

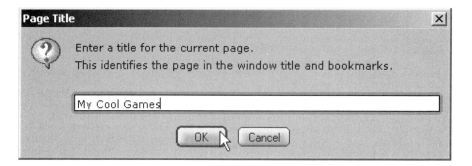

FIGURE 7.22 Enter a title for the COOLGAMES.HTML.

4. Save the new Web page in your MIAMI_GAMESTER folder as COOLGAMES.HTML.
5. Type the text "Cool Games" at the top of the Web page.
6. Select the text "Cool Games," change the text to a Heading 1, and center it on the Web page. The page should appear the same as in Figure 7.23.

FIGURE 7.23 Format the text "Cool Games".

7. Press Enter on the keyboard to move down one line from the heading. The cursor should be underneath the heading "Cool Games" and centered on the Web page.
8. Click the Table button from the Composition toolbar. The Table Properties box should appear.
9. Set the following properties:

 Rows: 2
 Columns: 2
 Width: 70%
 Border: 3

 The Table Properties box should appear as shown in Figure 7.24.
10. Click OK and the table will display on the Web page.
11. Click within the first cell (top, left).
12. Type "Game Name", and press Tab on your keyboard. The cursor will move to the next cell (top, right).
13. Type "Credit and Link", and press Tab. The cursor will move to the next cell (bottom, left).
14. Type "Random Numbers", and press Tab again. The cursor will move to the next cell (bottom, right).
15. Type "JavaScript CD Cookbook 3/e".

FIGURE 7.24 How the Table Properties box should appear.

16. Press Enter to move to the next line, and type "Erica Sadun & Brook Monroe".
17. Press Enter to move to the next line, and type "Published by Charles River Media".
18. Press Enter again and type "View Game". The Web page should appear as shown in Figure 7.25.
19. Select the top two cells with your mouse as shown in Figure 7.26, and then select Bold formatting from the Formatting toolbar.

Cool Games

Game Name	Credits & Links
Random Numbers	JavaScript CD Cookbook 3/e Eric Sadun & Brook Monroe Published By Charles River Media View Game

FIGURE 7.25 The COOLGAMES.HTML Web page.

Cool Games

Game Name	Credits & Links
Random Numbers	JavaScript CD Cookbook 3/e Eric Sadun & Brook Monroe Published By Charles River Media View Game

FIGURE 7.26 Apply bold formatting to the first row of the table.

20. Select the words "View Game" from the table.
21. Click the Link button from the Composition toolbar and type ran-
domnum.html in the Link Properties box as shown in Figure 7.27.

FIGURE 7. 27 Create a link to the text "View
Game" in the table to randomnum.html.

22. Click the Advanced property button. The Advanced property editor will appear.

23. Type "TARGET" in the Name: field, and "_BLANK" in the Value: field of the Add an HTML Attribute field. Click Add, and then close the Advanced property box. When the link is clicked, it will open in a new window.

24. Save your changes and click Browse to test the COOLGAMES .HTML in Navigator.

25. Launch Internet Explorer to view the Web page. The Web page should appear as it does in Figure 7.28.

FIGURE 7.28 The "Cool Games" Web page.

SUMMARY

- Tables are used for organizing information on a Web page.
- Most Web designers also use tables for layout designs that other HTML elements cannot offer.
- You can edit table properties as a whole from the default settings by accessing the Table Properties box.
- To change individual cells of a table, access the Cell Properties box.
- You can set the table size relative to a browser window by either using pixels or percentages.
- You can format text and images within a table in the same manner that you would if the text and images were inserted using other HTML elements.

Working with Forms

IN THIS CHAPTER

- Defining HTML Forms
- Composer and Forms
- The <FORM> Tag
- The <FORM> Tag Attributes
- Working with INPUT fields (Textboxes, Check Boxes, etc.)
- Working with Selection Boxes
- Working with Large Text Areas

DEFINING HTML FORMS

HTML forms make Web pages come alive. Readers can fill out text entry spaces, click on radio buttons, and select from pop-up menus. Forms transform pages from static presentations to places of commerce, research, and feedback. Forms permit readers to send data to site maintainers and interact with Web-based programs. Readers might submit background information, sign guest books, request searches, or order products. Figure 8.1 shows an example of a Web page that displays an HTML form that collects information from the user for a loan application.

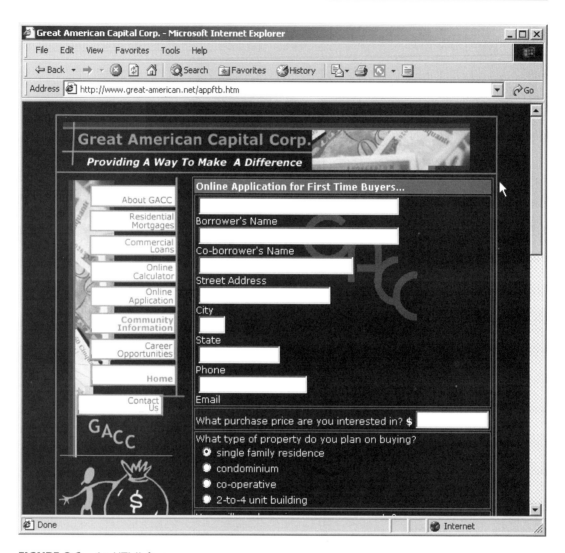

FIGURE 8.1 An HTML form.

COMPOSER AND FORMS

Unfortunately, Netscape Composer does not support forms, so you will need to learn how to code your own HTML forms in order to include them in your Web pages when using Composer as your sole Web editor. Other Web editors such as FrontPage 2000 allow you to create forms by selecting form commands from menus and buttons.

You can refer back to Chapter 1, "Understanding Web Pages," to learn HTML basics to help you through this chapter.

THE <FORM> TAG

All of the form fields found in an HTML form (see Figure 8.1), such as textboxes, radio buttons, and checkboxes, are created by HTML tags and are contained by the <FORM></FORM> container tags. As you learned in Chapter 1, all HTML elements that are to display in the body of the Web page need to be placed between the <BODY></BODY> tags, including forms. Therefore, the <FORM></FORM> tags need to be placed in between the <BODY> container tag.

Step Review: To Insert <FORM> Container Tags on a Web Page

1. Place your cursor in between the <BODY></BODY> tags where you want the form to be placed.
2. Type the on tag <FORM>.
3. Press Enter twice after typing <FORM>. The cursor will move down two lines.
4. Type the off tag </FORM>.

THE <FORM> ATTRIBUTES

You learned the basics of HTML in Chapter 1, such as the definition of an HTML tag; however, *tag attributes* were not discussed. Tag attributes are options that you can add to a tag to change the way the tag displays content on a Web page. For example, in the previous chapter you learned how to insert a table on a Web page. Behind the scenes, Composer created the table by using the <TABLE> tag. When you used Composer to specify the width of the table, you actually added an attribute to the table tag called WIDTH. The format looked something like this:

```
<TABLE WIDTH="100%">
```

Think of tag attributes as properties of a tag that you can add or change to affect the way you display text or images. A tag attribute is

comprised of three parts: the attribute, the = sign, and the value. In the <TABLE WIDTH="100%"> example, the WIDTH attribute is used to set the width; the = portion assigns the value portion (100%) to the attribute.

Most of the tags in the HTML language offer the option of using attributes. We will learn two attributes for the FORM tag in this chapter: ACTION and METHOD.

Here is an example of a complete tag and attribute set for the <FORM> tag:

```
<FORM  ACTION="mailto:yourname@yourdomain.com"  METHOD="POST">
</FORM>
```

ACTION ATTRIBUTE

The ACTION attribute instructs the Web browser where to send form data. In the preceding example, the data will mailed to the address yourname@yourdomain.com using the user's e-mail program. Form data can also be sent to special programs written in C, Perl, or Java, in which case the action attribute should point to that program's URL (e.g., <FORM METHOD="post" ACTION="http://www.8ballmedia.net/cgi-bin/ formail.pl">). The URL in the ACTION attribute is a location where a program called a Common Gateway Interface (CGI) is located. A CGI script is a program that processes forms on a server. However, in this chapter, you will learn how to process your form using the user's e-mail program.

HINT

Some browsers do not support the "mailto" action (Internet Explorer 3.01 and Navigator 2 and later do). Therefore we recommend that you use only the "mailto" action if no other option is available.

METHOD ATTRIBUTE

The METHOD attribute explains how the data will be sent. There are only two choices: POST or GET. Unless instructed otherwise, always use POST.

Step Review: To Add Form Attributes to a Form

1. Place your cursor inside the <FORM> on tag just after the letter "M".
2. Press the spacebar to insert a space after the word FORM.
3. Type an attribute/value such as ACTION="value", replacing the "value" with a mailto:email format or an URL to a program on a server that will process your form.
4. Press the spacebar again to insert a space after the ACTION="value" attribute.
5. Type "METHOD="post".
6. Save your changes.

FORM FIELDS

There are three main form field types supported by HTML 4: selection lists, text areas, and inputs, the last being a catch phrase for "everything else." While selection lists include both pop-up menus and multiple-selection forms, text areas are simply multi-line text entry fields. The remaining elements, such as buttons and single-line data entry, are inputs. Mix and match these elements to create forms.

WORKING WITH THE INPUT FORM FIELDS

The <INPUT> tag is used to specify the type of input field presented to the user. The input fields used are one-line text fields, radio buttons, check boxes, passwords, images, and buttons.

ONE-LINE TEXT FIELDS

Text input fields permit single-line data entry. The <INPUT TYPE="text"> tag creates a text-based data entry field. The VALUE, SIZE, and MAXLENGTH attributes control the text field's behavior. The VALUE attribute provides a default value in the actual text field that displays in the text box (see Figure 8.2). The SIZE attribute sets the size of the text box in characters. The MAXLENGTH attribute sets a maximum number of characters allowed in the text field. The NAME attribute

names the text field, denoting what input field the user filled out on the form. When you receive the form, results will be easier to identify because of the NAME attribute.

```
<FORM>
<P>
Enter Your First Name: <INPUT TYPE="text" NAME="fname" SIZE=7>
</P>
<P>
Enter Your Last Name: <INPUT TYPE="text" NAME="lname" SIZE=15
MAXLENGTH="15" VALUE="Last Name Please">
</P>
</FORM>
```

The code example creates the Web page shown in Figure 8.2.

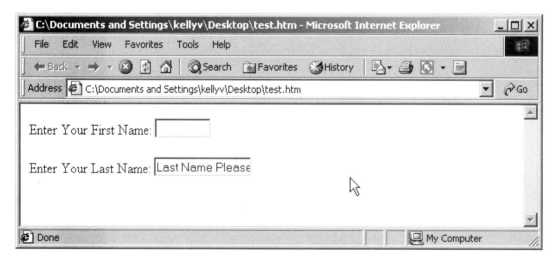

FIGURE 8.2 The <INPUT TYPE="text"> tag creates a one-line text box.

Step Review: To Create a One-Line Text Box

1. Place your cursor between the <FORM></FORM> container tags where you want the text box to display on a Web page.
2. Type <INPUT TYPE="text" NAME="value" SIZE="value". Replace the text "value" with your own specifications.
3. Save your changes.

CHECK BOXES

Check boxes provide simple on/off entry fields. The <INPUT TYPE=CHECKBOX> tag produces a selectable box. The CHECKED attribute causes the box to be chosen as the default. In the following example, the green check box is preselected. The example code that follows appears in the Web page as shown in Figure 8.3.

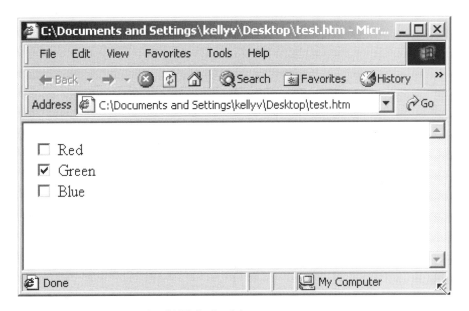

FIGURE 8.3 An example of HTML check boxes.

```
<FORM>
<INPUT TYPE="CHECKBOX" NAME="Red"> Red <BR>
<INPUT TYPE="CHECKBOX" NAME="Green" CHECKED> Green <BR>
<INPUT TYPE="CHECKBOX" NAME="Blue"> Blue <BR>
</FORM>
```

Step Review: To Create a Check Box

1. Place your cursor between the <FORM></FORM> container tags where you want the text box to display on a Web page.
2. Type <INPUT TYPE="checkbox" NAME="value". Replace the text "value" with your own specifications. You can include the attribute

CHECKED if you want the check box to display checked in the Web browser.

3. Save your changes.

RADIO BUTTONS

Radio buttons provide "one of many" selections. The <INPUT TYPE= RADIO> tag limits selection between a number of identically named fields. As with check boxes, the CHECKED attribute selects a default. Unlike check boxes, however, only one radio button out of the group can be selected. The VALUE attribute distinguishes between the identically named buttons.

A set of radio buttons is defined by the NAME attribute. All the radio buttons in a set must have the same name in order to work properly. Specifying a VALUE for each radio button in a set will render which option was selected when you receive the form results. Figure 8.4 shows an example of how the following code displays in a Web browser.

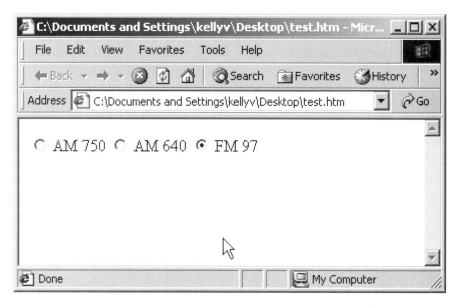

FIGURE 8.4 An example of HTML radio buttons.

```
<FORM>
<INPUT TYPE="RADIO" NAME="Station" VALUE="AM750"> AM 750
<INPUT TYPE="RADIO" NAME="Station" VALUE="AM640"> AM 640
<INPUT TYPE="RADIO" NAME="Station" VALUE="FM97" CHECKED> FM 97
</FORM>
```

Step Review: To Create a Radio Button

1. Place your cursor between the <FORM></FORM> container tags where you want the text box to display on a Web page.
2. Type <INPUT TYPE="radio" NAME="value" VALUE="value". Replace the text "value" with your own specifications. Remember that the NAME attributes must all have the same "value" in order to be considered as a group.
3. Save your changes.

RESET AND SUBMIT BUTTONS

Reset and submit buttons do exactly what you think they do. RESET buttons return form values to their defaults and are used when a viewer wants to clear all of the form fields in which he or she entered information. SUBMIT buttons send form data to the URL specified by the ACTION attribute. (If the URL is of the "mailto:" variety, for example, the form data is mailed.) The VALUE attribute defines the button text. Consider the following code examples shown in Figure 8.5 of how you can change the text that appears on the button changes by using the VALUE attribute.

```
<FORM>
<INPUT TYPE="RESET" VALUE="Reset">
<INPUT TYPE="RESET" VALUE="Erase Form">
<INPUT TYPE="SUBMIT" VALUE="Submit">
<INPUT TYPE="SUBMIT" VALUE="Send Data">
</FORM>
```

Step Review: To Create a Reset Button

1. Place your cursor between the <FORM></FORM> container tags where you want the text box to display on a Web page. Typically, this is the second to the last form element on a Web page.

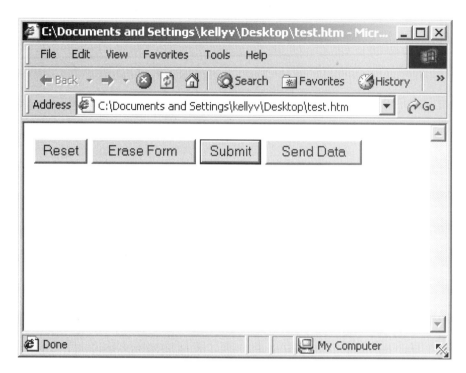

FIGURE 8.5 How the SUBMIT and RESET buttons can appear on a Web page.

2. Type <INPUT TYPE=RESET>. Replace the text "value" with your own specifications. You can add the VALUE="value" attribute to change the default text on the button.
3. Save your changes.

Step Review: To Create a Submit Button

1. Place your cursor between the <FORM></FORM> container tags where you want the text box to display on a Web page. Typically, this is the last form element on a Web page.
2. Type <INPUT TYPE=SUBMIT>. Replace the text "value" with your own specifications. You can add the VALUE="value" attribute to change the default text on the button.
3. Save your changes.

NON-INPUT FORM FIELDS

There are other form elements that you can place within your forms other than INPUT types. These form elements consist of selection menus, pull-down lists, and text areas.

SELECTION MENUS

Choose from a range of values with selection lists. Selection lists present a number of options and permit the user to select from them. However, this type of form field requires work from two tags, the <SELECT> container tag and the <OPTION> empty tag. Consider the following:

```
<SELECT NAME="Size">
    <OPTION> X-Small
    <OPTION> Small
    <OPTION SELECTED> Medium
    <OPTION> Large
    <OPTION> X-Large
</SELECT>
```

When loaded, the preceding code defaults to "Medium," because this option was SELECTED in the HTML definition. This is a default setting much like the VALUE option. The viewer can change the selected option by pulling down the list and selecting another option from the list.

Step Review: To Create a Basic Selection List

1. Place your cursor between the <FORM></FORM> container tags where you want the text box to display on a Web page.
2. Type the following code to create a basic selection list, and replace the text "value" with your own specifications. You can include the attribute SELECTED to have an option appear selected on the Web page.

```
<SELECT NAME="value">
    <OPTION> List Item
    <OPTION> List Item
    <OPTION> List Item
```

```
        <OPTION> List Item
        <OPTION> List Item
    </SELECT>
```

3. Save your changes.

In the preceding basic selection list, only one choice can be selected at a time. To bypass this limitation, insert the MULTIPLE attribute into the SELECT tag as shown in the example code that follows. This attribute permits readers to select several—meaning zero or more—choices. Figure 8.6 shows a basic selection list and a multiple selection list.

```
<SELECT NAME="Groceries" MULTIPLE>
    <OPTION SELECTED > Milk
    <OPTION> Butter
    <OPTION SELECTED> Bread
    <OPTION> Meat
    <OPTION> Vegetables
</SELECT>
```

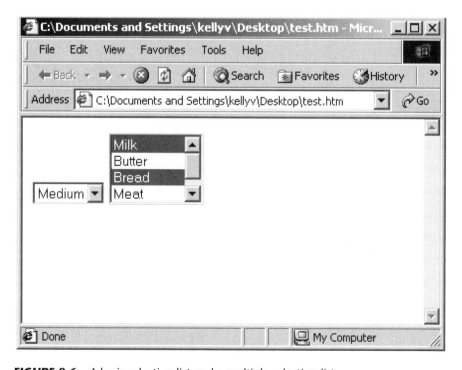

FIGURE 8.6 A basic selection list and a multiple selection list.

Step Review: To Create a Multiple Selection List

1. Place your cursor between the <FORM></FORM> container tags where you want the text box to display on a Web page.
2. Type the following code to create a multiple selection list, and replace the text "value" with your own specifications. You can include the attribute SELECTED to have an option display selected on the Web page.

```
<SELECT NAME="value" MULTIPLE>
    <OPTION> List Item
    <OPTION> List Item
    <OPTION> List Item
    <OPTION> List Item
    <OPTION> List Item
</SELECT>
```

3. Save your changes.

HINT
. .

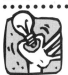

Consult your browser's manual to discover how to add and remove items from a multiple-selection list. Each platform and browser has slightly different methods for doing so. For example, in the Macintosh Netscape browser, depress the command (apple) key while you make selections with the mouse. On PCs, use the Ctrl key.

TEXT AREAS

You can enter large blocks of text with text area fields. The <TEXTAREA> tag creates a multi-line text input field. Set the field size with the ROWS (the number of lines) and COLS (number of characters across a line) attributes. The following code example displays as a large text box as shown in Figure 8.7.

FIGURE 8.7 A text area box on a Web page.

```
<TEXTAREA ROWS=3 COLS=40 NAME="Feedback">
```

EPILOGUE
SPOKEN BY PROSPERO
Now my charms are all o'erthrown,
And what strength I have's mine own,
Which is most faint: now, 'tis true,
I must be here confined by you,
Or sent to Naples. Let me not,
Since I have my dukedom got
And pardon'd the deceiver, dwell

In this bare island by your spell;
But release me from my bands
With the help of your good hands:
Gentle breath of yours my sails
Must fill, or else my project fails,
Which was to please. Now I want
Spirits to enforce, art to enchant,
And my ending is despair,
Unless I be relieved by prayer,
Which pierces so that it assaults
Mercy itself and frees all faults.
As you from crimes would pardon'd be,
Let your indulgence set me free.
</TEXTAREA>

Step Review: To Create a Text Box Area

1. Place your cursor between the <FORM></FORM> container tags where you want the text box to display on a Web page.
2. Type the following code to create a text area box. Replace the text "value" with your own specifications.

```
<TEXTAREA ROWS="value"> COLS="value"> NAME="value">
Default Text
</TEXTAREA>
```

3. Save your changes.

ACTIVITY
• • • • • • • •

In this exercise, you will create a form using some of the form elements learned in this lesson. You will use a text editor to create the Web page, since Composer does not support the creation of forms.

1. Start your text editor. A new blank Web page will appear.
2. Click Save from the File menu, and then navigate to and open the MIAMI_GAMESTER folder.
3. Save the HTML file with the file name SUBMITAGAME.HTML inside of the MIAMI_GAMESTER folder.

4. Begin typing:

```
<HTML>
<HEAD>
<TITLE>Submit a Game.</TITLE>
</HEAD>
<BODY>
<H1>Submit Your Game!!</H1>
<P>Copy and paste your JavaScript code to your game below.
We will review the game, and possibly add it to our online
collection. Be sure to provide your name and URL so we can
give you credit and a link to your Web site.</P>
<FORM ACTION="mailto:yourname@yourdomain.com"
  METHOD="POST">
  <P>
  Name: <INPUT TYPE="text" SIZE="40" NAME="full_name">
  </P>
  <P>
  E-mail: <INPUT TYPE="text" SIZE="30" NAME="email">
  </P>
  <P>
  URL: <INPUT TYPE="text" SIZE="30" NAME="url">
  </P>
<P>
  Submit Your Game:
</P>
  <TEXTAREA ROWS="10" COLS="40" NAME="game">
  </TEXTAREA>
</P>
  <P>
  <INPUT TYPE=RESET VALUE=Clear>
  <INPUT TYPE=SUBMIT VALUE=Submit Game>
  </FORM>
</BODY>
</HTML>
```

5. Click the FILE>SAVE to save the changes you made to SUB-MITAFORM.HTML.

6. Open the Web page in Internet Explorer or Netscape Navigator; it should appear as shown in Figure 8.8.

FIGURE 8.8 The Web page you created in this exercise.

SUMMARY

- Select, text area, and input fields collect form data.
- Select fields can be single or multi-valued, based on inclusion of the "Multiple" attribute.
- Text areas collect large multi-lined text data.

- Text and password fields collect single-line text data.
- Check boxes and radio buttons permit many-of-many and one-of-many data selection.
- Reset and Submit buttons restore defaults and transmit data to the action URL, respectively.

Cool
JavaScript

IN THIS CHAPTER

- What Is JavaScript?
- JavaScript Is Not HTML
- JavaScript Is Not Java Programming
- JavaScript and Web Browsers
- What Can You Do with JavaScript?
- Disadvantage of Using JavaScript
- How Do I Get a Script Already Created?
- Inserting a JavaScript
- Writing Easy Scripts

WHAT IS JAVASCRIPT?

When you create pages for the Web using HTML, those Web pages are static and noninteractive. In other words, HTML-based Web pages do not react from the actions of a user. To create Web pages that are interactive, you can use JavaScript.

JavaScript offers the capability for Web pages to change based on actions of your Web page viewer. This can be as subtle as buttons "highlighting" when the user places the mouse over the button, or as advanced

as a JavaScript program customizing (personal colors, horoscopes, e-mail, etc.) the Web pages based on the user login.

Figure 9.1 shows an example of a Web page that uses JavaScript to create a mouse-over effect on a button. When the page displays, the buttons are solid; when a mouse is placed over a button, the button changes by highlighting in a different color.

FIGURE 9.1 JavaScript creates an image flip. (© 2001. CDC Papers, Inc. All rights reserved.)

JavaScript is a scripting language and resides within the HTML code on a Web page. Figure 9.2 shows an example of an HTML source page that shows how JavaScript is written right into the HTML code.

```
www.cdcpapers[1] - Notepad                                    _ □ ×
File   Edit   Format   Help

<html>
<head>
<meta http-equiv="Content-Language" content="en-us">
<title>Welcome To CDC Chemical Design</title>          JavaScript

<script language="JavaScript">
<!--hide this script from non-javascript-enabled browsers  <=

function MM_findObj(n, d) { //v3.0
  var p,i,x;  if(!d) d=document; if((p=n.indexOf("?"))>0&&parent.frames.length) {
    d=parent.frames[n.substring(p+1)].document; n=n.substring(0,p); }
  if(!(x=d[n])&&d.all) x=d.all[n]; for (i=0;!x&&i<d.forms.length;i++) x=d.forms[i][
  for(i=0;!x&&d.layers&&i<d.layers.length;i++) x=MM_findObj(n,d.layers[i].document)
}
/* Functions that swaps images. */
function MM_swapImage() { //v3.0
  var i,j=0,x,a=MM_swapImage.arguments; document.MM_sr=new Array; for(i=0;i<(a.leng
   if ((x=MM_findObj(a[i]))!=null){document.MM_sr[j++]=x; if(!x.oSrc) x.oSrc=x.src;
}
function MM_swapImgRestore() { //v3.0
  var i,x,a=document.MM_sr; for(i=0;a&&i<a.length&&(x=a[i])&&x.oSrc;i++) x.src=x.os
}

/* Functions that handle preload. */
function MM_preloadImages() { //v3.0
 var d=document; if(d.images){ if(!d.MM_p) d.MM_p=new Array();
   var i,j=d.MM_p.length,a=MM_preloadImages.arguments; for(i=0; i<a.length; i++)
   if (a[i].indexOf("#")!=0){ d.MM_p[j]=new Image; d.MM_p[j++].src=a[i];}}
}
```

FIGURE 9.2 How JavaScript coexists with HTML. (© 2001. CDC Papers, Inc. All rights reserved.)

JavaScript programs run on Web browsers such as Internet Explorer and Navigator right from the HTML document. This means that any JavaScript-enabled Web browser can display your JavaScript programs without additional plug-ins.

JAVASCRIPT IS NOT HTML

One of the major misconceptions is that JavaScript is HTML. This is simply not the case. However, if you must, you can consider JavaScript as an extension of HTML. Since JavaScript is incorporated into HTML, it can be called an extension of HTML, meaning that JavaScript can extend the capabilities of your Web pages beyond the standard HTML.

When writing JavaScript, you follow some of the same writing composition that HTML follows. For example, JavaScript co-exists with HTML because it is placed within the HTML code, and is saved as text right along with the HTML document.

A major difference between the two (besides the coding) is that HTML is very forgiving in terms of its code structure. White space means nothing to HTML. How much space you leave between words or paragraphs will not matter. In fact, you can write an entire HTML document on one line, and the Web browser will render the Web page as if you had written it on several lines.

HINT

Syntax is the structure of a language, such as how commands are entered and how the code is punctuated.

The opposite is true in JavaScript. It does matter how you write the code structure within the HTML document. There are times when you can break the structure of a script, but not very often. For example, the following JavaScript is written on one line.

```
document.write("Hello world!")
```

If you were to write the JavaScript code like the following example within the HTML document, it will result in an error:

```
document.write("Hello
world!")
```

Another important factor to mention is that JavaScript is case sensitive, meaning that JavaScript commands must be written with proper letter casing or and error will occur.

JAVASCRIPT IS NOT JAVA PROGRAMMING

Another misconception is that JavaScript is derived from Java programming. Even though they are related, they are two completely different

languages. JavaScript is a scripting language that was created by Netscape and was originally called LiveScript. *Java programming* was created by Sun Microsystems, and is a full-fledged stand-alone programming language. A stand-alone programming language is not interpreted by another application such as a Web browser. Java needs to be compiled first before it can run. Once the Java program is compiled, the program will run on its own and does not need the support of a Web browser.

Since JavaScript is a scripting language, it does not need to be compiled; however, it does rely on another application source to run. JavaScript is scripted right into an HTML document and is deciphered from a Web browser application. This makes JavaScript more of an "interpretive" language, while Java is a "compiled" language. Once the JavaScript is included into the HTML document, you can immediately see the results within a Web browser window.

Java programs (usually called applets) are not included into the HTML document itself; however, Java programs (once compiled) are embedded and downloaded much the same way a GIF file is. Table 9.1 compares JavaScript and Java programming.

HINT

You can find out more information on Java programming by visiting Sun Microsystems online at http://java.sun.com.

TABLE 9.1

JavaScript	Java Programming
Scripting languages take after programming languages. However, scripting languages are easier to learn and do not need to be compiled.	Programming languages are difficult to learn and need to be compiled before they can run.
Script can be embedded into HTML without any additional files.	A stand-alone program that is embedded into HTML and run from a separate file on the server.
JavaScript does not need to be compiled before it can run from a Web page or on the server.	Operates like any standard programming language that needs to be compiled before it can be executed.

JAVASCRIPT AND WEB BROWSERS

Because Netscape created JavaScript, Netscape's Web browser Navigator is considered the native platform for running JavaScript. Internet Explorer runs JavaScript in the same manner as Netscape; however, some of the more advanced JavaScript features might render differently. Again, to ensure that JavaScript is rendering in Web browsers the way you intended, always test your Web pages in multiple Web browsers and versions. If you see that there are some differences in your JavaScript program among different Web browsers, you can offer alternatives for those particular viewers who will use the Web browsers that display your Web pages as you did not intend. Remember that accessibility is key in publishing your Web pages on the Web.

WHAT CAN YOU DO WITH JAVASCRIPT?

ON THE CD

With JavaScript, you can add interactivity to your Web pages with image buttons, text fields from forms, and other Web page elements such as animated text. JavaScript is most commonly noted for the "neat" effects, such as mouse rollovers that are used typically for navigational buttons, and fun games to entertain your users. More advanced JavaScript programming can create games as shown in Figure 9.3, which is an example of a JavaScript game found in the CD-ROM *JavaScript CD Cookbook, Third Edition* by Erica Sadun and Brook Monroe.

DISADVANTAGE OF USING JAVASCRIPT

Besides the fact that there may be some incompatibilities among Web browsers, another problem in using JavaScript is that viewers can see your scripts. Given that JavaScript is embedded directly into your HTML documents, viewers can view your source and copy and paste your JavaScript code onto their Web pages (see Figure 9.2). For that reason, Java Script should not be used for Web sites that require a sense of security. Doing so will compromise any passwords and server file locations you might be using within your Web pages.

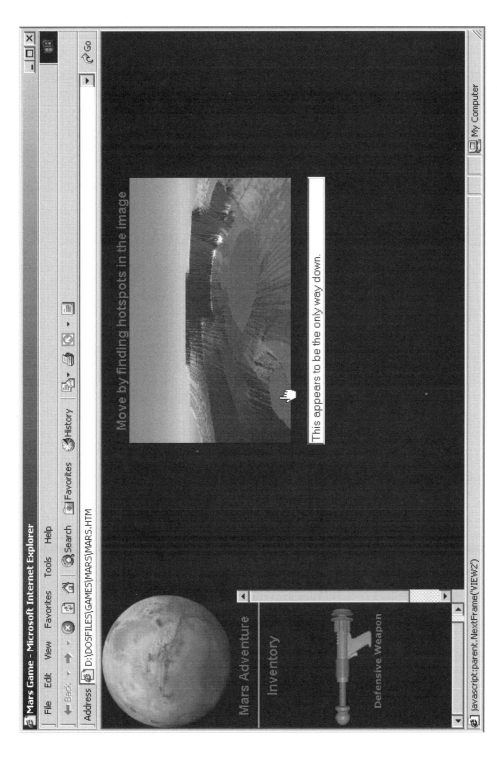

FIGURE 9.3 A JavaScript game found in the *JavaScript CD Cookbook, Third Edition.* (© 2001. Charles River Media. All rights reserved.)

HOW DO I GET A SCRIPT ALREADY CREATED?

You can find thousands of free scripts on the Web. Because JavaScript is a part of the HTML document, you can literally "copy and paste" a JavaScript program from another Web page onto your own Web page. Of course, getting permission to do so from the actual author of that Web page should be your first action. Many JavaScript programmers make their script available for the taking as long as you provide credit for them in the HTML code, and possibly a link back to their Web site.

FINDING SCRIPTS

There is an abundance of Web sites that allow you to use their scripts for free. Some of these Web sites may require a subscription. Here is a short list of some the Web sites that offer scripts for free:

www.javascript.com
www.javascripts.com
http://webdeveloper.earthweb.com/pagedev/webjs
www.jsworld.com/

INSERTING A JAVASCRIPT ON YOUR WEB PAGE

Inserting a JavaScript on your Web site is quite simple, provided that the author supplied instructions. You will need to access the source code of the HTML document, locate the code, and then copy and paste. Figure 9.4 shows a Web page with a script created by JavaScript that scrolls text that reads "Your Message Here" from right to left in the status bar of the window.

ON THE CD

To access the JavaScript code that creates the scrolling text, you have to view the source file of the HTML document. In this case, the HTML document is in the *JavaScript CD Cookbook*, *Third Edition*, and the author had provided a link to the source code as shown in Figure 9.5. How convenient!

When the View Source link is clicked in the left pane, the HTML source file displays in the main pane. You can then select the JavaScript

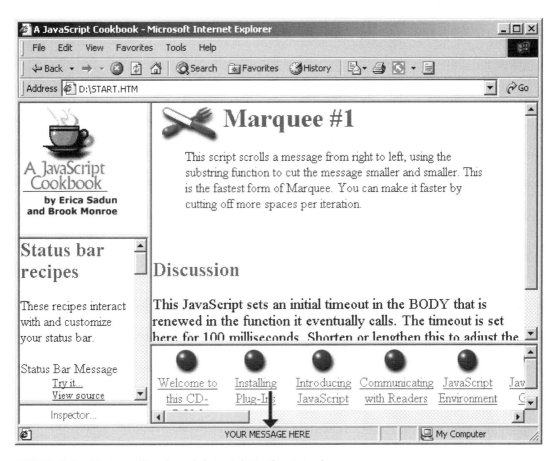

FIGURE 9.4 Text scrolling from left to right in the status bar.

code with your mouse, and then select your Copy command as shown in Figure 9.6.

HINT

When accessing scripts on the Web, the author might provide a link to the code for you to just then copy and paste over. However, there may be cases in which you will actually have to use the VIEW>SOURCE command on your Web browser, and copy and paste the code from the HTML source file that appears.

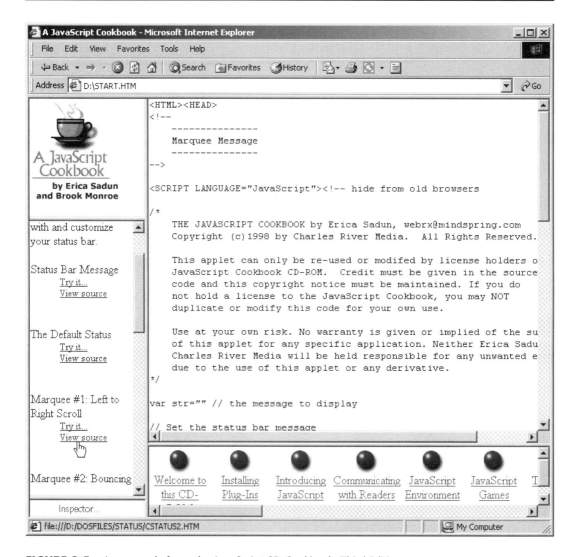

FIGURE 9.5 An example from the *JavaScript CD Cookbook, Third Edition*.

Once you have copied the JavaScript code, you can then paste the code into your own HTML source file as shown in Figure 9.7.

In order for the JavaScript code to work within your own HTML, you must retain the script's syntax and insert it in the same place as it was in the original document. For example, if a script was within the

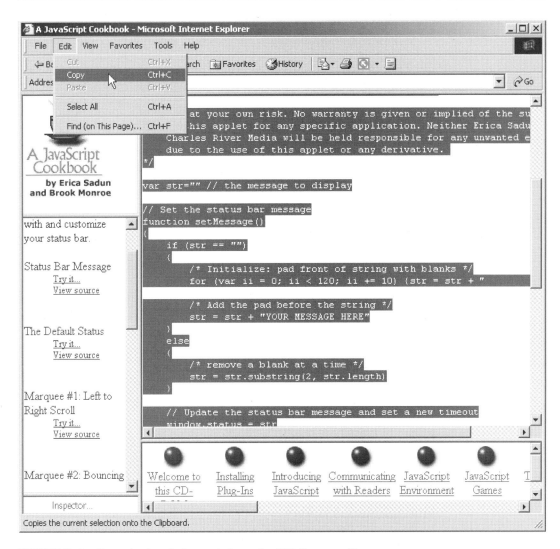

FIGURE 9.6 Copy the JavaScript code from the HTML source file.

<HEAD></HEAD> commands of the original document, then the script should be pasted in the <HEAD></HEAD> commands in your HTML source file. In Figure 9.7, the <BODY> tag had to be copy and pasted as well, since it also contained a line of JavaScript that was needed for the scrolling text to work.

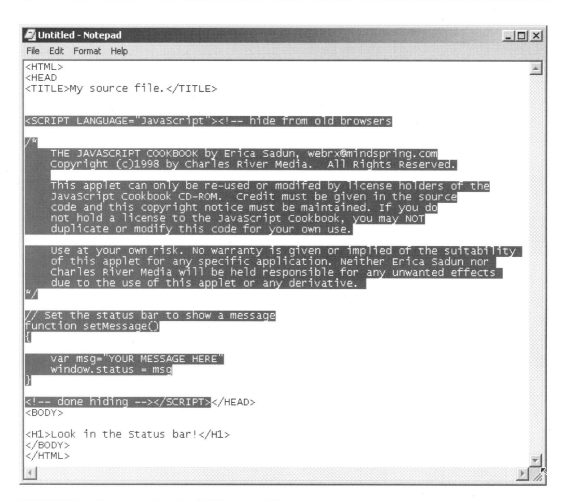

FIGURE 9.7 Paste code into the HTML source file.

Figure 9.8 shows the HTML file in Figure 9.7 displayed in the Web browser.

WRITING EASY SCRIPTS

Although we can't teach you JavaScript in this single lesson, we have included a few short, simple scripts for you to insert on your Web pages. Typing the code exactly as you see in the following examples will allow you to incorporate these simple scripts onto your Web pages.

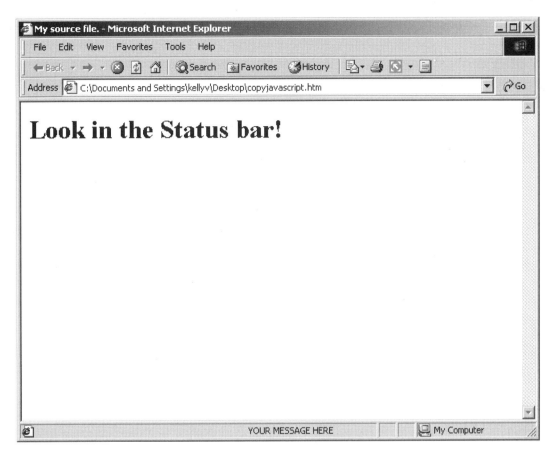

FIGURE 9.8 The HTML file displayed in a Web browser that contains the JavaScript code pasted in Figure 9.7.

STATUS BAR TEXT

You can use JavaScript to place text in the status bar. This is a popular feature used in place of the default text that goes in the status bar, which is usually the file path or URL to the HTML document. To do this, you simply write the following script:

```
<HTML>
<HEAD>
<TITLE>Staus Bar Text</TITLE>
<SCRIPT LANGUAGE="JavaScript">
        window.status = "This is my cool message in my cool
            status bar."
```

```
</SCRIPT>
</HEAD>
<BODY>
<p>A cool message is in the status bar.</p>
</BODY>
</HTML>
```

Most of the script should be familiar to you—it's HTML. However, notice after the closing </TITLE> tag that the script is a little different—that's JavaScript. The <SCRIPT LANGUAGE="JavaScript"> tells the Web browser that what follows is JavaScript. The second line window.status = "This is my cool message in my cool status bar." tells the Web browser to display the text "This is my cool message in my cool status bar." into the status bar of the window. The window is denoted first in the window.status command because it's the window that contains the status bar. The text is assigned using the "=" sign to the status bar. Figure 9.9 shows the actual Web page in a Web browser; notice the text in the status bar.

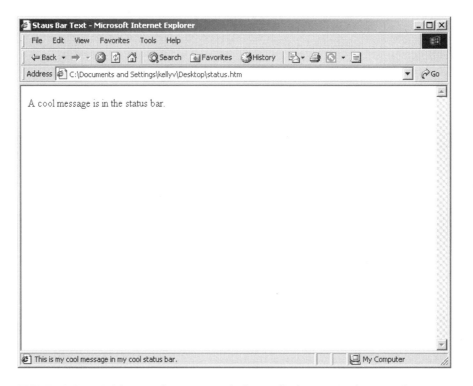

FIGURE 9.9 A Web page that uses JavaScript to display text in the status bar.

ENTERING DATE AND TIME

You can have your Web pages display the date and time when the user enters your Web page. The date and time are actually generated from the user's system clock. JavaScript captures the date and time, and then displays it on the Web page. Here is the script:

```
<html>
<head>
<title>JavaScript Date</title>
<SCRIPT LANGUAGE="JavaScript">
function date_time() {
thedate = new Date();
theday = thedate.getDate();
themonth = thedate.getMonth();
theyear = thedate.getYear();
thehour = thedate.getHours() - 12;
theminutes = thedate.getMinutes();
theseconds = thedate.getSeconds();
document.write("Today is " + themonth + "/");
document.write(theday + "/" + theyear + "<br>");
document.write("The time is " + thehour + ":" + theminutes);
}
</script>
</head>
<body>
<script language="javascript">
date_time()
</script>
</body>
</html>
```

The preceding script abstracts the date from the user's system clock, and then uses several commands to manipulate the date and to get the day, month, year, and time from the system clock. The document.write statements then use the commands in combination with text to display the message on the Web page as shown in Figure 9.10.

ON THE CD

You can write this code just as you see it in your HTML source file, or copy and paste the script from the DATETIME.HTML from the STUDENTFILES folder located on the CD-ROM.

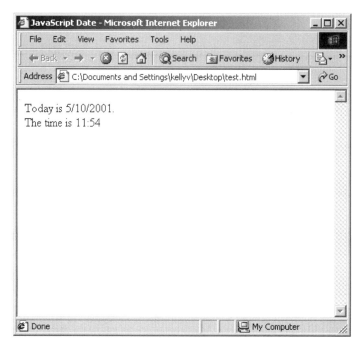

FIGURE 9.10 JavaScript can display the date and time on a Web page.

LEARNING MORE ABOUT JAVASCRIPT

There is an abundance of online JavaScript tutorials. The *JavaScript CD Cookbook, Third Edition* offers many JavaScript games, calculators, and animated text. In addition to offering a library of scripts, the book offers tutorials to teach you JavaScript.

What follows is a list of Web sites dedicated to JavaScript. Some of them offer free scripts, some offer tutorials, and some offer both.

- www.htmlgoodies.com
 HTMLgoodies.com offers a 30-step primer to learning JavaScript, and some interesting scripts you can have for free.
- www.javascript.com
 Offers help with complex scripts, and other resources.
- www.javascripts.com
 This is a huge site that offers free JavaScripts, tutorials, and resources for Web page developers.

- www.devhead.com

 The Web developers' one-stop shop online. This site has everything, including free JavaScripts.

- www.netscape.com

 The developers of JavaScript.

- www.wdvl.com

 An awesome resource for Web authors on JavaScript.

- www.coolarchive.com/buttons.cfm

 A Web site that allows you to create your own rollover buttons as shown in Figure 9.11.

FIGURE 9.11 © 2001. Coolarchive.com. All rights reserved.

ACTIVITY

1. Start your Web browser application and load the Web page statusbar.html from the studentfiles folder located on the CD-ROM.
2. Start Composer, and display default.html from your miami_ gamester folder.
3. Switch back to statusbar.html in the Web browser, and select the View>Source command from the menu bar. The statusbar source file will appear in a text editor.
4. Select the JavaScript code from the statusbar.html source file as shown in Figure 9.12.

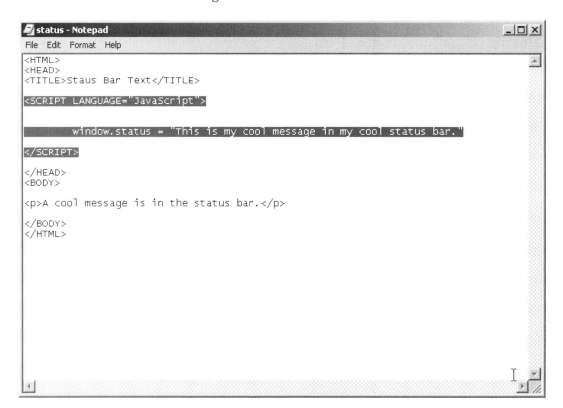

FIGURE 9.12 Select the JavaScript code in statusbar.html.

5. Select Edit>Copy to copy the code to the Clipboard.
6. Switch back to Composer to display default.html.

7. Place your cursor just under the "<title>Miami Gamester</title>" line as shown in Figure 9.13.

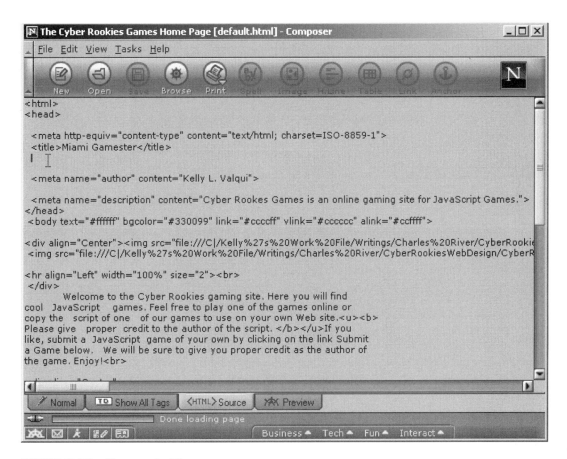

FIGURE 9.13 Placement of the cursor.

8. Click Edit>Paste from the menu bar. The code will paste in the HTML source of default.html

9. Swap the text "This is my cool message in my cool status bar." with "Welcome to Miami Gamester's Web Site!!!"

10. Save your changes, and click Browse from the Composition toolbar. The text will appear in the status bar as shown in Figure 9.14.

FIGURE 9.14 How the Web page should appear.

SUMMARY

- JavaScript is a scripting language used to create interactive Web pages.
- JavaScript is not HTML or Java programming.
- There are syntax rules when writing JavaScript, such as case sensitivity and white space.
- JavaScript must run on JavaScript-enabled Web browsers.
- You can copy and paste JavaScript by selecting the code from one HTML source and pasting it to another HTML file.

Webmaster
Tools

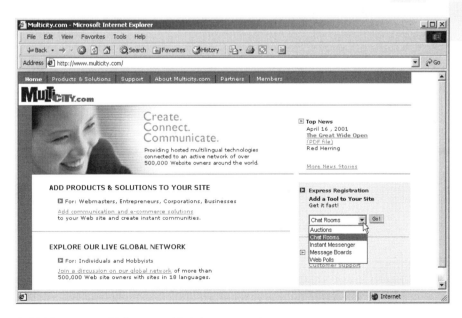

IN THIS CHAPTER

- What Are Webmaster Tools?
- Where Can I Find Webmaster Tools?
- Chat Rooms
- Message Boards
- Instant Messenger
- Sound Files

WHAT ARE WEBMASTER TOOLS?

Webmaster tools are all the cool gadgets that you can integrate in your Web pages, such as chat rooms, instant messenger, message boards, and Web polls. Typically, if you wanted to create these tools yourself, you would have to know advanced programming languages such as Java or C.

WHERE CAN I FIND WEBMASTER TOOLS?

Luckily, there are places on the Web that offer Webmaster tools for free. Once such place is Multicity.com. Founded in 1999, Multicity.com, Inc. is

an application service provider (ASP) of hosted multilingual communications and e-commerce solutions. Available in up to 17 languages, Multicity .com offers a diverse array of products that Webmasters can seamlessly integrate into their public Web sites.

In this chapter, we will show you how to integrate Multicity.com's awesome Webmaster tools. Let's start by logging on to `www.multicity .com`. Figure 10.1 shows Multicity.com's home page.

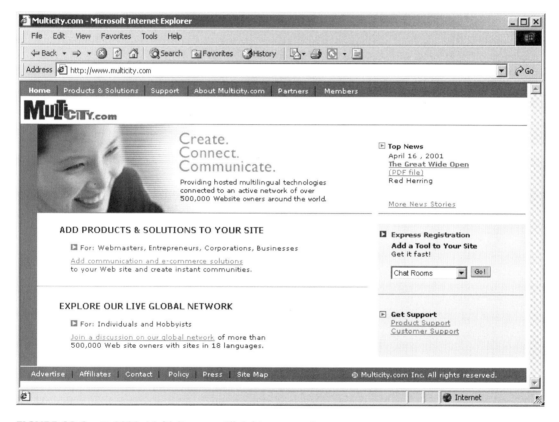

FIGURE 10.1 © 2001. Multicity.com. All rights reserved.

CHAT ROOMS

Even a newbie on the Web knows what a chat room is, and how to find one. Chat rooms are the best way for your viewers to log on and commu-

nicate with each other—and it's an excellent tool for getting your visitors back to your site.

Multicity.com offers free chat rooms for you to customize and use within your own Web site.

To get a free chat room from Multicity.com, select Chat Rooms and then click Go from the home page as shown in Figure 10.2.

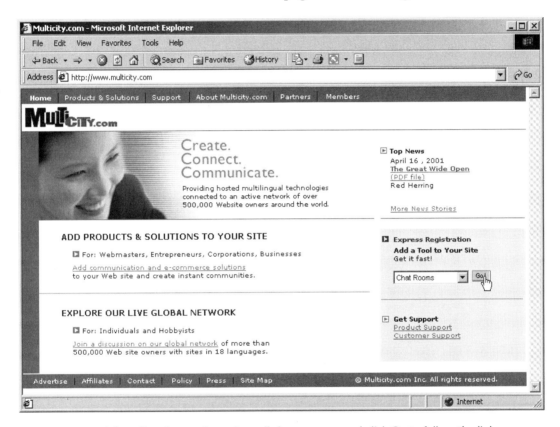

FIGURE 10.2 Select Chat Rooms from the pull-down menu, and click Go to follow the link.

If you are a new visitor to Multicity.com, you will be required to register with the site. When you click the link to access the chat room tool, you will be taken to a form page. In order to get the free chat room, you will be required to provide your personal information. On the same page, you will have a choice of what custom colors and fonts you would like to use for your chat room. At the bottom of the form, you will have a choice of

the types of chat rooms you want to place on your Web page. The top choice is the Basic Package, which is free. Figure 10.3 shows an example of the completed form.

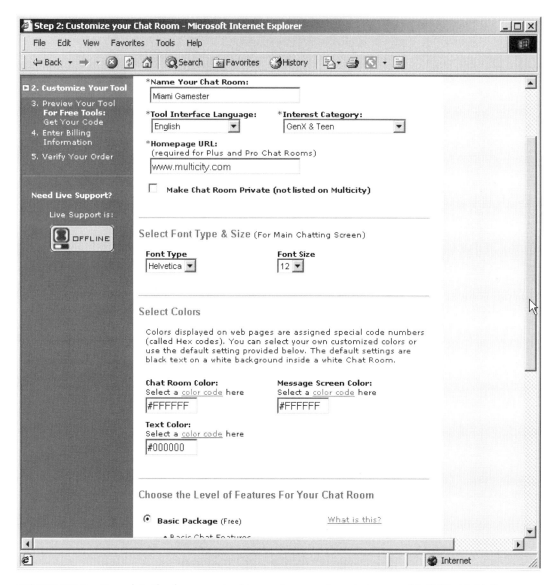

FIGURE 10.3 Complete the form required to receive your free chat room. (© 2001. Multicity.com. All rights reserved.)

Once you have completed the form, click the Go to Step 3 button at the bottom of the Web page as shown in Figure 10.4.

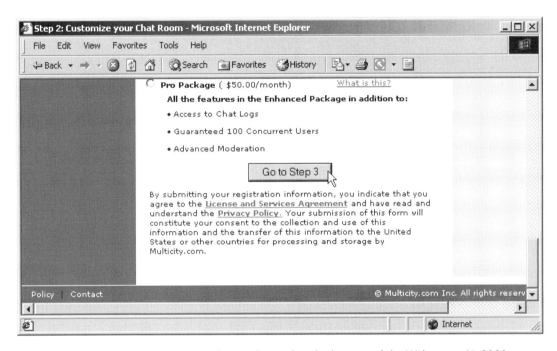

FIGURE 10.4 Click the Go to Step 3 button located at the bottom of the Web page. (© 2001. Multicity.com. All rights reserved.)

The next Web page will display your code to paste on your Web pages that will run the chat room as shown in Figure 10.5. The chat room was developed using the Java programming language. The actual chat room resides on Multicity.com's application servers. The code available for you to copy and paste in your Web pages will call on the chat room from Multicity.com's server. This is convenient, because there is no program to download or install on your own server.

To view the chat room before you copy and paste the code onto your Web page, click the "Preview your Chat Room in a new window" link as shown in Figure 10.6.

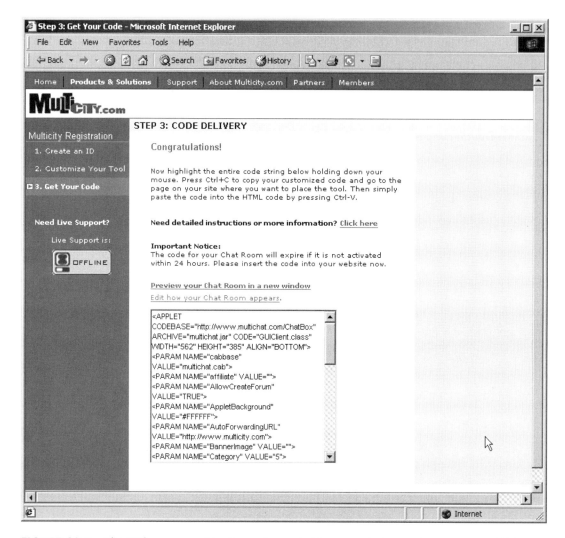

FIGURE 10.5 The Web page provides the code needed for your chat room to run on your Web page. (© 2001. Multicity.com. All rights reserved.)

The example of the chat room will display in another window as shown in Figure 10.7.

As you can see, the chat room is rather robust for a product that is free. If you are satisfied with the colors and fonts, close the window that dis-

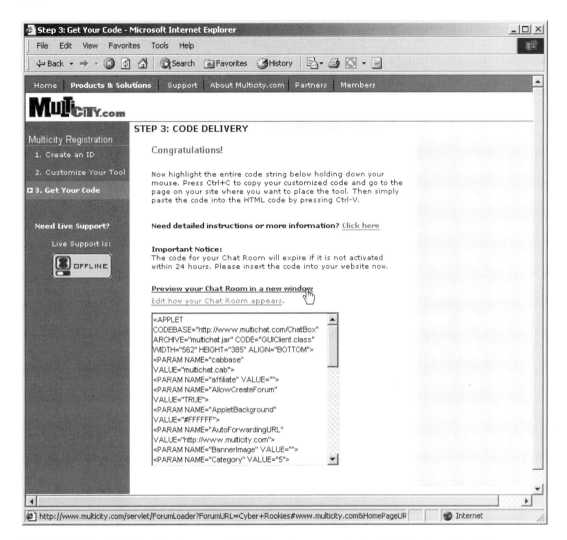

FIGURE 10.6 Click the "Preview your Chat Room in a new window" link to view the chat room.

plays the chat room so that you can copy the code as shown in Figure 10.8 to place within your own Web page.

Select the code from inside the text area box on Multicity.com's Web page. Click the Edit>Copy command from the menu bar to place the code

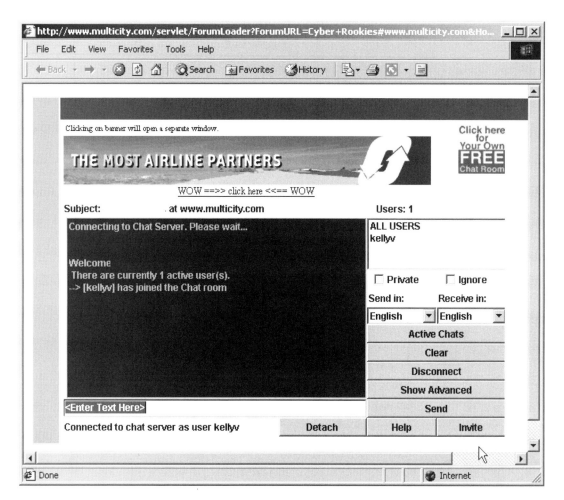

FIGURE 10.7 An example of the free chat room. (© 2001. Multicity.com. All rights reserved.)

on your clipboard. Open the source file from your computer in which you want to place the chat room. Paste the code in the HTML source file where you would like the chat room to display. Figure 10.9 shows an example of an HTML file opened in Notepad with the code pasted.

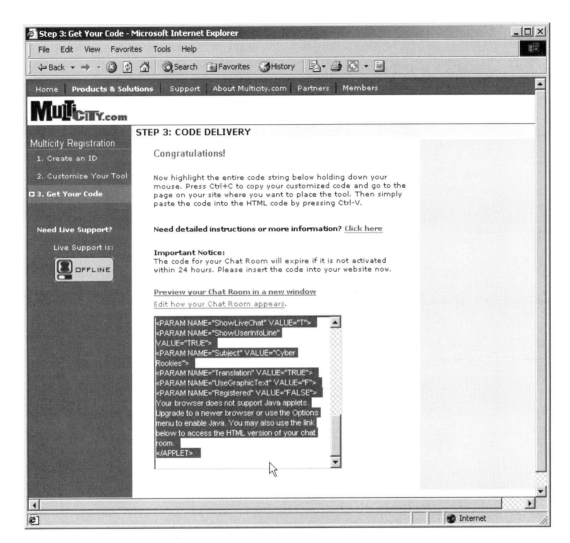

FIGURE 10.8 Copy the code for the chat room to insert in your own Web page. (© 2001. Multicity.com. All rights reserved.)

Figure 10.10 shows the HTML file in Figure 10.9 displayed in the Web browser. The page that displays in the user sign in; once you log in, you can begin chatting. You can log in as a guest (see Figure 10.10). Once logged in, you will be at the chat area as shown in Figure 10.11.

```
chat - Notepad
File  Edit  Format  Help

<html>
<head>
<title>       Miami Gamester        </title>
</head>

<body>

<h1>    Welcome to Miami Gamester's Chat Room     </h1>

<p align="center">
<APPLET CODEBASE="http://www.multichat.com/ChatBox" ARCHIVE="multichat.jar" CODE="GUI
<PARAM NAME="cabbase" VALUE="multichat.cab">
<PARAM NAME="affiliate" VALUE="">
<PARAM NAME="AllowCreateForum" VALUE="TRUE">
<PARAM NAME="AppletBackground" VALUE="#FFFFFF">
<PARAM NAME="AutoForwardingURL" VALUE="http://www.multicity.com">
<PARAM NAME="BannerImage" VALUE="">
<PARAM NAME="Category" VALUE="5">
<PARAM NAME="ChatAreaBackground" VALUE="#FFFFFF">
<PARAM NAME="ChatAreaForeground" VALUE="#000000">
<PARAM NAME="Description" VALUE="">
<PARAM NAME="Domain" VALUE="0">
<PARAM NAME="FontName" VALUE="Helvetica">
<PARAM NAME="FontSize" VALUE="12">
<PARAM NAME="HelpURL" VALUE="http://www.multicity.com/support/chat/index.htm">
<PARAM NAME="hidepassword" VALUE="FALSE">
<PARAM NAME="HomepageURL" VALUE="www.multicity.com">
<PARAM NAME="Language" VALUE="EN">
<PARAM NAME="LocatorEnabled" VALUE="TRUE">
<PARAM NAME="ShowLiveChat" VALUE="T">
<PARAM NAME="ShowUserInfoLine" VALUE="TRUE">
<PARAM NAME="Subject" VALUE="Cyber Rookies">
<PARAM NAME="Translation" VALUE="TRUE">
<PARAM NAME="UseGraphicText" VALUE="F">
<PARAM NAME="Registered" VALUE="FALSE">
Your browser does not support Java applets. Upgrade to a newer browser or use the Opt
</APPLET>
```

FIGURE 10.9 The pasted code.

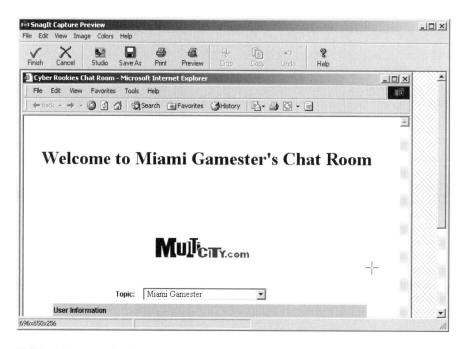

FIGURE 10.10 The login screen.

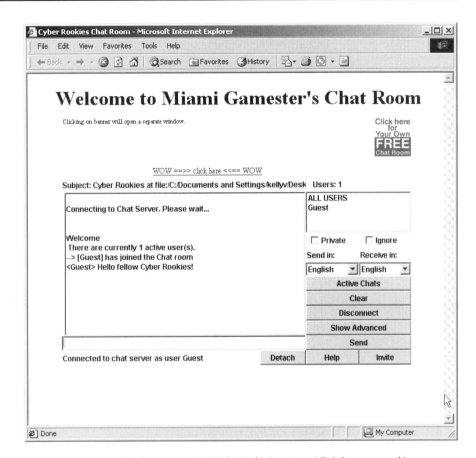

FIGURE 10.11 The chat area. (© 2001. Multicity.com. All rights reserved.)

Once you've inserted and tested the Web page in which you integrated the chat room, you can go ahead and customize the design of the Web page as long as you do not disturb the code from Multicity.com that you pasted into your Web page.

INSTANT MESSENGER

Instant messaging allows visitors to your Web site to quickly exchange messages with their online colleagues and friends. Unlike e-mail, instant messages appear in real time.

Multicity.com offers free instant messaging for your Web site. Just as you did for your chat room, you can log on to Multicity.com, and select Instant

Messenger from the same pull-down menu that you used for the chat room (see Figure 10.2). You may have to return to the home page, or click Products and Solutions in the navigation bar at the top of the Web page.

Once you select Instant Messaging, you will be sent to a Web page with a form similar to the one you filled out for the chat room. When the form is complete, click the Generate Instant Messenger button at the bottom of the page.

The next page displays the code that will be placed in your Web page to enable instant messaging from your Web site. Figure 10.12 shows the

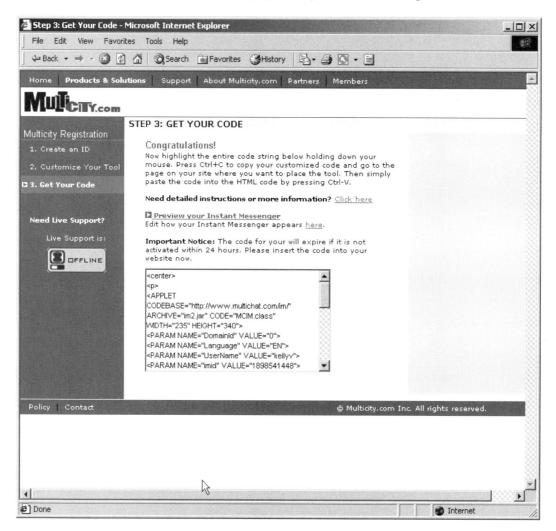

FIGURE 10.12 The Web page that displays the code for you to copy and paste into your Web page. (© 2001. Multicity.com. All rights reserved.)

Web page that displays the code for you to copy and paste. Figure 10.13 shows the generated Instant Messenger.

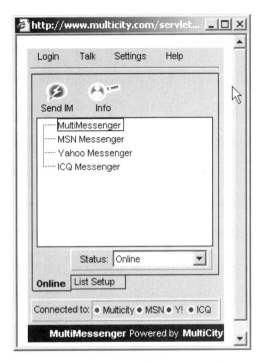

FIGURE 10.13 A preview of your Instant Messenger.
(© 2001. Multicity.com. All rights reserved.)

MESSAGE BOARDS

A message board is a tool used to post messages about a particular topic. All postings and responses are permanently visible on the message board until the moderator removes them.

Multicity.com also offers a free message board. Just as you did for your chat room and Instant Messenger, you can log on to Multicity.com, and select Message Board from the same pull-down menu that you used for the chat room and Instant Messenger (see Figure 10.14). You may have to return to the home page, or click Products and Solutions in the navigation bar at the top of the Web page.

Once you select Message Board, you will be sent to a Web page with a form similar to the one you filled out for the chat room and your Instant

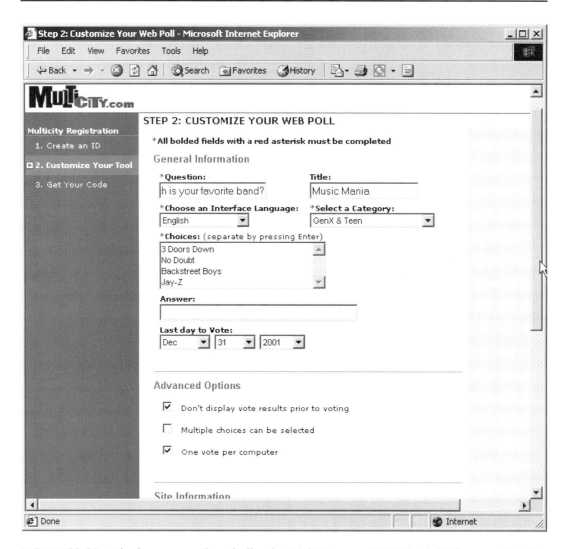

FIGURE 10.14 The free message board offered at Multicity.com. (© 2001. MultiCity.com. All rights reserved.)

Messenger. When you have filled out the form, shown in Figure 10.15, click the Generate Message Board button at the bottom of the page.

Once you click the Generate Message Board button you will receive the code for your own personal message board (see Figure 10.16).

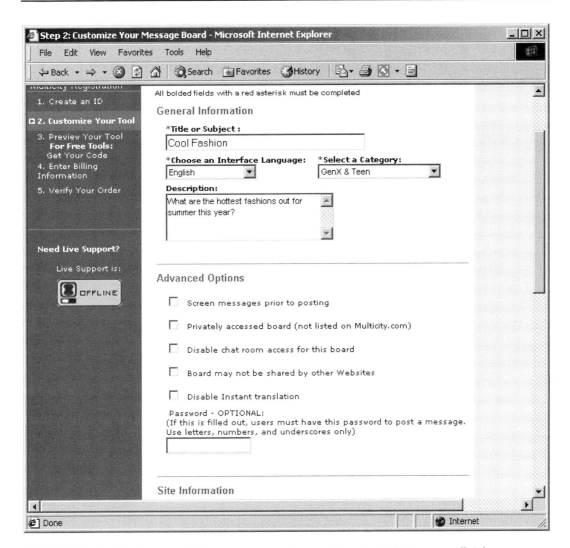

FIGURE 10.15 The form to obtain your message board. (© 2001. Multicity.com. All rights reserved.)

Before you copy and paste the code for the message board, you can preview it by clicking the "Click here to preview your Message Board" link. This is important in case the colors or design you chose do not look as good as you thought they would when customizing your message board. The preview for the example message board is shown in Figure 10.17.

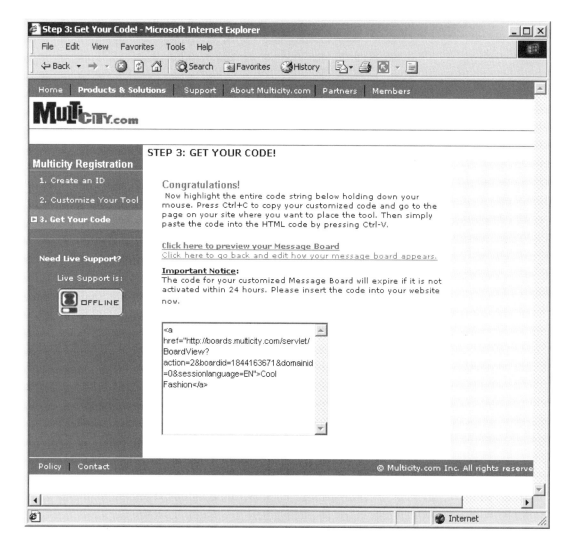

FIGURE 10.16 Your message board code. (© 2001. Multicity.com. All rights reserved.)

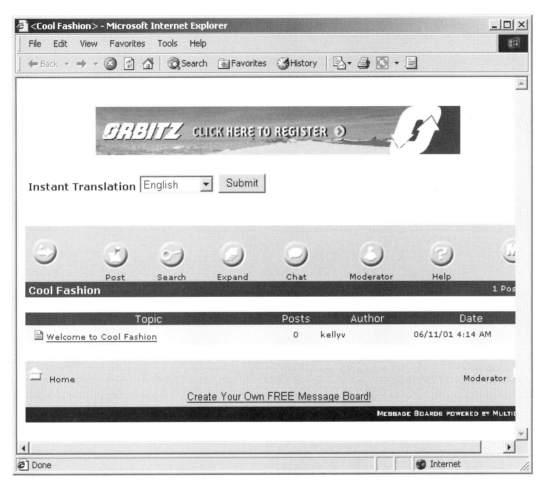

FIGURE 10.17 A preview of the message board. (© 2001. Multicity.com. All rights reserved.)

SOUND FILES

A popular type of multimedia found on the Web is sound. Have you ever logged on to a Web site and a song began to play? All you need is a computer equipped with a sound card, and a few *plug-ins* to enjoy audio files found on the Web. Plug-in applications are programs that can be easily installed and used as part of your Web browser.

THE MIDI FILE

MIDI is an acronym for Musical Instrument Digital Interface. What that means is that the computer generates the music using your sound card. It's almost as if someone plugged a piano into your computer and the computer played it. The MIDI file "plays" the sound card. For example, when the MIDI file plays, it tells the computer what note to produce and how long to play it. The type of sound card you have determines how the MIDI sounds. Higher-level sound cards can produce music as clear as an instrument. However, a lower-level sound card produces lower-quality music, almost like a "twanging" electrical keyboard.

OTHER SOUND FILE FORMATS

There are several different sound file formats available on the Web. One popular file format worth mentioning is the WAVE (.wav) file. A WAVE file stores a digital audio waveform, and is usually "heavier" in size. The new MP3 is a more compact and "lighter" size, and is becoming increasingly popular on the Web. However, MIDI files are much smaller than other audio files. The compact size of MIDI files makes them especially well suited for delivery over the Internet. A one-minute MIDI file might require about 10MB of disk space. Compare this to a .wav file of the same duration, which might require from 5MB to 10MB of disk space, depending on the audio qualities of the file.

DOWNLOADING SOUND FILES FROM THE WEB

You can find places on the Web that allow you to download MIDI files for your Web pages for free. One such place is `www.midi-network.com` shown in Figure 10.18. You can log on to `www.midi-network.com` and listen to or download MIDI files.

To download a MIDI file, right-click on the file link and select the Save Target As from the contextual menu. From the `www.midi-network.com`, we see a tool that shows you how to download the MIDI file as shown in Figure 10.19. The contextual menu appears in Figure 10.20.

For the activity in this chapter, we have placed a MIDI file called 3doorsdown_kryptonite in the **studentfiles** folder on the CD-ROM in the back of the book. (© 2001. Midi-Network.com. All rights reserved.)

ON THE CD

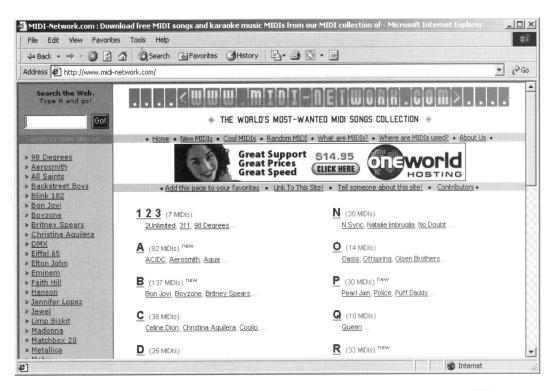

FIGURE 10.18 You can listen to or download files from www.midi-network.com. (© 2001. Midi-Network.com. All rights reserved.)

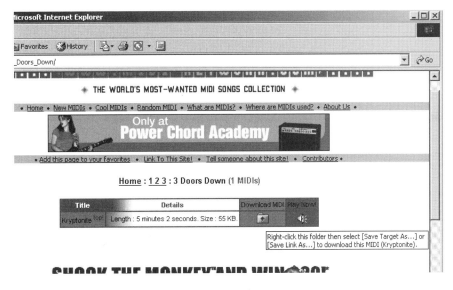

FIGURE 10.19 Midi-Network shows you how to download the MIDI file. (© 2001. Midi-Network.com. All rights reserved.)

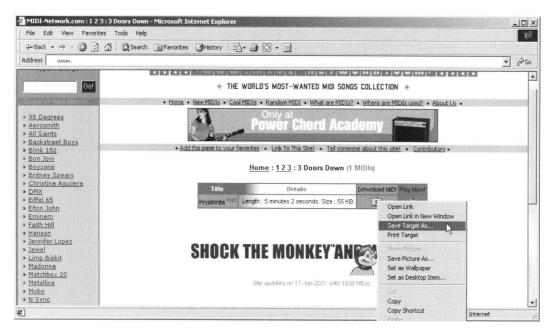

FIGURE 10.20 Contextual menu.

INSERTING SOUND FILES ON A WEB PAGE

You can also insert a music file on a Web page in the foreground where the viewer actually controls the sound file with a *console*. A console is a menu that controls a sound file. Figure 10.21 shows an example of a sound file console.

HINT

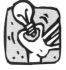

You must make sure that the Web server that you are hosting your Web site on has the correct MIDI "mime types." Contact your Webmaster to see if you're able to host sound files on your Web server.

FIGURE 10.21 An example of the console for a MIDI file.

EMBEDDING MIDIS

Sound files can be inserted on a Web page by using the EMBED tag. Here is the format for inserting a MIDI file on a Web page:

```
<EMBED src   = "filename.mid"
       width  = 200
       height = 60
       loop   = FALSE
       align  = right>
```

The EMBED portion of the syntax tells the Web browser to embed the SRC. SRC then refers to the file name of the audio file. The attribute width and height tells the Web browser the size of the console in pixels. A console is an element that allows the viewer to control the sound file. The loop attribute denotes whether to replay the sound file. The "false" value will not replay the sound over and over again; opposite to "false" is the value "true". The align attribute places the console relative to text on a Web page, much the same way you learned to align images.

ACTIVITY

In this activity, you will insert a MIDI file into a Web page.

1. Create the folder CHAPTER10 in the cyberookies_exercises folder.
2. Copy the file 3doorsdown_kryptonite.mid in the CHAPTER10 folder.
3. Start your text editor.
4. Type the following code:

```
<HTML>
<HEAD>
<TITLE>Sound Files</TITLE>
</HEAD>
<BODY>
<center>
<H1>3 Doors Down - Kryptonite</h1>
<embed src="3doorsdown_kryptonite.mid" width="200"
height="100" loop="FALSE">
</CENTER>
</BODY>
</HTML>
```

5. Save the file as sound.htm in the CHAPTER10 folder.

ON THE CD

6. Open the Web page in your Web browser. The MIDI file console should appear as shown in Figure 10.22 and begin playing. You can control the sound file by clicking the Stop, Play, and Rewind buttons on the console.

FIGURE 10.22 The MIDI file console.

SUMMARY
• • • • • • • • •

- There is an array of Webmaster tools on the Web, such as chat rooms and message boards.
- Multicity.com is an excellent source for robust Webmaster tools.
- Multicity.com can be found on the Web at www.multicity.com.

11

Getting People to Find You

IN THIS CHAPTER
- What Are Search Engines?
- Defining Search Engines and Directories
- Understanding How Search Engines Work
- How to Use HTML Meta Tags
- Getting Your Site to Rank High in a Search Engine
- Registering Your Web Site with Search Engines

WHAT ARE SEARCH ENGINES?

Search engines are one of the primary ways that Internet users find Web sites. A Web site with a good search engine listing will attract a large amount of viewers. Unfortunately, many Web sites appear low in search engine rankings or may not be listed at all because the developers are not aware of how search engines work.

HINT

Understanding how search engines work can increase the chances of your Web site ranking high in search engine results page.

Often, Web site owners try to find ways to trick search engines to place their Web site in high-ranking status. There are no "search engine secrets" that will guarantee a top listing. However, there are a number of techniques you can use that can sometimes produce big results, such as the efficient use of meta tags. In this chapter, you will learn some search engine registration techniques that will increase the number of hits your Web site receives.

DEFINING SEARCH ENGINES AND DIRECTORIES

The term *search engine* is often used to describe both search engines and directories. However, they are not the same. AltaVista, shown in Figure 11.1,

FIGURE 11.1 AltaVista, a popular search engine found on the Web. (© 2001. AltaVista.com. All rights reserved.)

is a popular search engine that does not use humans to index Web pages. Instead, AltaVista, like other search engines, crawls the Web reading the HTML files and then indexing the Web pages automatically. The way you design your Web pages can affect how you are listed. Web page titles, body content, and other Web page elements all play a role.

Directories such as Yahoo!, shown in Figure 11.2, depend on humans for its listings. You submit a short description to the directory for your entire site, or directory editors write one for sites they review. Your Web page text has no effect on your listing.

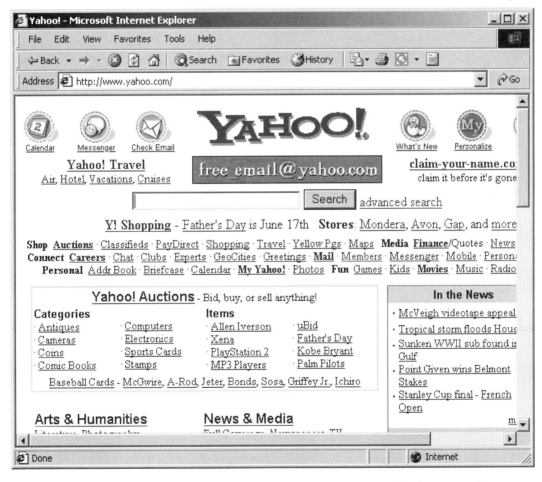

FIGURE 11.2 Yahoo!, a popular online directory. (© 2001. Yahoo.com. All rights reserved.)

Methods for improving a listing with a search engine are useless when dealing with directories. The only exception is how your site is graded by a directory editor. If your site is good, with good content, your site will more likely be indexed (added). Remember, a human is grading and indexing your Web site.

UNDERSTANDING HOW SEARCH ENGINES WORK

Search engines are comprised of three major elements. The first is the spider (sometimes referred to as a crawler). The spider visits a Web page, reads it, and then follows links to other pages within the site. This is what it means when someone refers to a site being "spidered." The spider returns to the site on a regular basis, and updates any changes.

Everything the spider reads is delivered to the second part of a search engine, the index. The index is like a database containing a duplicate of every Web page that the spider reads.

Search engine software is the third element of a search engine. This software examines millions of pages that were recorded in the index to find matches to a search criterion conducted by a viewer, and ranks the Web pages in order of importance.

HOW TO USE HTML META TAGS

Meta tags provide a useful way to help increase your ranking to the top of the list in some search engines. This is accomplished by providing keywords and descriptions on pages that might lack text, such as splash and frames pages.

HINT

Meta tags do not guarantee that your pages will rank at the top of every search engine results listing.

There are several types of meta tags, and they are an important HTML element for search engine submission. The meta tag uses the NAME at-

tribute to define the type of meta tag being used. There are several values for the META NAME tag/attribute pair, but the two most important ones concerning search engines are the *description* and *keywords* tags. Here is an example of how meta tags can be used to insert extra keywords and a description about a Web page.

```
<HTML>
<HEAD>
<TITLE>Example of a Web page using META tags.</TITLE>
<META NAME="description" CONTENT="Learn how to use META tags to
increase your chances of high ranking in a search engine results
    pages.">
<META NAME="keywords" CONTENT="example, meta, tags">
</HEAD>
```

HINT

WebPromote's META-Tag Generator is a useful tool that helps you generate meta tags for your Web site. You can find it at http://METAtag.Webpromote.com.

The <META NAME="description"> tag allows you to control the description that will appear in the search engine results page. The META keywords tag gives your page a chance to come up if someone types in any of the words listed. For example, someone might enter "meta" "tags," which will match with one of the keywords in the tag.

Remember, you are using these tags to help make up for the lack of text on your pages, not as a way to guess every keyword variation a person might enter into a search engine. The only hope you have of doing that is to have good, descriptive pages with good titles and text that are not buried on the bottom of the page by JavaScript, frames tags, or tables.

GETTING YOUR SITE TO RANK HIGH IN A SEARCH ENGINE

A search engine query often turns up hundreds or thousands of matching Web pages. In most cases, only the 10 most "pertinent" matches are displayed first. Typically, out of the hundreds of listings provided, only 30 are reviewed by the user. This means that if your Web site in not listed

in the first 30 listings, you will most likely not be visited. However, what follows are some techniques that can improve your chances of a higher rank.

PICK YOUR STRATEGIC KEYWORDS

How do you think people will search for your Web page? The words you imagine them typing into the search box are your strategic keywords. These keywords reflect the content of your Web pages.

Your keywords should always be at least two or more words. Usually, too many sites will be relevant for a single word, such as "dogs." This "competition" means that your odds of success are lower. Don't waste your time fighting the odds. Pick phrases of two or more words, and you'll have a chance at success.

POSITION YOUR KEYWORDS

Make sure your strategic keywords appear in the crucial locations on your Web pages. The page title is most important. Failure to put tactical keywords in the page title is a main reason why entirely relevant Web pages may be poorly ranked.

Use your keywords for your page headline, if possible. Have them also appear in the first paragraphs of your Web page.

Search engines read your Web pages from top to bottom. With this said, keep in mind that tables can "push" your text further down the page, making keywords less relevant because they appear lower on the page. This is because tables break apart when search engines read them.

Large sections of JavaScript can also have the same effect as tables. The search engine reads this information first, which causes the body text to appear lower on the page to the search engine. Place your script further down on the page, if possible. Using meta tags can also help.

HAVE RELEVANT CONTENT

Changing your page titles and adding meta tags is not necessarily going to help your page do well if your page has nothing to do with the topic. Your keywords need to reflect the contents of your page.

Some designers try to spam search engines by repeating keywords in the same color as the background color to make the text invisible to browsers. Search engines are catching on to these tricks. You can expect that if the text is not visible in a browser, it will not be indexed by a search engine.

Spamming doesn't always work with search engines. In addition, search engines may detect your spamming attempt and penalize or ban your page from their listings.

Search engine spamming attempts usually center around being top ranked for extremely popular keywords. You can try and fight that battle against other sites, but then be prepared to spend a lot of time each week, if not each day, defending your ranking. That effort usually would be better spent on networking and alternative forms of publicity, described next.

REGISTERING YOUR WEB SITE WITH SEARCH ENGINES

The first step in registering your Web site with search engines is to choose a search engine at which to register your Web site. Register with as many as you can find. Registering a Web site is quick and easy, so registering with 100 search engines will not take much time.

After you've chosen the search engine(s), go there and find a link called "Register your Site," "Submit a Site," or "Add URL." AltaVista's home page is shown in Figure 11.3. On the bottom left is a link called "Submit a Site." This link will send you to a page where you can choose which registration package you want for your Web site, as shown in Figure 11.4.

After choosing your registration package, click the button for that package. From there, you are sent to a page where you type your URL as shown in Figure 11.5. Again, this is an example of how to register your Web site with AltaVista; other search engines may require more information.

FIGURE 11.3 The AltaVista home page where you will find the "Submit a Site" link. (© 2001. AltaVista.com. All rights reserved.)

FIGURE 11.4 You can choose either the Basic Package, which is free, or the Express package, which carries a fee, to register your Web site. (© 2001. AltaVista.com. All rights reserved.)

FIGURE 11.5 Submit your URL to a search engine. (© 2001. AltaVista.com. All rights reserved.)

SUMMARY

- Search engines are one of the primary ways that Internet users find Web sites.
- Meta tags provide a useful way to manipulate your ranking in some search engines.
- Make sure your strategic keywords appear in the crucial areas on your Web pages.

Using the Companion CD-ROM

IN THIS CHAPTER

- HTML TemplateMASTER CD-ROM, 3rd Edition
- JavaScript CD Cookbook, 3rd Edition

HTML TEMPLATEMASTER CD-ROM, 3RD EDITION

Create your own Web pages and learn to use HTML through onscreen templates and clip art with this hybrid CD-ROM (Windows/Mac). *HTML TemplateMASTER CD-ROM, 3rd Edition* is an onscreen tutorial that covers everything you need to know to create home pages, through HTML lessons, graphics, templates, and forms. You can "cut and paste" or design your own! It is designed for HTML 4.0 and is compatible with the latest versions of MSIE and Netscape Navigator.

ON THE CD

What follows is the actual table of contents for the example figures of the *HTML TemplateMASTER CD-ROM, 3rd Edition*. You can find a complete copy of the *HTML TemplateMASTER CD-ROM* located in the folder HTML_TEMPLATE_MASTER on the CD that accompanies this book.

FIGURE 12.1 © 2001. Charles River Media. All rights reserved.

HTML 4.0 TUTORIALS

DETAILED CD-ROM DIRECTORY

This CD-ROM is full of all kinds of goodies, from evaluation software to clipart and every type of lesson to get you started developing Web pages. Locate software, clip art, and lessons using this easy-to-follow directory (Figure 12.2).

FIGURE 12.2 The directory page of the *HTML TemplateMASTER CD-ROM*.

JUMPSTART

This "can't wait to get started with something real" mini-tutorial shows you how to create an HTML Web page and use your browser to view it (Figure 12.3).

FIGURE 12.3 The *HTML TemplateMASTER CD-ROM's JumpStart* tutorial.

JUST ENOUGH HTML

From images to tables, and links to forms, these lessons will help you learn "just enough" HTML to create flexible and useful Web pages. Unlike the rest of the lessons sets on this CD, *Just Enough HTML* is packed with exercises so that you can get a "hands on" feel of HTML (Figure 12.4).

FIGURE 12.4 *Just Enough HTML.*

EXOTIC HTML

These lessons go beyond "standard" HTML to introduce slide shows, frames, low-source images, and marquees, and background sounds (Figure 12.5).

FIGURE 12.5 *Exotic HTML.*

The HTML Development Cycle

These lessons explore the HTML development cycle, focusing on how to write effective and understandable HTML. Learn how to comment, debug, and maintain your Web pages (Figure 12.6).

FIGURE 12.6 The *HTML Development Cycle.*

TECHNIQUES AND RESOURCES
WEB EDITOR REVIEWS

Information on several of the more popular Web editors used for Web page design.

WEB DESIGN RESOURCES

From online free image depots to free HTML codes, this page offers a wide variety of links to online resources in all ranks of Web development (Figure 12.7).

FIGURE 12.7 *Web Design Resources.*

GRAPHICAL TECHNIQUES

From animated GIFs to clip art to digitized images, these lessons put you on top of Web page graphical techniques (Figure 12.8).

FIGURE 12.8 *Graphical Techniques.*

PAINT SHOP PRO 6

Learn how to use this powerful, yet easy-to-learn paint program to create and animate your Web site graphics (Figure 12.9).

BANNER ADVERTISING

Find out more information about banner ads and marketing, and learn how to create your own animated banner ad using Paint Shop Pro's Animation Shop.

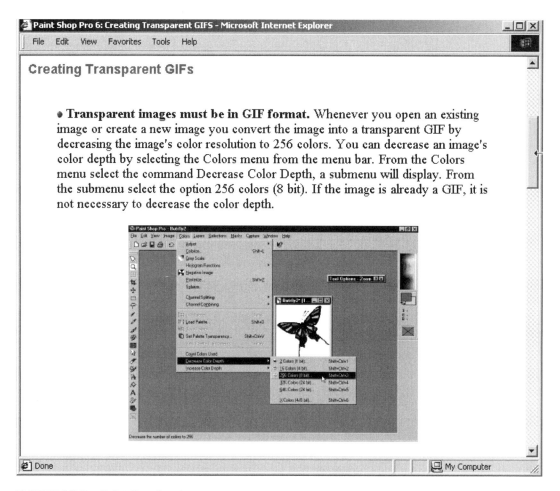

FIGURE 12.9 *Paint Shop Pro 6.*

MULTIMEDIA ON THE WEB

Find out more information about the popular Web editors used on the Web today.

ADVANCED WEB PROGRAMMING

From JavaScript to databases, find out what the more advanced Web programming can offer and where on the Web you can find it.

WEB SITE PLANNING

These lessons introduce site planning issues, raise questions, and give advice about creating plans before developing pages.

STYLE

From design philosophy to style guides, these lessons discuss the "do's and don'ts" of Web page style.

SAMPLE WEB PAGES

These samples provide a wide range of Web pages that you can adapt and use on your own pages. Stuck for an idea? Let these pages help you (Figure 12.10).

FIGURE 12.10 Sample Web Pages.

WEB PAGE THEMES

These Web page templates are a quick fix for your Web page needs. An excellent resource for the novice graphic designer (Figures 12.11 and 12.12).

FIGURE 12.11 An example page from *Web Page Themes*.

HTML TEMPLATES

These templates provide graphic design inspiration for your Web pages, suggesting various type treatments and spatial layouts to produce elegance and expression (Figures 12.13 through 12.16).

FIGURE 12.12 An example page from *Web Page Themes*.

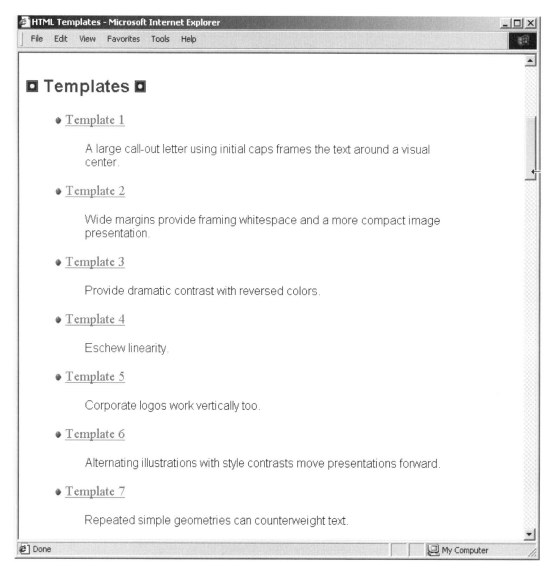

FIGURE 12.13 An HTML template from *HTML Templates*.

FIGURE 12.14 An HTML template from *HTML Templates*.

FIGURE 12.15 An HTML template from *HTML Templates*.

FIGURE 12.16 An HTML template from *HTML Templates*.

CLIP ART COLLECTION

Explore our large collection of clip art, which includes over 7MB of public domain images (Figures 12.17 through 12.29).

FIGURE 12.17 Clip art from the *Clip Art Collection*.

FIGURE 12.18 Clip art from the *Clip Art Collection*.

FIGURE 12.19 Clip art from the *Clip Art Collection*.

FIGURE 12.20 Clip art from the *Clip Art Collection*.

FIGURE 12.21 Clip art from the *Clip Art Collection.*

i4/whiteb.gif
i4/yellowb.gif
i4/d9.gif
i4/dd1.gif
i4/dd10.gif
i4/dd7.gif
i4/dd8.gif

i4/dd11.gif
i4/dd12.gif
i4/dd2.gif
i4/dd3.gif
i4/dd4.gif
i4/dd5.gif
i4/dd6.gif

FIGURE 12.22 Clip art from the *Clip Art Collection*.

FIGURE 12.23 Clip art from the *Clip Art Collection*.

FIGURE 12.24 Clip art from the *Clip Art Collection*.

FIGURE 12.25 Clip art from the *Clip Art Collection*.

FIGURE 12.26 Clip art from the *Clip Art Collection*.

FIGURE 12.27 Clip art from the *Clip Art Collection*.

FIGURE 12.28 Clip art from the *Clip Art Collection.*

FIGURE 12.29 Clip art from the *Clip Art Collection*.

WEB SITE PROMOTION

If you build it, will they come? Here are some ways you can promote your Web site.

JAVASCRIPT CD COOKBOOK, 3RD EDITION

ON THE CD

Use JavaScript the easy way, and make your Web pages come alive with this awesome book on CD. Add excitement to your site with sound, games, blinking marquees, and cool "mouse-overs." Includes over 150 "cut and paste" recipes and templates, saving you hundreds of program-

ming hours. Also provides the programming code for more advanced users and a complete JavaScript reference.

Create excitement and interest on your Web site with blinking frames, digital clocks, games, pop-up messages, and the latest plug-ins.

What follows is the table of contents of the *JavaScript CD Cookbook, 3rd Edition*, and some example images of the CD. You can find a complete copy of the *JavaScript CD Cookbook, 3rd Edition* located in the folder HTML_TEMPLATE_MASTER on the CD that accompanies this book.

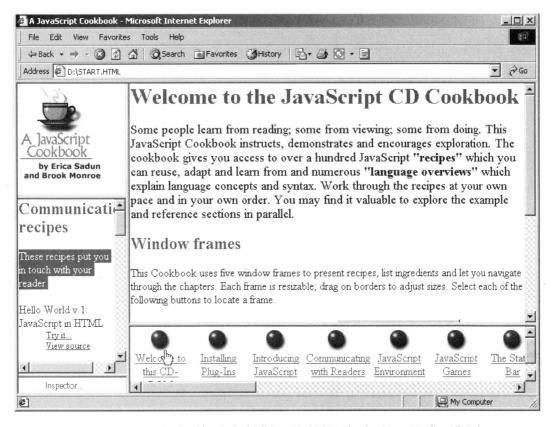

FIGURE 12.30 *JavaScript CD Cookbook, 3rd Edition.* (© 2001. Charles River Media. All rights reserved.)

INTRODUCING JAVASCRIPT

Welcome to the exciting world of JavaScript programming. Before you get started learning about JavaScript's bells and whistles, you probably

have a number of questions. This section will address common JavaScript questions.

COMMUNICATING WITH READERS

These recipes put you in touch with your reader.

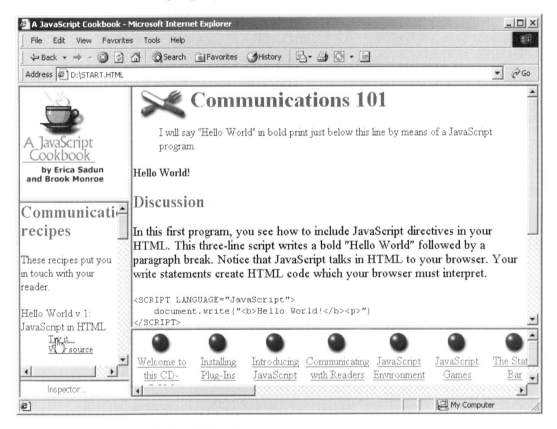

FIGURE 12.31 *Communicating with Readers.*

JAVASCRIPT ENVIRONMENT

Who am I? Where am I? These recipes show how to get a handle on the browser environment and other working details.

JAVASCRIPT GAMES

Some games to amuse and educate you. Look for new or changed items.

FIGURE 12.32 *JavaScript Games.*

THE STATUS BAR

These recipes interact with and customize your status bar.

JAVASCRIPT CLOCKS

These recipes keep you on top of the time.

JAVASCRIPT STRINGS

These recipes let you dice, slice and chop your strings. No Ginsu knives included, however. (Look for new and changed items.)

FIGURE 12.33 *JavaScript Clocks.*

JAVASCRIPT MATH

These mathematics recipes spice up your JavaScript. Look for new or changed items.

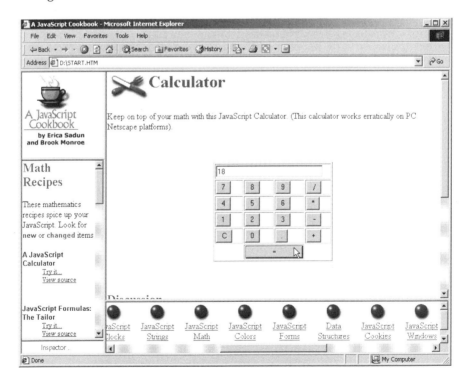

FIGURE 12.34 *JavaScript Math.*

JAVASCRIPT COLORS

These recipes handle links, anchors, and addresses.

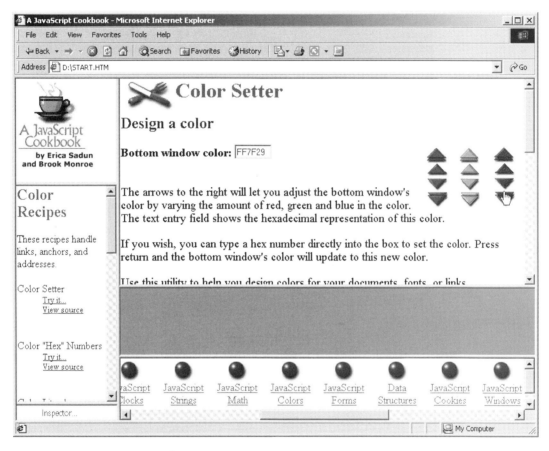

FIGURE 12.35 *JavaScript Colors.*

JAVASCRIPT FORMS

These recipes handle form input.

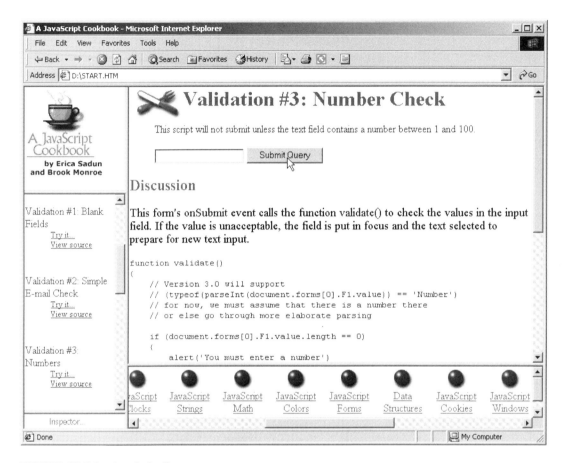

FIGURE 12.36 *JavaScript Forms.*

DATA STRUCTURES

These recipes show you how to add structured data to your JavaScript.

JAVASCRIPT COOKIES

Routines, functions, methods, and objects to help you use JavaScript cookies.

JAVASCRIPT WINDOWS

These recipes explain creating and maintaining windows.

JAVASCRIPT MULTIMEDIA

Lights! Camera! Action!

These recipes show what you can do with a little ingenuity and a few pictures and sounds.

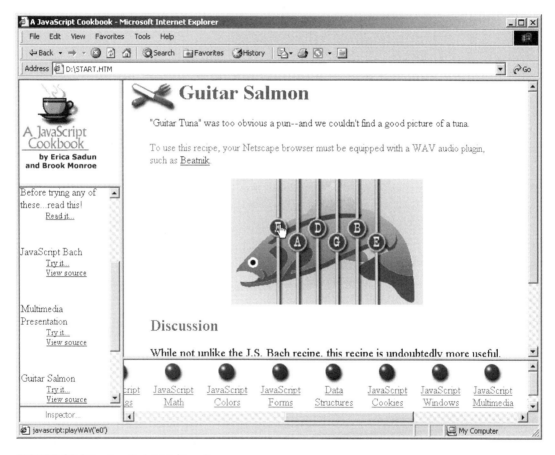

FIGURE 12.37 *JavaScript Multimedia.*

NEWER BROWSERS ONLY

These recipes feature aspects of JavaScript supported only by Netscape's and Microsoft's latest browsers. They can make your Web pages work much faster and more smoothly.

JAVASCRIPT 1.2 GOODIES

There's a lot of new keywords and functions available in JavaScript 1.2. Here are the ones we think you'll use most often. Look for new items and changed items.

Hors d'oeuvres

Tiny recipes with a lot of spice and variety.

THE FUTURE OF JAVASCRIPT/JSCRIPT

JavaScript reference.

TO START THE HTML TEMPLATEMASTER CD-ROM, 3RD EDITION

1. Insert the CD-ROM that accompanies this book into your CD drive.
2. Double-click the CD Drive icon, usually Drive D.
3. Double-click the HTML_TEMPLATE_MASTER folder.
4. Double-click the file start.htm. The *HTML TemplateMASTER CD-ROM* will open in your default Web browser.

TO START THE JAVASCRIPT CD COOKBOOK, 3RD EDITION

1. Insert the CD-ROM that accompanies this book into your CD drive.
2. Double-click the CD Drive icon, usually Drive D.
3. Double-click the JAVASCRIPT_CD_COOKBOOK folder.
4. Double-click the file start.htm. *The JavaScript CD Cookbook* will open in your default Web browser.

Career
Opportunities

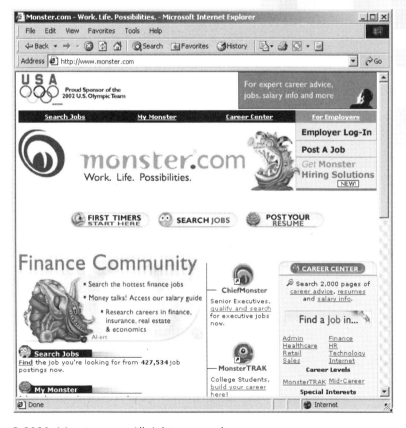

Recounting the Web's history (five years or so ago), anyone who had anything to do with the World Wide Web was assumed to be a computer scientist, researcher, engineer, or professional within the educational industry. Today, because the Internet has exploded as a mass medium, the Web has taken on a whole new set of professionals: Web developers.

Basically, a Web developer is a person who creates Web pages either as a profession or as a hobby. A Web developer who does well in producing for the Web wears many hats: a technical professional, a layout designer, an information analyst, and a creative thinker.

There can be several types of Web developers who are experts within their defined field. For example, you can have a graphic artist/multimedia specialist, HTML programmer, Java developer, database developer, information architect, and e-commerce specialist all on one team. This appendix provides some examples of the types of Web site developers, and what roles they play within their profession, to tell you how you can tap into the particular type of Web development of your interest.

TYPES OF WEB DEVELOPERS

Before we can really define some of the types of Web developers, it's important to understand the sort of person who holds an interest in the Web, and what background experience he or she might possess. For example, we know that the Web is still in its infancy; meaning that if you were to take a poll of everyone's background in the Web development industry, you will find that most of the Web developers today have specialties in many other areas except Web design. We are in an era in which Web development is so new that very few people realized that this is what they wanted to do when they grew up.

In fact, it wasn't until recently (around 1999) that many, if any, colleges or universities offered any courses in Web development. Today, you can find educational institutes offering certification, workshops, and degrees in the Web development area. Nevertheless, most Web developers you will find are self-taught professionals from other professions; very few skilled Web developers in the workplace are products of formal Web education.

HINT

If you are interested in becoming a Certified Internet Webmaster (CIW), you can find more information at www.ciwcertified.com. Becoming CIW certified gives you the recognition you need to become a professional Web developer.

THE WEB APPLICATION DEVELOPER

Let's look at the "old school" programmer for our first example. Most application developers for the Web have some type of experience in programming. Of course, this is not to say that all the programmers strictly have an interest in the application development side of the house of Web design. It is simply to point out where a seasoned programmer might be able to apply his or her knowledge to the Web industry. Rather than using the professional label "programmer," this type of Web developer might take on the label "Web application developer," or something of that nature. A Web application developer develops and deploys application-based Web content in areas of Java, Visual Basic, Perl, SQL, JavaScript, and other scripting/programming.

HINT

Scripting languages are scaled-down programming languages that can be embedded in Web pages, whereas a full-scale programming language such as Java can create stand-alone applications.

THE GRAPHIC/MULTIMEDIA WEB DEVELOPER

Web developers who focus more on graphic design and multimedia creation typically have some type of graphic design, print, or layout experience. Again, this is not to say that this is the rule—just the norm. Graphic designing for the Web is a whole new departure from traditional graphic design for print media. A graphic/multimedia Web developer generally creates advanced images and multimedia that combine animation and sound, and offer some type of interactivity with the viewer. These

designers use advanced software such as Adobe Photoshop, Macromedia Flash, and Macromedia Director (to name a few) to create images and animations specifically for the Web.

ELECTRONIC COMMERCE WEB DEVELOPER

The e-commerce Web developer is able to design advanced Web sites, offering the capability for users to buy online. These developers usually have some type of CGI-scripting and HTML form-handling experience, are able to gather and organize information well, and offer easy-to-use payment solutions for viewers who want to shop online. The e-commerce Web developer should have some experience in database development, and be able to run or understand how a secured server works with a merchant account. Some understanding about retail, sales taxes, and other finances will help as well .

HTML/SITE DESIGN WEB DEVELOPER

The HTML/site design Web developer's job is to strictly develop the HTML aspect of a Web site project, or develop and design the Web site using a Web editor such as FrontPage 2000. Typically, an HTML/site design author will be a key player in developing the basic Web page structure within a team of developers, leaving the more complicated development to programmers and graphic designers. This allows application developers and graphic designers to focus on their specific forte. Often, some job descriptions for an HTML author may also include CGI scripting, Java scripting, and Visual Basic scripting, allowing an individual to incorporate several different Web technologies into a team of Web developers.

Regardless of the type of Web developer you are or want to become, you should learn HTML. HTML is the foundation of Web development, and should be a basic requirement in any type of Web design job. You will learn more about HTML throughout this book.

THE ROLE OF A WEB DEVELOPER

A Web developer plays many roles in the creation of a Web site. For example, a developer can offer a client a complete solution, including consulting, designing, and marketing. However, his or her job may entail

simply providing a logo design for the current Web site. Following is an example of what a professional Web developer might provide to a client seeking a complete Web solution.

Step 1: Meet with the client to discuss several options in designing a Web site, such as Web and server technology, multimedia design, and marketing strategies.

Step 2: After the initial consultation, organizational structure and content development are implemented.

Step 3: Once the layout of the Web site is created, the Web developer designs the site using the technologies and options discussed in the initial consultation. These technologies could consist of HTML authoring, database development, multimedia design, e-commerce, and various scripts.

Step 4: Finally, once the developer completes the Web site project and the client approves it, it is placed on a Web server on the Internet. At this point, any agreed-upon marketing options are fulfilled.

These steps are just a suggestion as to how you might apply yourself as a Web developer in a team environment or as a self-employed contractor. As you gain experience working with clients and developing Web sites, you will develop your own sense of style in your role as a Web developer.

WHAT CAN YOU EXPECT TO CHARGE/SALARY?

This question is the most difficult to answer. It would be a mistake to quote a price or salary. For every pricing rule or standard, there will be someone who will break it. Obviously, large Web marketing/design firms will make more money than the new Web design companies will. There will always be a wide variation of pricing ranges.

Of course, experience and knowledge are key—the more you have, the more money you will make. Prospective clients and employers typically want to see some type of portfolio. A good portfolio is more compelling than all the good grades and degrees in the world.

You can build a portfolio by designing your own Web site in many different ways, using different types of technologies, graphics, colors, and strategies to show a potential client or employer that you are creative and self-motivated.

Once you have equipped yourself with a portfolio, you're ready to begin working, but how much can you expect to be paid? If you plan on starting your own business, a huge factor goes into pricing. Web sites can cost anywhere from $5M to $50M. Obviously, a three-page basic HTML Web site will cost considerably less than a 2000-page, database-driven site. There are all types of hidden costs when it comes to supporting yourself or a team of Web developers in your own firm. How much is your time worth, multiplied by the time it will take to develop your Web site? What about the bidding, marketing, day-to-day operational and health care costs?

You will most likely undercharge your first few clients until you can establish an overhead cost. Try finding other Web design firms on the Internet to see what their rates are. Apply their rates against your overhead, and see if you can come up with rates of your own.

If you are trying to get a job in a Web design firm, or work as a freelance Web designer, log on to online job banks such as www.monster .com to see the average salary and position requirements. By accepting an inhouse or freelance position, you might not make as much money, but will most likely gain more experience.

HINT

Although there are many resources on the Web, the book *The 10th Edition of Graphic Artists Guild Handbook: Pricing & Ethical Guidelines* lists pricing guidelines for many areas of design, including Web design. You can purchase the book and find more information at www.gag.org (Graphic Artists Guild).

SUMMARY

- There are many types of Web designers within the Web development industry.
- Web developers play many roles, and many have backgrounds in areas other than Web development.
- Finding your area of expertise and mastering it will enable you to mature into a professional Web developer.
- How far you take this expertise will determine the salary you can expect to make.

Glossary

· ·

background The area of a display screen not covered by characters and graphics. The background is like a canvas, on top of which are placed characters and graphics.

bandwidth Data transmitted in an amount of time, expressed in bits or bytes per second (bps).

border Surrounds a table; adds depth to the table and definition to the page.

browser A program that enables the viewing of Web pages.

bulleted list Each item in a bulleted list or unordered list is preceded by a dark, solid circle. Follow-on text in a bulleted list item adheres to a hanging indent that wraps the text directly underneath the previous text line.

C Structured, procedural programming language used for operating systems and applications.

caption Descriptive text usually placed at the top or bottom of a table or figure.

chat room A virtual room in which people chat online.

Color box A box that allows you to select colors for the font or background.

container tag A pair or set of HTML tags with "on" and "off" tags that contains text or images.

crawler (spider) A program that looks for Web pages on the World Wide Web

directory A subject guide organized by topics and subtopics.

empty tag A tag that only has an "on" tag that inserts an element such as a horizontal rule.

font Typeface used to display text.

format Changes to text size, color, and/or font.

graphic image Electronic art files that are referenced in an HTML document and displayed by a Web browser.

hexadecimal value Code values for the color in a Web page to give you more control over its appearance because these values translate more exactly between various browsers and computer platforms.

home page The first page seen when arriving at a Web site.

HTML (HyperText Markup Language) A series of tags, sometimes called containers, elements, or codes, that surround text you are coding for special treatment. Allows all types of computers to interpret information on the World Wide Web.

HTML editor Allows creation/modification of Web documents using tags from drop-down lists and toolbar buttons.

hyperlink Using HTML tags to connect to another Web location.

hypertext A database system in which objects can be linked to each other.

index A list of keys or keywords that identify a record.

inline image A graphic file in a Web page that is aligned with text using special HTML tags.

Instant Messenger A communications service with which you can open a personal chat room to talk online, in real time, with another person.

Java A high-level, object-oriented programming language.

JavaScript A scripting language developed by Netscape used to design interactive Web sites. It can interact with HTML source code.

keyword An entry that specifies a record or document.

link Connections to other Web site addresses (URLs) that are coded into an HTML document. Created using an anchor and hyperlink.

MAILTO Attribute that allows readers to send e-mail with a single mouse click.

message board A service that allows people to "post" a message on a virtual bulletin board, where others can view and comment on the message.

meta tag Tag used to describe the contents of a Web site. Search engine crawlers look at meta tags when looking for a Web site.

multimedia Full-motion video and sound files. Full-motion videos tend to have large file sizes and can be cumbersome on the Internet. Audio files vary in size.

NAME Defines the name of the data; a required field.

numbered list Sometimes referred to as an *ordered list*; each line of text in the list is preceded by a number.

ordered list Items listed in numeric order.

pixel Acronym for PICture ELement. The smallest units of a picture on a monitor screen.

platform The computer/operating system combination.

preformatted text Text that displays exactly as it is typed in the HTML document; it can include enhancements, such as bolding and italics, and allows you to include your own line spaces and breaks.

resolution The number of pixels displayed on the screen. In many cases, the default setting is 640×480, but many people set their resolution at 800×600 or 1024×768.

search engine A program that, when given a keyword, looks for all the Web sites on which the keyword was found, and returns a list of those Web sites.

spam Internet junk mail sent to your e-mail address.

storyboard Sketch or layout of a Web site on paper that can include side notes for design purposes.

table Composed of columns and rows, with data contained in individual cells.

tag attributes Property names of the HTML tags that allow you to change the way a tag displays a Web page element.

tag HTML code; can be written in upper- or lowercase, is enclosed in brackets "<>," and sometimes occurs in pairs (both before and after the text they surround). The ending tag differs from the beginning tag; it contains a / (slash) as the first character within the brackets.

thumbnail A small picture of a page.

tiled Arranged so each image does not overlap another.

Web editor An application that allows you to create Web pages using menus and buttons that create the HTML code.

Web page Document containing HTML codes that can be viewed by multiple platforms on the World Wide Web.

Webmaster The manager of a Web site. Makes sure that the Web server hardware and software is running properly, creates CGI scripts, and monitors traffic to the Web site. The Webmaster may also participate in designing the Web site.

What's on the CD-ROM

HTML TEMPLATEMASTER CD-ROM 3RD EDITION

PC (Windows 95 or Higher) or MAC (System 7 or later recommended), with at least 8MB RAM; hard disk drive; CD-ROM drive; Web browser (Netscape Navigator or Internet Explorer recommended); any word processor application (Microsoft Word recommended); mouse and monitor.

JAVASCRIPT CD COOKBOOK, 3RD EDITION

PC (Windows 95 or Higher) or MAC (System 7 or later recommended), with at least 8MB RAM; hard disk drive; CD-ROM drive; Web browser (Netscape Navigator or Internet Explorer recommended); any word processor application (Microsoft Word recommended); mouse and monitor.

STUDENT FILES

Student files are located in the Student Files folder and contain HTML files or images used in some of the lessons.

Index

A

ACTION attribute, 174
Activities. *See* exercises
Addresses. *See* Uniform Resource Locators (URLs); Web site addresses
Address format option, 56
Alignment
 formatting alternatives, 61–63
 of horizontal lines (rules), 85
 images aligned with text, 128
 of table cell text, 157–158
 of tables on page, 152–153
Align menu, 61–62
Anchors, 96, 99–102
Animated GIF images, 113–114
Applets, Java, 195
Aspect ratio for images, 128
Author property setting, 49

B

Background color, tables, 154–155, 158–159
Background Image property setting, 75–76
Backgrounds
 color changes, 76–77
 property settings for, 75
 table background colors, 154–155
 table cell color, 158–159
 tiling, 75–76
Background sounds, 255–256

Bandwidth, 109
Banner advertising, tutorial on CD-ROM, 259
Blockquote format option, 56
Body tags, 7–8
Bold face, 82–83
Borders
 around images, 130–131
 blue borders around images, 130
 red dotted borders, 144
 in tables, 151–152
Browsers, 3–5
 JavaScript compatibility, 196
 JavaScript recipes for newer browsers, 287
 viewing pages with, 17, 64–65
Bulleted lists, 58–59
Buttons
 radio buttons for forms, 178–179
 Reset and Submit buttons for forms, 179–180
 scripts for rollover buttons, 207

C

Captions for tables, 153–154
Career opportunities, 290–294
CD-ROM contents, 299
 HTML TemplateMASTER, 251
 JavaScript CD cookbook, 3rd edition, 288
Cell Properties Box, 156

Cells in tables
 adding, 159–160
 alignment in, 157–158
 background color, 158–159
 deleting, 160–161
 editing, 156–159
 merging (combining), 161
 splitting, 162
 styles, 158
 text wrapping, 158
CGI (Common Gateway Interfaces), 174
Characters and Symbols option of Insert menu, 87–88
Chat rooms, 214–223
Check boxes for form data, 177–178
Clip art collection, 268–280
Color
 background colors, 71–77, 76–77, 154–155
 changing backgrounds, 76–77
 font color, 78
 hyperlink custom color, 88
 JavaScript color recipes, 285
 property settings for, 75
 table backgrounds, 154–155
 web-safe colors, 78–79
Columns
 adding in tables, 159–160
 deleting in tables, 160–161
Common Gateway Interfaces (CGIs), 174
Composer. See Netscape Composer
Composition toolbar in Netscape Navigator, 40
Compression, 110
Consoles for music files, 232–233
Container tags, 7
Content
 adding text to pages, 52–54
 keywords and, 244–245
 tables to organize, 141–143
Cookies, JavaScript recipes on CD-ROM, 286

Crawlers in search engines, 242

D
Data
 ACTION attribute and form data, 174
 check boxes for forms, 177–178
 JavaScript data structure recipes, 286
 METHOD attribute and form data, 174
 one-line text boxes for forms, 175–176
 radio buttons for forms, 178–179
Date and time displays, 205–206
Definitions of terms, 295–297
Definition tags, 58
Description property setting, 49
Description tags, 243
Design elements
 background color or images and, 71–73
 site planning, 261
 storyboarding and, 9–12
 tables, 141–143
 Web design resources on CD-ROM, 258
Directories, 240–242
Directory for CD-ROM, 252–253
Displaying pages in Navigator, 64–65
Document tags, 7–8
DOS extensions, 114
Downloading
 images and file size, 109, 115–117
 Netscape Composer, 29–34
 sound files, 230–232

E
Editing
 cell properties, 156–159
 tables, 148–149
Edit Mode toolbar in Netscape Navigator, 40–41
Edit Preview mode, 41

Electronic commerce Web developer, 292
E-mail, links for, 96–97
Exercises
 color, fonts, rules and special characters, 88–89
 e-mail links, 103
 formatting pages, 65–67
 form creation, 185–187
 image links, 133–138
 JavaScript, 208–210
 links to list items, 103
 MIDI sound files, 234–235
 table creation, 162

F
Fees for Web site development, 293–294
File extensions, 14
Files
 compression, 110
 platforms and file sizes, 118–119
 size and download times, 109–110
Fireworks paint program (Macromedia), 110
Flowcharts, 12–13, 23
FONT pair tags, 77
Fonts
 bold, italic, and underline styles, 82–83
 changing font properties, 77–82
 color of, 78
 size of, 81–82
 type face for, 80—81
Formatting
 background colors, 71–77
 defined, 53
 Format menu, 54–56
 horizontal lines, 83–87
 line breaks, 52–54
 paragraphs, 52–54
 preserving layout, 56
 toolbar in Netscape Navigator, 40

Forms
 check boxes for data, 177–178
 defined and described, 171
 field types, 175
 JavaScript recipes on CD-ROM, 285–286
 non-input fields, 181–183
 one-line text boxes for data, 175–176
 radio buttons, 178–179
 Reset and Submit buttons, 179–180
 selection lists on, 181–183
 text box areas, 185
FORM tags, 173–175
Frames, 255–256
FrontPage, 16

G
Games, JavaScript games on CD-ROM, 282–283
GET, 174
GIF file format, 110–114
 animated GIF images, 113–114
 interlaced GIF images, 113
 transparent GIF images, 112–113
Glossary, 295–297
Graphical techniques tutorials on CD-ROM, 258–259
Graphic Artists Guild, 294
Graphic/Multimedia Web developer, 291–292

H
Headings, 56–58
 levels of, 57
Hexidecimal color chart, 79
Home pages, naming, 16, 23
Horizontal lines, 83–87
 default settings for, 85
 width, height, alignment, and shading settings, 85
HTML. *See* HyperText Markup Language (HTML)
.html and .htm extension, 14

HTML forms. *See* forms
HTMLgoodies web site, 206
HTML Source mode, 41
HTML TemplateMASTER CD-ROM,
 3rd Edition, 251
 starting, 288
Hyperlinks. *See* links
Hypertext, described, 93
HyperText Markup Language
 (HTML), 5–9
 vs. JavaScript, 193–194
 defined and described, 6–7, 23
 development cycle tutorial on CD-
 ROM, 256–257
 Exotic HTML tutorial on CD-ROM,
 255–256
 HTML Source mode, 41
 Jumpstart tutorial on CD-ROM,
 253–254
 "Just enough" tutorial on CD-
 ROM, 254–255
 source code pictured, 6
 See also tags

I
Image Properties box, 120–123, 124
Images
 alternative text for, 122–123
 animated GIF images, 113–114
 background images, 71–77
 blue borders around, 130
 borders for, 130–131
 clip art collection, 268–280
 constraining, 127–128
 editing properties of, 124–131
 file location of, 119
 file size and download times, 109
 formats for, 110–115
 GIF images, 110–114
 Graphical techniques tutorials on
 CD-ROM, 258–259
 inserting with Composer,
 119–124
 interlaced GIF images, 113

JPEG (JPG) format, 114
 as links, 102, 132–138
 measuring size of, 118–119
 PNG format, 114–115
 resizing, 126–128
 thumbnails, 116–117
 transparent GIF images, 112–113
 white space and, 128–130
Indexes
 in search engines, 242
 search engines and Page Proper-
 ties, 47–48, 49, 67
Inputs, forms and, 175
 check boxes, 177–178
 one-line text fields, 175–176
 radio buttons, 178–179
 Reset buttons, 179–180
 Submit buttons, 179–180
 text, large text areas, 183–185
INPUT tags, 175
Insert menu, Characters and Symbols
 option, 87–88
Instant messenger, 223–225
Interactive web pages, JavaScript
 used in, 196
Interlaced GIF images, 113
Internet Explorer, testing pages in,
 17–18
Italics, 82–83

J
Java programming, *vs.* JavaScript,
 194–195
JavaScript
 browsers and, 196
 date and time display, 205–206
 defined and described, 191–193
 disadvantages of, 196–198
 exercise, 208–210
 games on CD-ROM, 282–283
 vs. HTML, 193–194
 inserting scripts, 198–202
 interactive web pages and, 196
 vs. Java programming, 194–195

JavaScript CD cookbook, 3rd edition, 280–288

online tutorials and information about, 206–207

recipes on CD-ROM, 280–288

script sources, 198

security and, 196

source code, 196, 198, 199

status bar text from, 203–204

strings, 283

syntax errors, 194

writing scripts, 202

JavaScript CD cookbook, 3rd edition, 280–288

starting, 288

JPEG extension, 114

JPEG images, 114

JPG extension, 114

Jumpstart HTML tutorial, 253–254

K

Keywords

location on page, 244

selection of, 244

tags, 243

Keyword tags, 243

L

Layout

preserving text format, 56

See also formatting

Line breaks, 52–54

Link Properties dialog box, 94–96

Links

anchors, 96

creating, 94–96

custom colors for, 88

drag-and-drop creation, 94

e-mail links, 96–97

images as, 102, 132–138

Link Properties dialog box, 94–96

removing, 102–103

targeting to new windows, 98–99

within pages, 99–102

Lists

bulleted lists, 58

creating, 58–59

formatting styles, 59–61

numbered lists, 58

ordered and unordered, 58–59

Term and Definition, 58

Location setting, 49

Low-source images, 255–256

M

Mac platform, measuring image file size, 119

Macromedia (Fireworks paint program), 110

Mailto: command, 96

Marquees, 255–256

Math, JavaScript recipes, 284

Message boards, 225–229

Meta tags, 50

search engine ranking and, 242–243

METHOD attribute, 174–175

MIDI (Musical Instrument Digital Interface) files, 230

Mouse-over effects, 192

Multicity.com, 213–214

Multimedia

CD-ROM contents about, 260, 287

JavaScript recipes on CD-ROM, 287

See also sound and sound files

Multiple-selection lists on forms, 183–183

adding and deleting items in, 183

Musical Instrument Digital Interface (MIDI) files, 230

N

Named Anchors Property box, 100–101

Naming

anchors, 100–101

home pages, 16, 23

Navigator. *See* Netscape Navigator

Netscape Composer
 closing, 42
 downloading, 28, 29–34
 inserting images with, 119–124
 interface, 38–41
 launching from Navigator, 37–38
 Page Properties, 47–50
 Save As dialog box, 15
 starting, 34–37
Netscape Navigator
 browsing in, 64–65
 testing pages in, 19–21
Normal mode, 41
Numbered lists, 58–59

O
One-line text boxes for form data,
 175–176
Ordered lists, 58–59

P
Padding for table cells, 151–152
Page Colors and Background dialog
 box, 74–75
Page Properties in Netscape Com-
 poser, 47–50
Pages
 defined, 3, 23
 examples pictured, 4, 5
Page Titles and Properties settings,
 48, 49
Paint programs, 29
Paint Shop Pro 6 tutorial on CD-
 ROM, 259
Paragraph format option, 56
Paragraphs, 52–54, 56
PC platform, measuring image file
 size, 118
Percentages, setting table widths as,
 147
Pixels, setting table widths in,
 145–147
Planning methods
 flowcharts, 12–13

storyboarding, 9–12
Planning stage, 9–13
Platforms
 measuring image file size, 118
 viewing pages in different
 browsers, 17
PNG images, 114–115
POST, 174
Preformatted format option, 56
Programming, advanced Web pro-
 gramming information, 260
Promotion, 280
 See also search engines

R
Radio buttons for form data, 178–179
Ranking, improving search engine
 ranks
 keywords and, 243–245
 meta tags and, 242–243
Reader's Default Colors property, 75
Reset buttons, 179–180
Rollover buttons, script source for,
 207
Rows
 adding in tables, 159–160
 deleting in tables, 160–161
Rules. *See* horizontal lines

S
Salaries for Web developers, 293–294
Sample pages, 261
Saving web pages, 13–16
 in Composer, 63–64
Scripts and scripting languages. *See*
 JavaScript
Search engines
 defined and described, 239–242
 vs. directories, 240–242
 indexes, 242
 key words, 243–244
 meta tags and, 242–243
 Page Properties settings and,
 47–48, 49, 67

ranking for pages, 239–240, 242–245
registering your Web site, 245–248
software, 242
spamming, 245
spiders or crawlers, 242
Security, JavaScripts and, 196
Selection lists, 175
 on forms, 181–183
Shading, of horizontal lines, 85
Show All Tags mode, 41
Site design Web developer, 292
Size
 of font, 82
 of table cells, 157
 of tables in rows and columns, 149–151
Slide shows, 255–256
Sound and sound files, 229–231
 background sounds, 255–256
 consoles, 232–233
 embedding on page, 233–234
 host server compatibility, 232
 inserting on page, 232
 MIDI files, 230
 WAVE (.wav) files, 230
Source code
 JavaScript source code, 196, 198, 199
 pictured, 6
 viewing, 8
 View menu to see, 50–52
Spacing, around images, 128–130
Spamming, 245
Special characters, 87–88
Spiders in search engines, 242
Status bar text, JavaScript to generate, 203–204, 283
Step-by-step reviews
 aligning text to images, 128
 backgrounds, changing color or image, 76–77
 borders for images, 131
 captions for tables, 153–154

cell properties, 159
check boxes, 177–178
color in tables, 155
e-mail links, 97
formatting, applying to text, 56
form attributes, 175
heading creation, 58
horizontal lines, inserting, 87
HTML pages creation, 21–23
image insertion, 124
image links, 132
image resizing, 128
link creation, 96
link targets (new windows), 98–99
lists, creating and formatting, 60
Netscape Composer basics, 42
one-line text boxes, 175–176
page properties settings, 50
radio buttons, 179
removing links, 103
Reset buttons on forms, 179–180
rows, column, and cells in tables, 161
selection lists, 181–183
size of font, 82
Submit buttons on forms, 180
symbols and special characters, 87–88
table alignment, 153
table borders and spacing, 152
table insertion, 145
Table Properties Box, 149
table resizing, 150–151
text box areas in forms, 185
text color, 80
typeface changes, 81
within-page links, 101–102
Storyboarding, 9–12, 23
Strings, JavaScript, 283
Student files on CD-ROM, 299
Style guides, 261
Submit buttons, 179–180
Symbols, 87–88

T

Table Properties, 147–148

Tables
adding and deleting cells, 159–161
alignment of text in cells, 157–158
alignment on page, 152–153
borders and spacing between cells, 151–152
captions for, 153–154
cell size, 157
editing, 148–149
editing cells, 156–159
fixed widths, 145–147
inserting, 143–145
merging (combining) cells, 161
organizing content with, 141–143
padding for cells, 151–152
resizing, 149–150
size in rows and columns, 149–151
size of cells in, 157
splitting cells, 162
Table Properties to change appearance, 147–148
widths of, 145–147

Tags
attributes defined, 173–174
body tags, 7–8
container tags, 7
defined and described, 6–7
Definition tags, 58
description tags, 243
document tags, 7–8
EMBED tags, 233–234
FONT pair tags, 77
FORM tags, 173–175
INPUT tags, 175
keyword tags, 243
meta tags, 50, 242–243
Show All Tags mode, 41
Term tags, 58
title tags, 49

Targeting links, 98–99

Targets, anchors as, 99–102

Templates, HTML, 262, 264–267

Term tags, 58

Testing pages
in Internet Explorer, 17–18
in Netscape Navigator, 19–21

Text, formatting
aligning sections of text, 61–63
Format menu options, 54–56
line breaks, 52–54
paragraphs, 52–54
text wrapping in table cells, 158
See also fonts; lists

Text as alternative for images, 122–123

Text box areas, 183–185

Text editors, saving web pages in, 13–15

Text wrapping, 158

Themes, 262, 263

Thumbnail images, 116–117

Tiling, 75–76

Time and date
displays, 205–206
JavaScript clocks on CD-ROM, 283, 284

Titles, 49
See also headings

Title tags, 49

Toolbars in Netscape Composer
activating, 38–39
Composition toolbar, 40
Edit Mode toolbar, 40–41
Formatting toolbar, 40

Tools. *See* Webmaster tools

Transparent GIF images, 112–113

Tutorials
HTML 4.0 tutorials on CD-ROM, 252–280
online JavaScripting tutorials, 206–207
See also exercises; step-by-step reviews

U

Underlining, 82–83
Uniform Resource Locators (URLs)
 defined, 93
 as links, 96
Unordered lists, 58–59
URLs (Uniform Resource Locators).
 See Uniform Resource Locators
 (URLs)
Use Custom Colors property, 75
Users, forms and interactivity, 171

V

View menu, 50–52

W

WAVE (.wav) files, 230
Web addresses
 GIF information source, 113
 Graphic Artists Guild, 294
 midi-network (MIDI sound file
 downloads), 230
 Multicity.com (Webmaster tool
 source), 214
 WebPromote (meta tag generator),
 243
Web application developers, 291
Web developers, job descriptions and
 career opportunities, 290–294

Web editors
 described, 27–28
 reviews of, 257
 saving web pages with, 15
Webmaster tools
 chat rooms, 214–223
 defined and described, 213
 instant messenger, 223–225
 message boards, 225–229
 sound files, 229–231
 sources of, 213–214
Web site addresses
 HTMLgoodies web site, 206
 Internet Explorer, 17
 JavaScript source code sites, 198
 Macromedia (Fireworks paint
 program), 110
 Netscape Communicator, 17
 Sun Microsystems (Java informa-
 tion), 195
Web space, 29
Windows
 JavaScript recipes on CD-ROM, 286
 new windows activated by
 links, 98–99
Workspace in Netscape Composer, 41